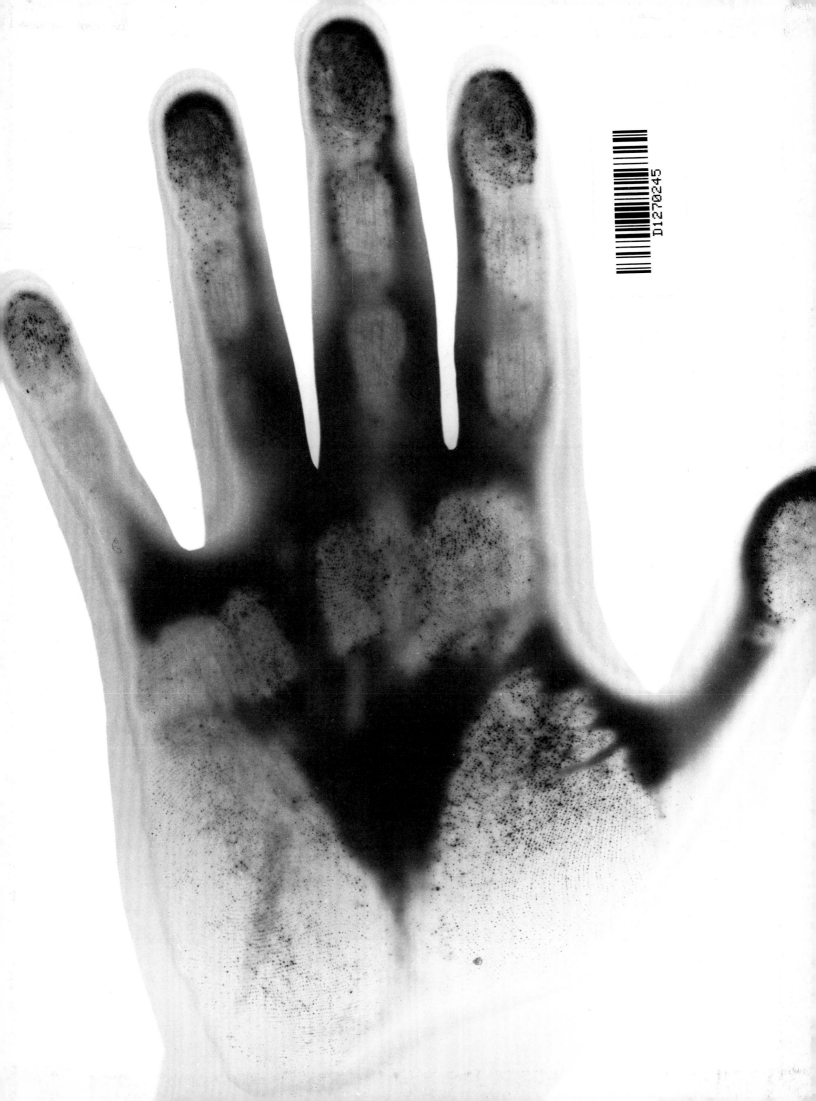

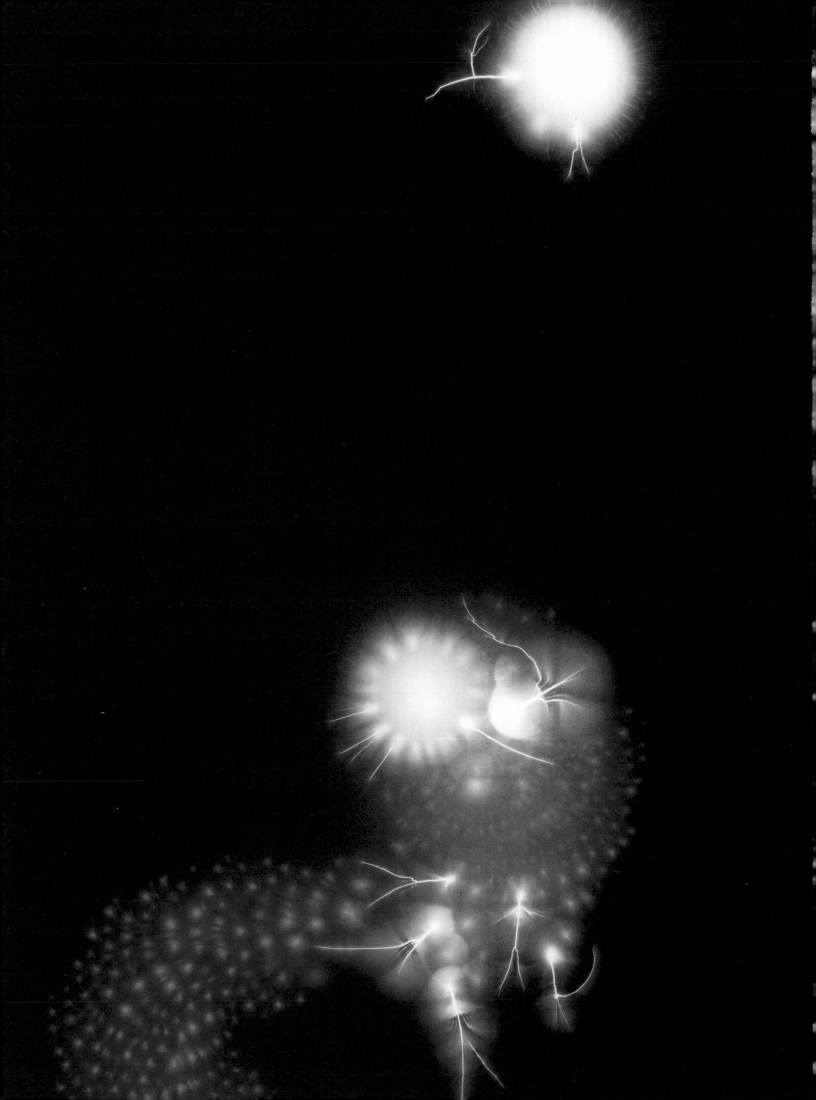

The Extended Moment

The Extended Moment

Fifty Years of Collecting Photographs at the National Gallery of Canada

Ann Thomas John McElhone

5 Continents Editions

Canadian Photography Institute of the National Gallery of Canada

As the Founding Partner of the Canadian Photography Institute, Scotiabank is proud to support *The Extended Moment: Fifty Years of Collecting Photographs.* One of the most ambitious projects undertaken by the Canadian Photography Institute, this exhibition and the accompanying catalogue provide a window into the past fifty years of Canadian artistic excellence.

Scotiabank has a long history of supporting Canadian artists, culture and heritage in communities across Canada. Our commitment stems from our belief that the arts enrich our lives and communities in meaningful ways. The Canadian Photography Institute, the Scotiabank Photography Award and the Scotiabank CONTACT Photography Festival, are our way of celebrating the creativity and accomplishments of Canada's most gifted photographers.

I hope you enjoy the exhibition.

Brian J. Porter
President & CEO, Scotiabank

FOUNDING PARTNER OF THE CANADIAN PHOTOGRAPHY INSTITUTE

 Scotiabank®

Published in conjunction with the exhibition *The Extended Moment: Fifty Years of Collecting Photographs.*

Itinerary
National Gallery of Canada, Ottawa, from 4 May to 16 September 2018
The Morgan Library and Museum, New York, 15 February to 26 May 2019

National Gallery of Canada
Chief, Publications and Copyright: Ivan Parisien
Editor: Lauren Walker
Picture Editor: Andrea Fajrajsl
Production Manager: Anne Tessier
Translator: Christine Dufresne

Designed and typeset in Sequel Sans by François Martin
Colour Separation: Conti Tipocolor, Italy
Printed in Italy on GardaPat Kiara by Conti Tipocolor

Cover: Gary Schneider, *John in Sixteen Parts, V*, 1996, printed 1997 (detail, pl. 174)
Inside front cover: Lisette Model, *Woman with Veil, San Francisco*, 1949 (detail, pl. 165)
Flyleaf recto: Gary Schneider, *After Naomi*, 1993, printed 1994 (detail, pl. 14)
Flyleaf verso: Hiroshi Sugimoto, *Lightning Fields 138*, 2009 (detail, pl. 10)
Back flyleaf recto: Anna Atkins, *Polypodium crenatum*, Norway 1854 (detail, pl. 26)
Back flyleaf verso: Southworth & Hawes, *Portrait of a young girl with hand on shoulder*, c. 1850 (detail, pl. 20)
Inside back cover: Robert Walker, *Times Square*, New York 2009 (detail, pl. 38)
Back Cover: John Vanderpant, *The Ebony Mask*, 1936 (detail, pl. 158)

Published by 5 Continents Editions, Milan, in association with the National Gallery of Canada.

© For texts and illustrations National Gallery of Canada, 2018.
For the present edition, 5 Continents Editions, 2018

5 Continents Editions
Piazza Caiazzo 1 - 20124 Milan, Italy
www.fivecontinentseditions.com

Cataloguing data available from Library and Archives Canada.

ISBN: 978-88-7439-802-7

Distributed in the United States and Canada by Abrams, an imprint of ABRAMS, New York.

Distributed outside the United States and Canada, excluding Italy and South America, by Yale University Press, London

Contents

Foreword

The Extended Moment: Fifty Years of Collecting Photographs celebrates an outstanding and diverse collection of international photographs built up over a fifty-year period. This exhibition and its accompanying catalogue also salute the pioneering efforts of visionary colleagues who advocated for the establishment of a collection of photographs that would represent the historical breadth and depth of the medium. At the forefront of these initiatives were the National Gallery's Director, Jean Boggs (1966–1976), the Board of Trustees, and the Gallery's Director of Exhibitions and Education, later to become the founding curator of the photographs collection, James Borcoman. The history of the collection's growth, as outlined in Senior Curator Ann Thomas' essay, "In the Right Light, at the Right Time," is indeed marked by the scholarship, foresight and conviction of the aforementioned individuals and governing bodies but also shaped by private and federal support. Without our annual allocations for acquisition purchases we would not have been able to add the finishing touches to comprehensive collections with masterpieces such as Gustav Le Gray's *Queen Hortense, the Emperor's Yacht, Le Havre* (1856), Alvin Langdon Coburn's *Vortograph* (1917) or Frederick H. Evans' *Wells Cathedral: A Sea of Steps* (1903).

While there was an appreciation of photography's archival significance and its role in the evolution of modern art, the revolution that would occur in what we persist in calling photography and the overwhelming scale of the ensuing culture of images could certainly not have been predicted fifty years ago. Not only have enormous strides been made in colour printing, digital capture and printing of images we have also, in recent years, been introduced to three-dimensional image making.

Since artists avail themselves of all manner of contemporary imagery, it seemed only appropriate that the National Gallery's Collection of Photographs should widen its collecting base to include photojournalism and vernacular photography as well as other forms; this was the subject of a discussion that I had with the staff of the collection some seven years ago. While continuing to emphasize photography as a medium of artistic expression, the collection's expanded mandate was further consolidated in the fall of 2016 when with our partners, Scotiabank and the Archive of Modern Conflict, we founded the Canadian Photography Institute of the National Gallery of Canada.

Marc Mayer
Director and Chief Executive Officer
National Gallery of Canada

Acknowledgments

While attempting to summarize five decades of collecting, exhibiting, publishing and bring some kind of intellectual order to tens of thousands of photographs in the collection of the Canadian Photography Institute (CPI) of the National Gallery of Canada, I was somewhat surprised to realize that I have been around this collection for four-fifths of its life. When I accepted the position of Assistant Curator of Photographs forty years ago, I planned to stay only five years. This plan was foiled; when other opportunities arose I was already committed to some deeply engaging exhibition project. And, photography's connections to art, politics, history, social engagement, memory and numerous other facets of human experience manifest in the images in this collection, certainly preclude the onset of boredom.

These in-depth and diverse holdings are due in large part to the support of many generous donors who took our mission to enrich the collection as their own. Their generosity has helped to create an abundant resource for research into many aspects of the history of photography.

Gifts from Dorothy Meigs Eidlitz and Phyllis Lambert, founding Director of the Canadian Centre for Architecture, made in the first decades of the collection, helped to define the ambitious scope the Gallery would take in establishing its photographs collection. In the succeeding years many others donated individual works and albums and collections of photographs, all of which contributed in numerous ways to the growth and excellence of the collection (see list of donors, p. 334).

Outstanding and transformative bodies of work, mentioned in the introductory essay, were gifted to the collection more recently by individuals who prefer to remain private and they are equally deserving of our sincere thanks. Phyllis Lambert, Mark McCain and Caro McDonald, and Anne Shabaga assisted by establishing dedicated photographs acquisitions funds. The Photography Collectors' Group Fund, was established by a group of collectors to whom a special thanks is due for their consistent support. Their donations of contemporary photographs have enriched the collection over the years. Additionally, as a federal institution

with a national mandate, we receive annual appropriations that have allowed us to take advantage of rare opportunities and to tailor the collection by adding exceptional works. The CPI now enjoys a deep and encompassing base to build upon.

An exhibition of this calibre would not have been possible without the unwavering support for acquisitions that the photographs department has received from Director Marc Mayer, Chief Curator Paul Lang and the National Gallery's Board of Trustees and Advisory Committee. As the CPI develops a collection representative of today's spectrum of photographic image making, their ongoing encouragement of and commitment to quality and connoisseurship will remain as essential as ever.

Both this exhibition and catalogue have in every sense been a labour of devotion, if not love. Sincere thanks go to project managers Elizabeth Hale and Christine La Salle, designer David Bosschaart, photographs conservator Christophe Vischi, conservation technician Stephanie Miles, framing technician Heather McLeod, senior framer Robert Roch, documentation and storage officer Shawn Boisvert, and cataloguer Erika Dole.

Becca Wallace, Paul Elter and Lawrence Cook, my colleagues in Multimedia Services, were meticulous in their efforts to obtain the best possible reproduction quality for the book and I thank technician François Labelle for his engagement. It is thanks to the expertise and careful handling of the works by my colleagues in Technical Services, under the watchful eye of Jean-François Castonguay, Chief Technical Services, that our exhibitions, once installed, take on the life and grace that they do.

Jonathan Newman was a cheerful and invaluable assistant in helping with the selection for the exhibition and catalogue. My appreciation extends to the team under Ivan Parisien, Chief, Publications and Copyright, who put it all together: English editor Lauren Walker, translator Christine Dufresne, French editor Marie-Christine Gilbert, photo editor Andrea Fajrajsl, production manager Anne Tessier and copyright manager Véronique Malouin supported every stage of production. It was a great pleasure to work again with designer François Martin.

Sue Lagasi, recently retired Chief, Collections Management, provided assistance in researching the collection. Andrea Kunard, Associate Curator of Photographs, and Lori Pauli, Curator of Photographs, kindly reviewed the chronology. Committed to the values of scholarship and sound collections custodianship, they and curatorial assistant Jonathan Newman have been excellent colleagues and sources of inspiration through their writings and exhibitions. Jim Borcoman was also kind enough to respond to questions, as were numerous artists. Cyndie Campbell, Chief, Library, Archives and Research Fellowships Programs, was an indispensable resource person, helping us find what we were looking for. She and her staff were, as always, extremely obliging, making documents regarding the history of the collection readily available to all of us and providing dates and data whenever requested.

Charlotte Gagnier, Museums Studies graduate student, University of Toronto, exceeded the requirements of her summer internship by undertaking myriad duties. She learned first-hand the nature of the battle to condense a collection of more than 200,000 images into a representation of fewer than 200 works and scoured Board Minutes and other records to compile a chronology of the collection's history up until today.

I am grateful to my many learned and thoughtful colleagues outside the institution who have shared expert advice on acquisitions or related matters over the years. Among them, Joel Smith, Richard L. Menschel Curator of Photography at The Morgan Library & Museum (a future venue for a scaled-down version of *The Extended Moment*) is owed thanks for steering me toward the theme of this exhibition and coming up with its title. He and the many others who so willingly shared their expertise and convictions about collection building will always be greatly appreciated.

I owe a special thank you to my co-author and colleague of many years, John McElhone. As recently retired Photographs Conservator and Chief, Conservation and Technical Research, John has been an invaluable source of advice and knowledge, bringing reason to arguments, and standards, knowledge and a healthy pragmatism to questions of photographs preservation and conservation. He is a born educator.

Scotiabank is a national leader in the support of Canadian photography. We owe them a heartfelt thank you for their ten-year commitment to funding the Canadian Photography Institute of the National Gallery of Canada. *The Extended Moment* is both a celebration of an inspired moment in the past and a milestone in a future collaboration.

For their ongoing support, I thank Marc Mayer, Director and CEO of the National Gallery of Canada, Paul Lang, Deputy Director and Chief Curator, Anne Eschapasse, Deputy Director, Exhibitions and Outreach, Stephen Gritt, Director, Conservation and Technical Research; from the National Gallery Foundation, Karen Colby-Stothart, Director and CEO, and Christine Sadler, Managing Director; and Luce Lebart, Director, Canadian Photography Institute.

Lastly, a personal thank you to Emily and Brian, my home support team.

Ann Thomas
Senior Curator
Canadian Photography Institute

In the Right Light, At the Right Time

Ann Thomas

The picture, divested of the ideas which accompany it, and considered only in its ultimate nature, is but a succession or variety of stronger lights thrown upon one part of the paper, and of deeper shadows on another.

William Henry Fox Talbot, *The Pencil of Nature*, 1844

Photography's emergence as a naturalistic and relatively fast way of composing and obtaining pictures revolutionized image making. The public announcement of the invention of the daguerreotype at a joint gathering of the Académies des Sciences and des Beaux-Arts in Paris in August 1839 challenged the common perception that only the eye and hand, free of mechanical intervention, could produce a proper representation of people, places and things. The popularization of reproducible photographic prints made from negatives that followed not long after the daguerreotype resulted in an eruption of images. The public embraced this product of technology and chemistry with great enthusiasm, leaving painters somewhat conflicted about the new highly naturalistic medium. On one hand they saw their professional status being thrown into question and on the other were attracted to its potential not only as an *aide-mémoire* but also as a tool for picture-making. The debate about its status as an art form would linger throughout the rest of the century and even into the next one.

Like our global society today that is exposed to a voluminous and constant stream of images through Facebook, Instagram, Pinterest, Snapchat and other social media image platforms or contained in personal computer libraries, the western world of the mid nineteenth century was also overwhelmed by these mechanically but also apparently magically produced images, if to a somewhat lesser degree (see pl. 29). Were these images fact or fiction? Art or science? It also created opportunities of an artistic, investigative and economic nature. The photograph's ability to capture fragments of the world, both visible and invisible to the naked human eye, was sensational, controversial and popular.

Despite enormous technological advances over the past 180 years, the impetus behind the making of what were called, and what we continue to call, photographs (despite the shift from analogue to digital) remains the same: curiosity about the world, attachment to the likenesses of friends and family members, recording events and the lives of others, and self portrayal. And from this list we should not forget the simple aesthetic appreciation of picture-making. It is not only the way in which the camera – analogue or digital – captures and fixes a moment in time and thereby prolongs the instant that captivates us, but also the enduring fascination with the resulting images that gives this exhibition and catalogue the title: *The Extended Moment*.

Starting to Collect Photographs at the National Gallery of Canada

Photographs are deceptively mute. Loaded with detail but best suited to ask rather than answer why the world is as it is, they continue, nonetheless, to have a firm hold on the imagination. Photographic images are conserved in archives and museums, researched, written about and exhibited because we delight in the struggle of the mind's eye to connect and make sense of what we see around us, including such representations of the world.

Placing photographs in a museum to preserve, order and interpret them seems logical and natural to us today but the road to that realization was relatively slow. The Victoria and Albert Museum, London, was in all likelihood the first museum to collect photographs beginning in 1852.[1]

Although Jean Sutherland Boggs and James Borcoman (fig. 1) were the architects of the collection of photographs at the National Gallery of Canada in 1967, a considerable amount of background preparation was done in the preceding three years by Gallery staff, administrators and Board members to include photographs in its collecting mandate.[2] By the time Dr. Boggs arrived as Director of the National Gallery of Canada in 1966, the groundwork to implement her nascent plan for a photography collection had thus been laid. As an internationally renowned scholar of the works of Edgar Degas, the French painter and sculptor, Dr. Boggs had encountered a profusion of nineteenth-century French photographs in need of preservation and intellectual organization during her research. Furthermore, discussions with her friend Man Ray had convinced her of the importance of including photography in the collecting plans of the National Gallery of Canada if it were to be a truly modern museum. Doing due diligence as incoming Director, Boggs examined personnel files and found the ideal future custodian of a collection of photographs in the then-Director of Exhibitions and Education, James Borcoman. His passion for and knowledge of the medium had already been demonstrated by the support he had given to the programming of a number of external photography exhibitions as an Assistant Education Officer.[3]

At the time none of these advocates for a national photographs collection had any idea, however, that an extraordinary proposal had been made to Canada thirteen years earlier. On 14 September 1954 Helmut Gernsheim, a collector and author of several publications on the history of photography wrote Canada's Governor General Vincent Massey [1952–59][4] offering his collection along with his and his wife Alison's services to Canada. The Gernsheims had met Massey in London when he was Canadian High Commissioner to the United Kingdom.

After reminding the Right Honourable Vincent Massey of this meeting, Gernsheim described the work he and his wife had done on the history of photography and the various recent and significant exhibitions that had been drawn from their collection. The purpose of the letter, he wrote, was:

> ... to enquire whether you would be willing to put forward to the Canadian Government our proposal for a Museum and Institute of Photography... . Canada is in a considerably more favourable economic situation than Britain, and as the Canadian Government has shown interest in the idea of a photographic portrait gallery, for which purpose Youssuf [sic] Karsh was sent to Europe and America to photograph the famous personalities of our time, my wife and I wonder whether you would be willing to lay our proposition before the Canadian Government. ... [our collection] is at present valued at and insured for £20,000.

The letter went unanswered, as Gernsheim's later annotation "No reply received!" indicates. Years later he sent a copy to James Borcoman. "Just found it again. For your file. Without comment," he penned at the head of the first page.[5] This exceptional collection of more than 33,000 photographs, 4,000 books, research notes, his own correspondence, and collected correspondence, including letters by Daguerre and Fox Talbot, was purchased by the University of Texas at Austin in 1963.[6]

Nothwithstanding the missed opportunity to secure the Gernsheim collection, Canada would eventually have a collection of photographs housed in a national museum. Under the direction of Boggs and Borcoman, two visionaries buoyed by a national mood of optimism and innovation in its centenary year, the collection was established in the spring of 1967. The timing was excellent. Opportunities abounded and the market for photography would not assume the vigorous growth pattern that we have witnessed over the last several decades for another five years. James Borcoman confirmed his interest in founding the collection of photographs and Jean Boggs endowed it with an annual budget of $5,000 – Canadian – and told him to "go ahead and do it."[7]

In his report to the Board of Trustees in December 1967 Borcoman proudly reported that "... a start has been made on a permanent collection. If it continues, we shall be the first national gallery in the world to have an active collection."[8] At the same time he cautioned them: "We are already late in making a start. This year has seen a sudden spurt of activity in founding photographic collections. Prices, however, are still reasonable; it is still possible to build an historic collection. But not for much longer. From now on the competition is going to become increasingly sharp."[9]

Building a collection that will not only serve immediate needs but also be preserved for future generations brings with it custodial responsibilities to ensure proper storage and conservation and correct documentation. In the early 1980s, James M. Reilly, a specialist in the preservation of

Fig. 1
James Borcoman examining the
collection, September 1973

photographs and early photograph technology from the Rochester Institute of Technology, conducted a review of the Gallery's photographic collection. In his report, his "single-most important recommendation" was to assign a trained photographs conservator to the staff.[10]

Shaping the Collection

When launching a new enterprise, we invariably turn to outside experts who ultimately help to influence the direction it will take. Among those who assisted in the shaping of the newly formed collection of photographs were André Jammes, an antiquarian and bibliophile in Paris and astute collector of what was then known as "French Primitive" photography, and Beaumont Newhall, photography historian, first curator of photographs at the Museum of Modern Art, New York, and Director of the George Eastman House.

Jammes' approach was archival. His advice was to collect everything, including photographs that did not conform to the canon. The interpretation of these less iconic, less widely collected photographs could, he felt, be left to future generations to contextualize.

Newhall, on the other hand, an art historian by training and curator by practice, urged connoisseurship in the acquisition of images, emphasizing a discriminating approach to collecting works by master photographers that would anchor the collection in the history of photography. "It is my belief, as an art historian as well as a photographic historian," he wrote, "that the photograph, by its very genesis and development, has been inextricably linked with painting."[11] Both gentlemen were invited to give public lectures at the Gallery in 1967. Newhall's topic was *Photography in America in 1867* and took place on 31 January; Jammes spoke on *La photographie en France en 1867: un second souffle* on 4 April.[12]

Jammes and Newhall provided an invaluable balance of opposing perspectives, but Borcoman, in the throes of situating photography within an institutional collection dedicated to the traditional genres of fine arts, favoured Newhall's formalist appreciation of the photograph.

The Photograph as Object 1843–1969: Photographs from the National Gallery of Canada (fig. 4), the first exhibition drawn from the collection, was predisposed to the aesthetic of form and object quality over informational content as evidenced by its title. Launched in 1969, it engaged and delighted the public with the variety of styles and processes as well as the historical sweep of its content. At the same time it educated viewers about the purpose and direction of the collection. In his essay in the modest catalogue – one wishes now that this had been more ambitious – Borcoman argued for "the photograph as expression rather than as description" and cautioned against mistaking it for "a *picture of* rather than an *object about*." He further clarified the role that photography would play in the museum:

The purpose of this exhibition is to show that the range of camera imagery is and has been sufficiently broad and the goal of the image maker sufficiently complex that to limit the role of the photograph to an information or narrative medium is to ignore a great force indeed."[13]

He also developed a vocabulary to elucidate the finer points of photographic print appreciation.

In 1974, seven years after the establishment of the collection, which now numbered more than 6,000 individual works, an issue of *artscanada* dedicated to "an inquiry into the aesthetics of photography," published a timely review by Peter C. Bunnell, Director of the Art Museum and McAlpin Professor of the History of Photography and Modern Art at Princeton University. While Bunnell lauded the Gallery's commitment to developing an international collection and Borcoman's insistence on representing the work of a photographer by acquiring groups of prints rather than single images, he – justly – made the point that the collection did not adequately represent the Modernist period. Bunnell wrote: "this is where the thrust of future acquisition must lie."[14]

Indeed, Man Ray's portfolio of twelve modern Rayograph prints, acquired from Jammes in 1968, was an isolated representation of European avant-garde work. Catch-up was needed in other Modernist areas like Neue Sachlichkeit as well. A superb Rayograph from the Arturo Schwarz collection was added in 1982 (pl. 99). The work of August Sander, whom Bunnell had particularly singled out as a hiatus in the collection, was addressed by adding fifty-five Sander prints to the collection between 1976 and 2001. In addition works by twentieth-century master photographers László Moholy-Nagy, Aleksandr Rodchenko, Gustav Klutsis, Franz Roh, Josef Sudek, Jaromír Funke and Jaroslav Rössler, among others, would enrich the appreciation of photography's contribution to modernism. The representation of such major figures as Edward Weston, Walker Evans, Lisette Model, Paul Strand and members of Photo League would be increased through donation and purchase over the next thirty-five years to make the collection a rich resource for research and exhibitions.

Yet another aspect of developing a collection is the importance of providing context for iconic figures in the history of photography. August Sander, for example, is well known for his precisely seen portraits of German citizens in the first half of the twentieth century and their organization into a social hierarchy in his legendary 1929 publication, *Antlitz der Zeit* (Face of our Time). While Sander's body of work is unique in the history of photography, it is instructive to know that his selection of subjects and his style of photographing was shared by lesser-known German photographers of the period such as Karl Spiess who had less lofty philosophical aims but left a record of small town Germany of the 1920s and 1930s (figs. 2, 3).

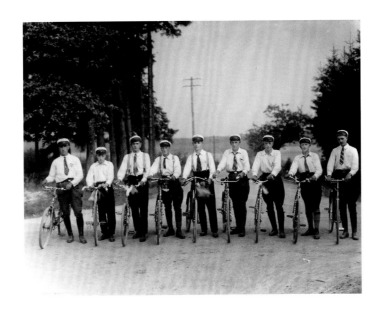

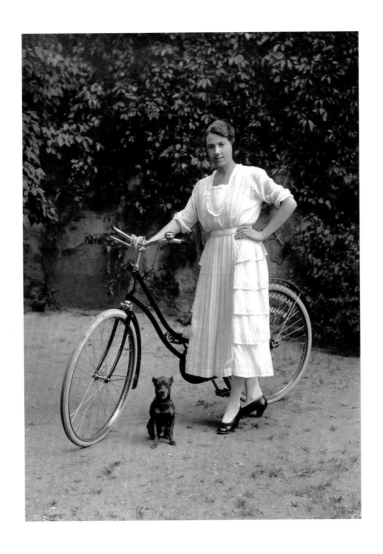

Fig. 2
August Sander, *The Cycling Club*,
c. 1927, printed c. 1955, gelatin
silver print with black ink border,
20.9 × 26.6 cm

Fig. 3
Karl Spiess, *Woman with Bicycle*,
c. 1930–35, from a glass negative,
18 × 13 cm

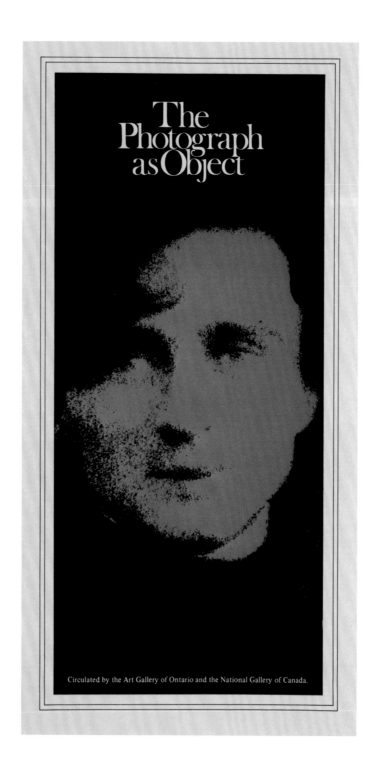

The Photograph as Object

Circulated by the Art Gallery of Ontario and the National Gallery of Canada.

Consistent government appropriations for acquisitions ensured steady and focused building of the collections, including photographs. But the market for photography would accelerate rapidly from the late 1970s to the 2000s, making the already modest budget for photographs inadequate by the mid 1970s and jeopardizing the prospect of it becoming a collection of world-class stature.

The generosity of donors, however, ensured that these expectations would be met. The first donation of photographs arrived, unannounced, in the receiving room of the Gallery in 1968. It contained more than three hundred photographic prints, over two-thirds of which were photogravures in *Camera Work* but also included the first Lisette Model, Minor White and Edward Weston prints to enter the collection. Coming from Dorothy Eidlitz, an American who summered in St. Andrews New Brunswick where she ran Sunbury Shores, an arts and crafts school, the donation also included non-photographic works by American Modernist masters, Charles Sheeler, Arthur Dove and Lyonel Feininger.

Since that first gift, the number of donors to the collection increased significantly. Among them was Phyllis Lambert (fig. 5), architect, author and founder of the Canadian Centre for Architecture who recognized early on the importance of the Gallery's commitment to photography. Between 1975 and 1988 she donated major holdings (including Alexander Gardner's *Photographic Sketchbook of the War*), 279 prints by Walker Evans and a collection of 126 exquisite European and American daguerreotypes coming from the German photographer and collector Werner Bokelberg. Ms Lambert also augmented the annual photographs budget with an annual fund to allow for exceptional purchases including the development of our Modernist holdings.[15]

Mark McCain and Caro McDonald provided generous acquisitions funding to help the Gallery develop their mutual interest in African contemporary photography. The support that Anne Shabaga gave also assisted in growing this and other parts of the collection.

The Gallery's plans to look more inclusively at photography as a cultural phenomenon were underway in 2010 when an anonymous donor gave two press archives – one from the *Sydney Morning Herald* and another, the Haynes Archive, a diverse and rich resource of photographic material from Buenos Aires publisher Alberto M. Haynes – a British ex-patriot whose company was active from the 1920s to the 1960s – as well as an historical collection of aviation photographs. Wishing to strengthen the Gallery's art and documentary holdings, he also donated a body of work by Frederick Evans and his circle as well as two other outstanding gifts: more than 1,700 works by Czech photographer Josef Sudek and the Origins of Photography, an extraordinary collection encompassing more than 10,000 items including the Matthew Isenburg collection that constituted, among other holdings, daguerreotypes from the legendary Boston studio of Southworth and Hawes and the California Gold Rush.

Likewise the development and evolution of other federal government agencies would help to shape the collection. The Canadian Cultural Property Export Review Board, established in 1977, encouraged a new climate of collecting and donating in Canada from which the collection has been greatly enriched. The Canadian Museum of Contemporary Photography (CMCP) – formerly the Still Photography Division of the National Film Board of Canada (established in 1941) – was founded in 1985 as an affiliate museum of the National Gallery of Canada.[16] By 1992 it occupied its own purpose-adapted space supporting the collecting and exhibiting of Canadian contemporary photography.[17] Due to building maintenance issues, its collection and exhibition program were absorbed into the Gallery in 2009, bringing staff and expertise on contemporary Canadian photography to the Gallery.[18] While Canadian photography had been included but not emphasized in the collecting and exhibiting of the Gallery's collection, the integration of more than 150,000 images from the CMCP greatly enriched the scope and potential of the existing collection, not only giving it a strong twentieth-century Canadian focus and making the photographs collection more relevant to our institutional and national mandate, but also prompting the Gallery to make a greater commitment to the history of Canadian photography in general.

This expanded mandate of the collection vis-à-vis Canadian photography along with the addition of vernacular photography and photojournalism, was further enhanced with the establishment of a new institute within the Gallery in 2016. The Canadian Photography Institute (CPI) was made possible by the partnership of Scotiabank's generous financial support over a ten-year period and a private donor's commitment to enriching the holdings with annual donations of photographs from his collection.

The Collection Now

Over its half century the collection has been subject to changes that have occurred mainly in the last ten years. If the first four decades were devoted to serving the principle of developing a comprehensive collection covering the history of photography from its pre-history to the present and representing the work of major contributors in depth, the last decade or so has included a review of direction and seen a resulting expansion of the collecting mandate for photographs.

The neat dichotomy of "the photograph as expression rather than as description" – an admittedly clear and focused canon with which to start building a fine art collection – was thrown into question in the 1980s when photography began to play an increasingly important role in the field of cultural

Fig. 4
Cover of *The Photograph as Object: Photographs from the National Gallery of Canada* showing a colorized detail of Edward Steichen's *Portrait, Lake George*, 1903, printed April 1906

studies. By the late 1990s globalization, digital technology and the internet had increased awareness of the complex cultural currency of the photograph, making it impossible to exclude "descriptive" photographs from the discourse of art photography and from the collection.

Even with the stated intent of observing the canon, photographs and albums of photographs that were decidedly not made as art had in fact entered the collection at its inception. This is borne out by the abundance of nineteenth-century war photographs (Crimean, China 1860, American Civil War and Franco-Prussian) acquired by purchase and donation from 1967 through to the 1980s. This part of the collection needed to be acknowledged for what it was and enhanced by adding twentieth-century examples. Later donations would ensure that this happened.

Photographic images from magazines and newspapers have exerted an influence over the human imagination ever since the reproduction technology was made possible in the last decades of the nineteenth-century. The amassing of these images, stockpiled day after day, become repositories of our national and global histories. Archival press prints replete with croppings and other handwork on the rectos allow us to follow precisely the ways in which images are manipulated to fit the art editor's take on a story or a publisher's corporate philosophy. These images' versos most often have typed or handwritten cutlines, date stamps and written annotations. Front and back, these photographic prints are invaluable artifacts chock full of data regarding usage, interpretation and social relevance. In contrast, the apparently pristine digital image is phantom-like, the history of its final form for the most part inaccessibly encoded.

In summing up the affective power of press photographs *The Sunday Times* editor, Harold Evans reminds us of the degree to which we invest meaning in what is essentially an abstraction:

> Each photograph is only a small, flat series of tones from black to white. Its depth is an illusion, its animation symbolic. Yet it has this mysterious richness transcending all its limitations so that our impressions of major and complex events may be permanently fashioned by a single news photograph.[19]

The spur to diversify and represent genres such as vernacular and press photography to tell the full story of the cultural reach of the medium was supported by the donation of the previously mentioned group of 1,500 photographs relating to aviation history, a part of the *Sydney Morning Herald* Press archives and the Haynes Archive. This donor was also instrumental in having a selection of 25,000 images from the *Globe and Mail* archive donated to the CPI.

The Gallery more or less adhered to Treasury Board's directive to include but not emphasize Canadian photography but presciently purchased Ralph Greenhill's collection containing fine examples of nineteenth-century Canadian

material in the mid 1970s. Also purchased were works by contemporary photographers Robert Bourdeau and Lynne Cohen as early as in 1969.[20]

The incorporation of the CMCP into the structure of the National Gallery of Canada was a transformative occasion. It also brought the promise of greater collaboration with peers in Library and Archives Canada and academic institutions across the country to produce comprehensive and well-researched exhibitions and publications on the histories of Canadian photography.

Canadian twentieth-century and contemporary photography would henceforth play a major role in determining the collecting and exhibiting priorities of the photography collection – now the CPI.

With nearly 200,000 objects, the CPI's collection is now a rich aggregate of images, supporting technology and related materials. It could be described as having a topography composed of highways and byways, peaks and valleys. It is a repository of art and documentary photography – the term "documentary" being used here as a catchall for the genres of photojournalism, advertising, propaganda, scientific and pseudo-scientific reportage, and vernacular photography that frequently draw from, or, in the course of time, become appreciated as art.

The act of building a collection is not as straightforward as compiling a shopping list, but rather a complex intersection of expertise, opportunities (sometimes more accidental than planned) and resources. It is dependent upon the levels of support, trust and independence the curators receive from the Director, the Chief Curator and the Board of Trustees. Also critical to successful collection building is a continual dialogue with, and the backing of, collectors and donors, photographers, artists and fellow curators and scholars.

The Extended Moment

There were many good reasons behind establishing a collection that was broad and deep: rather than merely presenting the greatest hits in photography, we could explore photographers' working methods and evolution; create monographic and thematic exhibitions; and provide living photographers the opportunity to study the best possible examples of their precursors' prints. In Borcoman's words such a collection would allow photographers to "... become familiar with the traditions of their art and to provide them with examples that will encourage them to use their art as a medium of intense personal expression by giving form simply, sincerely and effectively to the experiences of the world in which they live."[21]

In encouraging the Gallery to include work by August Sander, Peter Bunnell made the point that Sander was "pivotal, both in his own right as well as for his influence on the late Diane Arbus."[22] In 1969 Arbus saw Sander prints

Fig. 5
James Borcoman, Phyllis Lambert
and Jean Boggs at the opening
of the exhibition *Charles Nègre*,
20 May 1976

laid out on a study room table at New York City's Museum of Modern Art and was profoundly moved by the crisp reality and almost tangible presence these photographic portraits possessed. The inspiration did not end there. When Arbus saw Model's Coney Island Bather in an exhibition at the Museum of Modern Art in 1960 she wrote Model "What a beautiful photograph that is."[23] Lisette Model was given a copy of Sander's *Menschen Ohne Maske* by his grandson, Gerd Sander and used it as a teaching tool.

Eugène Atget, August Sander, Walker Evans, Lisette Model and Diane Arbus would be a short list of the photographers in the collection whose prints have been examined by contemporary photographers in special pilgrimages to our Study Room. Ed Burtynsky cites two photographers well represented in the collection whose work made an impression on him: Edward Weston for his "... ability to locate the 'extraordinary within the ordinary,'"[24] and seeing August Sander's *Untitled* (Quartz Quarry and Construction Site, near Cologne), c. 1932 gave him a moment of revelation:

> It wasn't part of his normal oeuvre, it was a landscape – all white, bright, iridescent. I remember looking at this picture and I could not put it together. Sander had shot down into the bowl of a limestone quarry, but the optics and the spatial relationships created an ambiguity of scale and perspective I stared at it for a minute before I could begin to figure out what I was looking at, and a minute is like eternity to just comprehend what you are seeing. No one had ever done that to me. It was exciting.[25]

The connections made between photographers and their precursors are often less direct than cited above and related to mutual formal approaches or accidental discoveries. For instance, in 2012 Lynne Cohen was invited by the Museo Universidad de Navarra to examine their collection of nineteenth-century calotypes of the Castle of Montjuic in Barcelona by Gustave de Beaucorps and Louis de Clerq with the idea that she, along with other photographers, would undertake a re-photography type of project.

Reflecting on the proposal, Cohen instead decided to take another approach. Going through the Navarra archives she recognized that a characteristic feature of much nineteenth-century photography was a formal quality her work shared and that she liked to call – citing Walker Evans – the "deadpan" or artless photograph. She saw this head-on approach as antithetical to the self-conscious emulation of romantic painting found in the Pictorialist aesthetic. She also talked about this as the "dumb angle" to describe the kind of uncontrived composition she was after. Cohen's contribution was to make a selection of these photographs and write about them. "It is not that I've borrowed formal devices from or have even been influenced by nineteenth-century photographers," she stated, "It is rather that I share, perhaps coincidentally and often for different purposes, many of their methods and devices."[26]

The collection's comprehensiveness, connoisseurship and inclusivity have made it possible to curate this exhibition illustrating the "extended moment" as a rich interchange of ideas and vocabularies linking images and photographers over a span of 180 years.

Notes

1 It was forty years before this challenge was taken up. In 1893 Alfred Lichtwark, art historian and director of the Kunsthalle, Hamburg, organized the first photographic exhibition to be held in a museum. The first recorded purchase of photographs by a museum occurred in 1896 when the Director of the United States National Museum purchased fifty photographs from the *Washington Salon and Photographic Art Exhibition.*

2 The Gallery's former Associate Director (1955–1960), Donald W. Buchanan, an accomplished photographer and member of the Board of Trustees since 1963, along with board member Jean M. Raymond, proposed in 1964 that the Board support a motion to include "fine photography" "as collected and exhibited by the National Gallery" in the National Gallery Act of 1957. A year later, Chief Curator R.H. Hubbard recommended to the Board of Trustees that the Gallery "immediately found a department of Photography, build up a collection, and appoint a curator," National Gallery of Canada, Minutes of the 101st Meeting of the Board of Trustees, 15–16 April 1964, p. 1267.] The Act gave it the mandate to encourage "Canadian public interest in the fine and applied arts" and "works of art" to include "pictures, sculpture and other similar property."

3 The National Gallery hosted its first photography exhibition in 1934; exhibitions of photography brought in before and during Borcoman's tenure as Curator of Photographs included: *Britain, 1921–1951: A Photographic Survey*, 3–31 May 1951 (organized by *The Times*, and circulated by Art Exhibitions Bureau, London and circulated in Canada 3 July 1951– April 1952 by the NGC); *Henri Cartier-Bresson: The Decisive Moment: Photographs, 1930–1957*, 11–30 November 1958 (circulated by the American Federation of Arts, New York); *Portraits of Greatness: Photographs by Yousuf Karsh*, 23 September–23 October 1960; *A Not Always Reverent Journey: Photographs by Donald W. Buchanan*, 16 March–9 April 1961 (Buchanan was involved in the NGC and NFB in several ways and an advocate for photography as art); *Robert Capa: War Photographs* 1–25 March 1962 (produced by Magnum Photos in co-operation with *LIFE Magazine* and circulated by the Smithsonian Institution); and, *The Photographer and the American Landscape*, 24 January–16 February 1964 (organized and circulated by MoMA).

4 Massey served as Chairman, Board of Trustees of the National Gallery of Canada from 1948 to 1952. In 1949 he was appointed as the head of the Royal Commission on National Development in the Arts, Letters and Sciences. The resulting Massey Report of 1951 led to the establishment of the National Library of Canada in 1953 and the Canada Council of the Arts in 1967. See en.wikipedia.org/wiki/Vincent_Massey#Diplomatic_career [accessed 26 October 2017].

5 Copy of letter Gernsheim later sent in personal correspondence to James Borcoman.

6 Retrieved from en.wikipedia.org/w/index.php?title=Helmut_ Gernsheim&oldid=769105769 [accessed 26 October 2017].

7 James Borcoman and Robert Hubbard, then-Deputy Director of the Gallery, later met separately with Georges Delisle, Chief of the Picture Division, the repository of historical Canadian photographs at the Public Archives of Canada, and Marcel Martin, Director of French Production at the National Film Board, who was also responsible for the Still Photography Division, to ensure there would be no excessive duplication of collecting activities. A Memorandum of Agreement determined that the NGC's mandate would be to create an international collection of photographs to include but not emphasize Canadian works, and would embrace the entire history of the medium from pre-photographic image-making to the present day.

8 Borcoman Report, 109th Meeting of the Board of Trustees, p. 1618.

9 Ibid., p. 1619.

10 Report of James M. Reilly for General Survey of National Gallery of Canada Photograph Collection, 16 March 1983, Survey of Photography Collection, Department of Restoration Conservation Laboratory, Box 27, National Gallery of Canada fonds, National Gallery of Canada Library and Archives. The first trained photographs conservator to work with the collection was John McElhone, hired in 1986.

11 National Gallery of Canada, Minutes of the 109th Meeting of the Board of Trustees, Appendix G.

12 National Gallery of Canada, Minutes of the 107th Meeting of the Board of Trustees, 26 April 1967, p. 1521.

13 James Borcoman, *The Photograph as Object 1843–1969: Photographs from the National Gallery of Canada*, exh. cat. (Ottawa: National Gallery of Canada, 1969), n.p.

14 Peter C. Bunnell, "The National Gallery Photographic Collection: A Vital Resource," *artscanada* vol. 31, nos. 3 & 4, issue nos. 192/193/194/195 (December 1974): 43.

15 In total Ms. Lambert donated 508 photographs to the collection, including an album containing 99 photographs; the Phyllis Lambert fund permitted the purchase of numerous photographs and portfolios, for a total of 133 images.

16 Three publications chronicle the history of the National Film Board of Canada's Still Photography Division and the Canadian Museum of Contemporary Photography: National Film Board of Canada, Still Photography Division, *Contemporary Canadian Photography from the Collection of the National Film Board* (Edmonton: Hurtig, 1984); Carol Payne, *The Official Picture: the National Film Board of Canada's Still Photography Division and the Image of Canada 1941–1971* (Montreal: McGill-Queen's University Press, 2013), and Andrea Kunard, *Photography in Canada 1960–2000* (Ottawa: Canadian Photography Institute of the National Gallery of Canada, 2017).

17 The CMCP was located at 1 Rideau Street, Ottawa.

18 Director Martha Hanna, Associate Curator Andrea Kunard, Curatorial Assistant Jonathan Newman and Registrar, Sue Lagasi were among the staff who moved their offices to the NGC.

19 Harold Evans, "Eyewitness: The Pictures that Made News," in *Eyewitness: 25 Years through World Press Photos* (London: Quiller, 1981), pp. 6–7.

20 Contemporary Canadian photographers such as Dave Heath, Robert Bourdeau, Lynne Cohen, Michael Schreier, Michel Campeau, Sam Tata, and Tom Gibson were well represented in both NGC and CMCP collections.

21 Borcoman report to the Board of Trustees Appendix G, Minutes of the 109th Meeting of the Board of Trustees, pp.1617–1624.]

22 Bunnell, "The National Gallery photographic collection," p. 44.

23 Postcard, Diane Arbus to Lisette Model, 1961. National Gallery of Canada Library and Archives, Lisette Model Archive, Box 2, File 3.

24 Quoted by Lori Pauli, "Seeing the Big Picture," in *Manufactured Landscapes: The Photographs of Edward Burtynsky*, (Ottawa and London: National Gallery of Canada, Yale University Press, 2003), p. 11.

25 Cited by Michael Torosian "The Essential Element: An Interview with Edward Burtynsky," in Pauli, ed., *Manufactured Landscapes*, p. 22.

26 Lynne Cohen, "More or Less: The Anonymous, Deadpan and Uncontaminated – Then and Now Kindred Spirits," unpublished English manuscript translated for *Lynne Cohen: Almas Gemelas* (Pamplona: Museo Universidad de Navarra, 2016).

Plates

Conversations in Time

 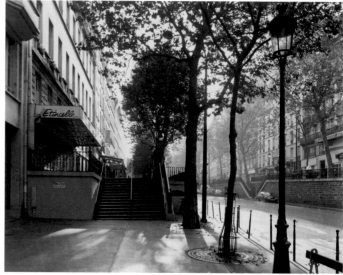

Although much changes in the course of time, human curiosity about certain subjects and ideas remains constant. Also, artists have always looked at the work of other artists and learnt from one another thereby lending a continuing relevance and extended life to the art of the past. This is still true today.

Living on through the photographic print or digital display, photographs are part of a reservoir of images continually referred to and re-evaluated. As Teju Cole cogently put it, "... every photograph is a time-lapse image, and photography is necessarily an archival art."[1]

The National Gallery's collection contains works whose dates span almost one hundred and eighty years, allowing us to enjoy an exchange of formal strategies, technical explorations, ruminations, and ideas shared by photographers often separated by several generations. Photography has changed, social mores have changed, but what contemporary photographers have to say about the world today differs more in its execution and expression than in its substance.

Each generation of photographer following the invention of photography has enjoyed the advantage of being able to encounter if not study their predecessors' efforts. Photographs are part of contemporary iconography and when made available for thoughtful evaluation they have – on occasion – been incorporated and appropriated into works of art in a variety of media. Studied also in their original print form they have generally served as sources of inspiration.

Canadian photographers Geoffrey James and Chuck Samuels illustrate the various ways in which their precursors have influenced not only ways of structuring and seeing but also the conceptual underpinning of some contemporary photography practices. From a close study of Atget (fig. 6) and Josef Sudek's prints, James learned how his predecessors saw and recorded the city's elements of urban facades and street corners, and incorporated some of this rich complexity into his own compositional structures (fig. 7).

By appropriating Edward Weston's 1936 study of a nude (fig. 8) and positioning himself in the model Charis Wilson's, pose, Chuck Samuels addresses contemporary issues of gender and the gaze in his image, *After Weston* (fig. 9), made more than fifty years later.

Félix-Jacques-Antoine Moulin's nude study (pl. 1) and Richard Learoyd's work (pl. 2) are separated by more than 160 years. Differing in process, scale and intent they share nonetheless an air of contemplation and distillation. One writer has described Learoyd's photographs as slowing photography down "... to a standstill so that we might finally see."[2] The scale of these two works could not be more opposite. Moulin worked with one of the standard and most popular daguerreotype plate sizes, the sixth plate (8.2 × 7.0 cm) while Learoyd, whose "camera" is a primitive, room-sized camera obscura equipped with a high quality lens and bellows, contact-printed *Agnes* onto a sheet of paper 157.5 × 121.6 cm.[3]

Moulin's daguerreotype of a female nude was made as an *académie* – a study from life that gave him occasion to display his mastery of both the process and the genre rather than his ability to engage the viewer with his model's character. In short, Moulin's approach conformed to traditional requirements for the nude study. Posed and surrounded by elaborate props, the unidentified model in turn enacts the part required for the genre. The long exposure time needed to take a daguerreotype presented the opportunity for the sitter's guard to come down. But revealing the inner life of the model was not Moulin's intention.

Conversely, contemporary British photographer, Richard Learoyd, embraced the several hours needed to stage the setting of his model, deliberately seeking out "... the projection that people [the models] allow themselves." He finds this more challenging and rewarding than "photographing what you already know." Describing his protracted method of taking photographs as "an anti-digital therapy" Learoyd distinguishes himself from the current technological trend of immediate and plentiful images by often producing fewer than twenty photographs a year.[4]

Hermann Biewend was inspired to take up the daguerreotype to make photographs of himself, his wife and his children. Exploring the intangible realm of kinship and affection he created a small but endearing body of work (pl. 3). The desire to make these ties visible endures.

Twentieth-century and contemporary photographers August Sander (pl. 7), Robert Frank (pl. 5), Joel Sternfeld (pl. 4), Karen Smiley Rowantree (pl. 6) and Anne Fishbein (pl. 8) have turned not only to their families, but also to friends and strangers to capture these emotions with poignant results.

The archive Cole refers to includes nineteenth-century scientific and pseudo-scientific photographic images. Many of them are artifacts of imaginative rather than controlled experiments. Regardless of their intent, the resulting images of elemental phenomena, the cosmos, the microcosm, time and motion, and the human body continue to enthral and to resonate with one another across time.

Like Learoyd's portrait of Agnes, these photographs by entomologist, astronomer and illustrator Étienne Léopold Trouvelot (pl. 9) and photographer Hiroshi Sugimoto (pl. 10) were made more than 100 years apart without cameras.

In Trouvelot's series "Electrics" and Sugimoto's series "Lightning Fields," sensitized glass plates and sheets of film were respectively placed in contact with negatively charged plates to which positive charges were applied to capture the effects of electromagnetism. While Sugimoto was aiming to create a much more ambitious narrative by simulating the primordial conditions that existed at the time of the earth's creation,[5] Trouvelot, whose project also connected to nature's forces, wanted to make artificially conducted electricity visible and at the same time provide proof that different types of charges created different patterns of lightning.[6]

Fig. 6
Eugène Atget, *Café, Boulevard Montparnasse, 6th and 14th Arrondissement*, June 1925, gelatin silver print, 17.2 × 22.1 cm

Fig. 7
Geoffrey James, *Boulevard St. Martin, Paris*, 2000, gelatin silver print, image: 35.1 × 45.2 cm; sheet: 63.5 × 71.2 cm

Also cameraless, Adrien Majewski and Gary Schneider's hand pictures address an ancient theme: individual human identity marked by an impression of the human palm. Made a century apart *Mr. Majewski's Right Hand ...* [pl. 13] and *After Naomi* (pl. 14), used much the same photogram technique: hands pressed directly onto a photosensitive surface. In the case of Majewski's image his hand was placed in contact with a glass plate negative while Schneider used an acetate-based panchromatic film for his. An exposure was made once their hands were firmly placed on the light sensitive surfaces. Both processes rely on the oils, sweat and temperature of the hand to leave their unique impression. They were made in two profoundly differently evolved scientific and artistic eras and directed toward vastly different ends. Made at the dawn of the discovery of X-Ray technology, Majewski's hand reflects the belief that human magnetism was an externalization of the nervous system; that hands, feet, forehead and vertebral column were the centres of the greatest energy emanations, and that human character could be read from the patterns in the print.[7] Schneider's handprint *After Naomi*, was made when the mapping for the Human Genome Project, described as "an instruction book for a human being," was well underway. In 1997 and 1998 Schneider subjected himself to a series of high-tech laboratory scans to obtain microscopic images of critical parts of his body and his DNA sequence. The visual records were subsequently printed as components of a 1998 multi-image panel installation *Gary Schneider: a Genetic Self Portrait*. The inclusion of his pair of handprints, "auto-thermohyrdrographs," in this work was especially significant for the qualities of recognition – tactility and salutation – that they evoked.

In making his handprints Schneider pays homage equally to the hand as a marker of human biological individuality and to it as a symbol of human mortality.

Spring Hurlbut's *James #5* (pl. 12) is also an homage. From her series *Deuil II*, this work commemorates her deceased father. Coming into possession of his ashes inspired her to make *Deuil I,* her first series of portraits of departed people and animals whose spread ashes she viewed as assuming a kind of cosmic formation.

The relationship between Spring Hurlbut's *James #5* and Pierre Jules César Janssen's sunspots (pl. 11) is formal: abstractions of radiating light and receding dark formations. Janssen's photograph[8] is part of a series capturing sun spot activity while Hurlbut's series transforms human and animal ashes into arrangements that resemble nebulae, comets and galaxies, thereby acknowledging their eventual and inevitable return to cosmic matter. Hurlbut's large inkjet prints (roughly 27 × 31 inches) in both *Deuil I* and *Deuil II* [Mourning] are made with an inkjet process that creates a seductively rich surface that upon deeper observation reveals subtle tonality and muted colour. Janssen's prints are Woodburtypes, an ink process also rich in monochromatic tonalities (see McElhone p. 272).

Eadweard Muybridge's photographic recording and publication of his images of human and animal locomotion in the 1870s and 1880s influenced artists not only in their attempts to obtain more accurate representations of galloping horses but also in less literal ways. Alison Rossiter's *Goya* (pl. 18) from *Light Horses* and Muybridge's *Lizzie M. trotting, harnessed to sulky* (pl. 17) are delightful counterpoints to one another. Muybridge's pictures were made with a battery of strategically located cameras whose shutters were calibrated to trigger at precise moments. His collotype prints showing the sequence of the animal and human locomotion were particularly suited to the mass production of photographic images. Rossiter's is a one-off image, drawn with a flashlight freehand in the darkroom directly onto photographic paper. It celebrates the Spanish artist Francisco Goya y Lucientes' lively renderings of rearing stallions – an artist whose career predated photography. Both photographic, both investigating and closely observing equine movement, Muybridge's *Lizzie M* is a rigidly sequenced 6 × 4 grid of consecutive images; Rossiter's *Goya*, is a single freehand black image on a white background drawn by hand in a near dark room[9].

Lynne Cohen and Mark Ruwedel both favour uninflected formal attributes in their work: central compositional viewpoint, neutral lighting and uniform tonalities. These qualities are visible in nineteenth-century photography, early postcards and annual reports among other sources, but it was Walker Evans' work (pl. 15) and words that left a strong impression on both of them. Cohen invoked his use of the term "artless" to describe images made without compositional exaggeration or theatrical lighting and as a quality to aspire to.

Drawn to sites that were artless in themselves, Ruwedel liked the desert because "nobody ever cleans up after themselves" (pl. 16).

For Cohen this approach complemented her own way of seeing and responding to the world: "... it seemed that the quieter, more understated, even anonymous, the look of my pictures, the more compelling the hidden commentary might be. Indeed it struck me that the simpler the means of retrieving or documenting a piece of the world the greater likelihood that the subject's quintessential quality might surface (assuming there is one)."[10]

To look at contemporary works in the light of earlier practices is not to find derivative responses but to discover refreshingly new additional points of access to meaning and formal structuring of images and evidence of exchange rather than influence.

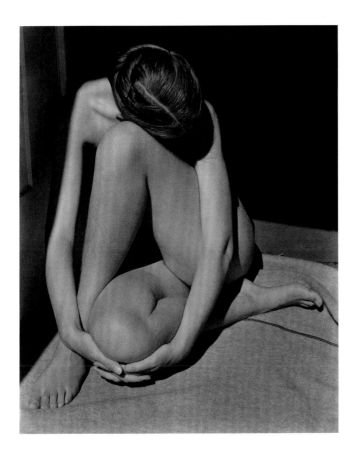

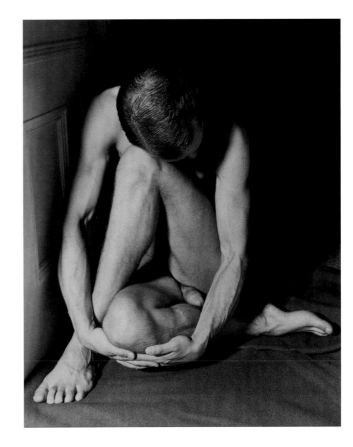

Notes

1 Teju Cole, "Disappearing Shanghai" *Known and Strange Things: Essays* (New York: Random House, 2016) p. 165.

2 Mark Alice Durant, "Richard Learoyd" in *Richard Learoyd: Portraits and Figures*, exh. cat. (New York: McKee Gallery, 2011). Essay also available online at: saint-lucy.com/essays/richard-learoyd-portraits-and-figures/ [accessed 19 December 2017].

3 The set-up comprises a closed off room in a roughly 1,000 square-foot studio through which a gigantic lens protrudes. On the opposite wall is the huge uncut sheet of film onto which the model's inverted image is projected. Richard Learoyd in conversation with Ann Thomas, 20 May 2014. Although the exposure is instantaneous aided by an electronic flash, Learoyd will often take eight hours to make a picture.

4 Ariel Rosen, "Review: 'The Outside World' by Richared Learoyd, Fraenkel Gallery, San Francisco," SFAQ International Arts and Culture, 23 September 2013, see sfaq.us/2013/09/review-the-outside-world-by-richard-learoyd-at-fraenkel-gallery-san-francisco/ [accessed 8 December 2017].

5 "I wish to simulate the history of the earth in three periods: first, a dark hot planet shrouded in thick clouds of gas its primordial sea repeatedly struck by lightning and pelleted by tiny asteroids; second, a stable atmosphere and vast murky protobiotic waters; and third, the Paleozoic sea churning with biological phenomena." Hiroshi Sugimot, cited in press release for exhibition *Hiroshi Sugimoto – Lightning Fields*, Axel Vervoordt Gallery, 8 December 2011 – 21 January 2012. Available online at: http://www.axel-vervoordt.com/en/gallery/exhibitions/hiroshi-sugimoto-lightning-fieldshttp://www.axel-vervoordt.com/en/gallery/exhibitions/hiroshi-sugimoto-lightning-fields [accessed 6 December 2017].

6 Trouvelot experimented with two different types of machines (a Wimshurst machine and a Ruhmkorff coil), each time producing an image of both a positive and a negative charge. He discharged the current between two back-to-back photographic plates. Trouvelot described the prints as follows: "The images created by opposing poles are completely different in nature and form. The image created by the positive pole is one of sinuous lines full of branches; from its main branches stem thousands of long, lacy fibres, not unlike seaweed. The image produced by the negative pole is very different: its principle branches are, in general, made up of straight lines that are often broken at right angles, which make them look somewhat like the lightning bolt in the hands of Jupiter. This image, with its infinitely more gracious forms, resembles the leaf of a latanier palm." Cited by Marie-Sophie Corcy, "Electricity and Magnetism," in *Brought to Light: Photography and the Invisible 1840–1900*, Corey Keller, ed., exh. cat. (San Francisco: San Francisco Museum of Modern Art, 2008). Trouvelot's description aptly combines scientific description with analogy, pointing to both his own interests in both art and science and to the nature of the "art-science" of photography. These types of images of positive and negative charges became known as "Trouvelot Diagrams."

7 Fernand Girod, *Pour photographier les rayons humains : exposé historique et pratique de toutes les méthodes concourant à la mise en valeur du rayonnement fluidique humain* (Paris: Bibliothèque Générale d'Éditions, 1912), p.13. Online at: www.iapsop.com/ssoc/1912__girod___pour_photographier_les_rayons_humains.pdf [accessed 19 December 2017].

8 From the album *Annales de l'observatoire d'astronomie physique de Paris*, a scholarly report on the status of physical astronomy and solar photography, illustrated with 12 woodburytypes, 8 engravings and 1 wood-engraving, 1896. National Gallery of Canada (no. 38533.1-21).

9 Her reference for these photogenic drawings is art historical and includes sources as diverse as equestrian sculptures and paintings from early Renaissance artists such as Andrea Del Verrocchio and collotypes of animal motion studies by Eadweard Muybridge.

10 Lynne Cohen, "More or Less: The Anonymous, Deadpan and Uncontaminated – Then and Now Kindred Spirits," unpublished English manuscript translated for *Lynne Cohen: Almas Gemelas* (Pamplona: Museo Universidad de Navarra, 2016), n.p.

Fig. 8
Edward Weston, *Charis, Santa Monica*, 1936, printed before July 1969, gelatin silver print, 24.1 × 19.2 cm

Fig. 9
Chuck Samuels, *After Weston*, 1991, gelatin silver print, 23.2 × 18.6 cm

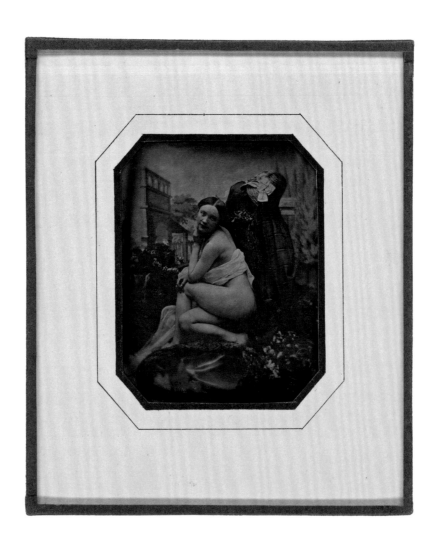

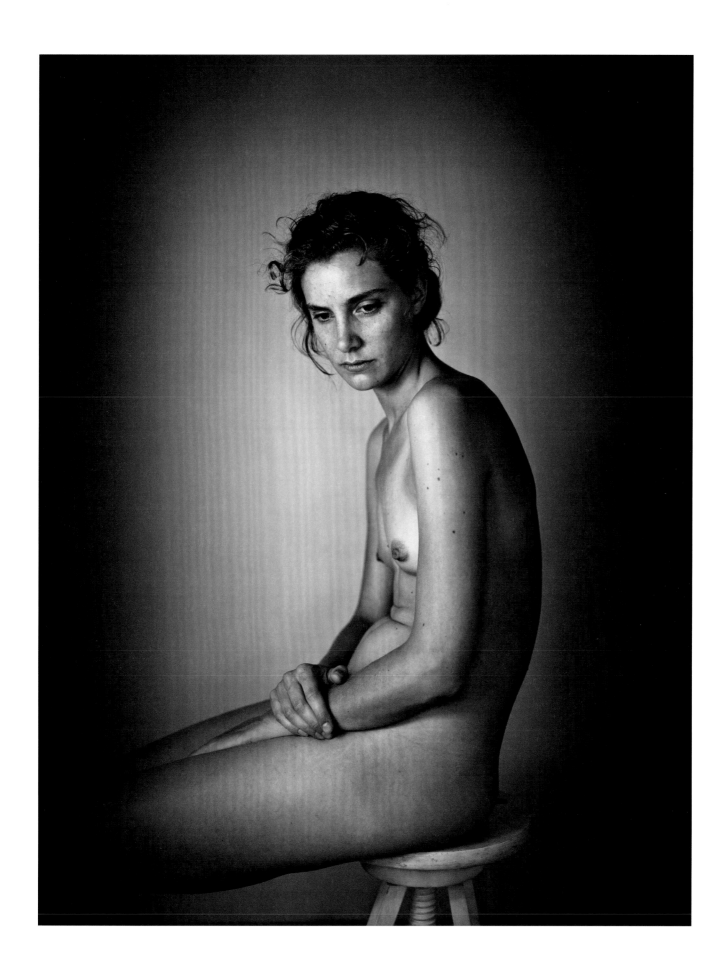

1
Félix-Jacques-Antoine Moulin
Académie c. 1845

2
Richard Learoyd
Agnes, July 2013 (4) 2013

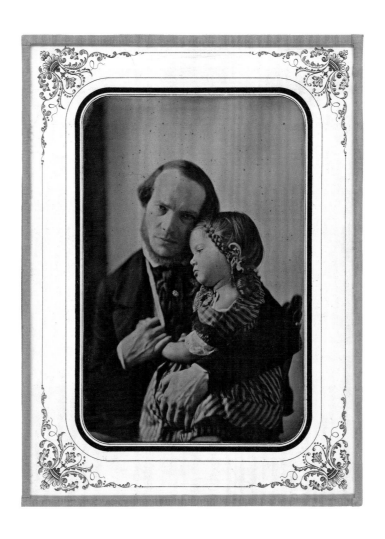

3
Hermann Carl Eduard Biewend
Myself, with Little Luise on my
Lap, Hamburg 4 June 1850

4
Joel Sternfeld
Canyon Country, California,
June 1983 June 1983, printed
August 1987

5
Robert Frank
U.S. 90, en route to Del Rio, Texas
c. 1955–56, printed 1968

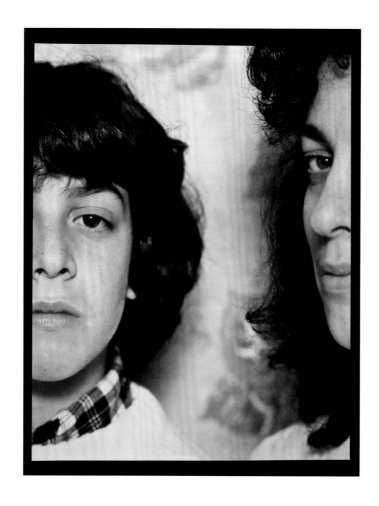

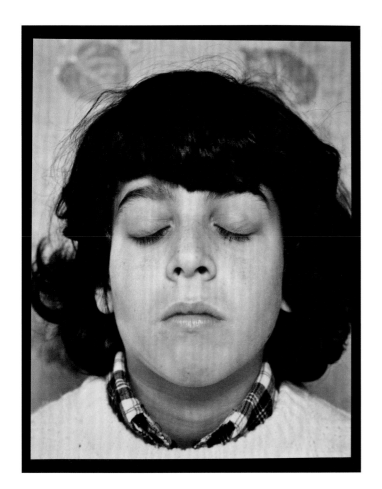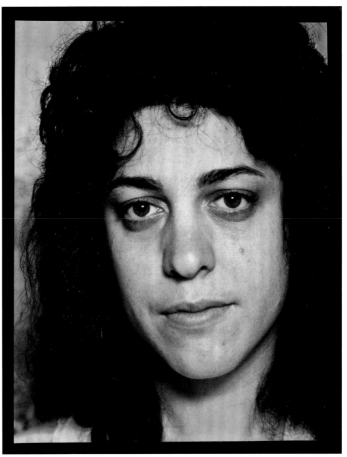

Karen Smiley (now Rowantree)
David Isakson and Audrey
Isakson, Son and Mother 1980

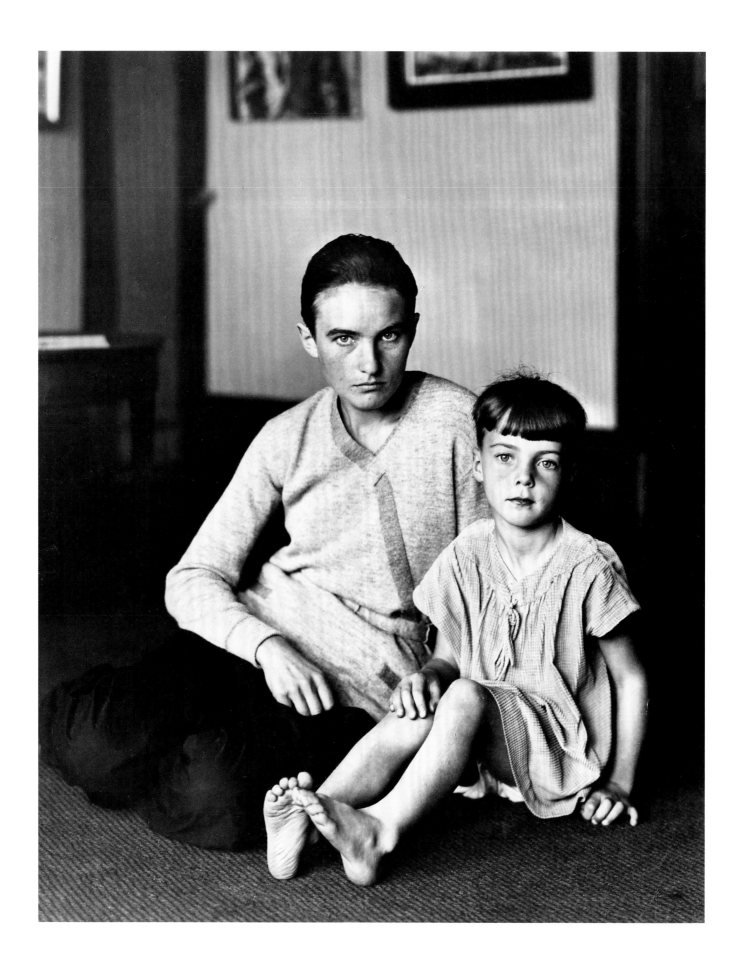

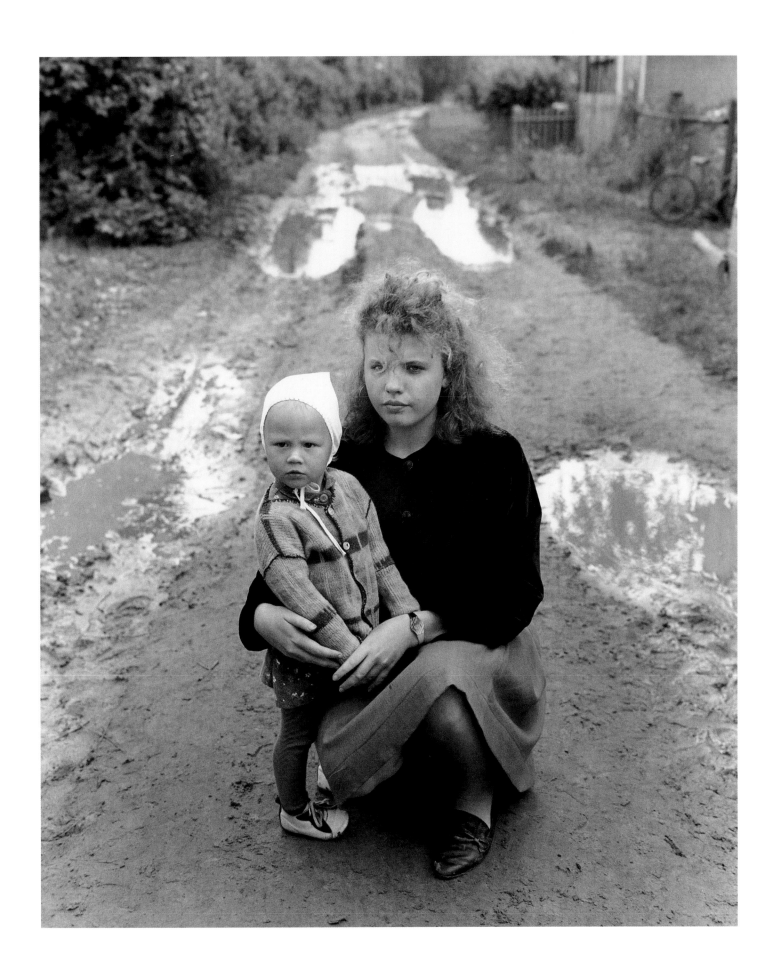

7
August Sander
*Mother and Daughter [Helene
Abelen with Daughter Josepha]*
c. 1926, printed 1928

8
Anne Fishbein
Portrait on a Muddy Path 1991,
printed 1993

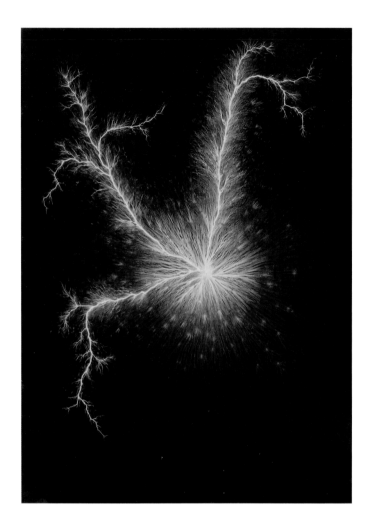

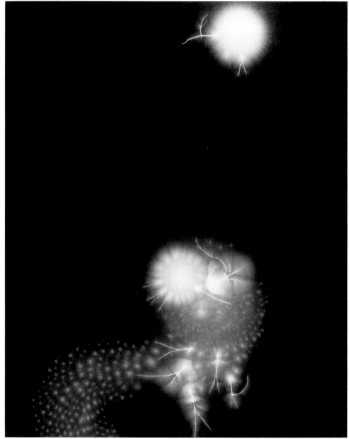

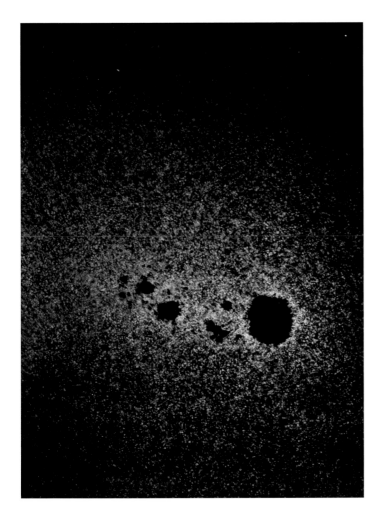

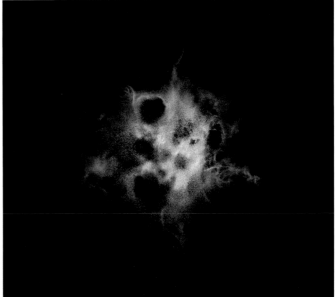

9
Étienne Léopold Trouvelot
Direct Photograph of an Electric
Positive Spark (Wimshurst Static
Machine) c. 1888

10
Hiroshi Sugimoto
Lightning Fields 138 2009

11
Jules Janssen
Studies of the Solar Surface,
1 April 1894 1 April 1894, printed
1896

12
Spring Hurlbut
James #5 2008
from the series *Deuil II* [Mourning]

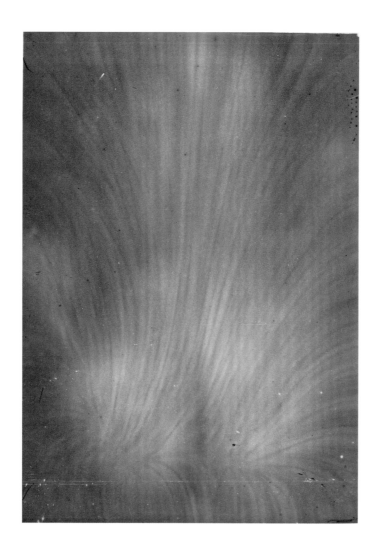

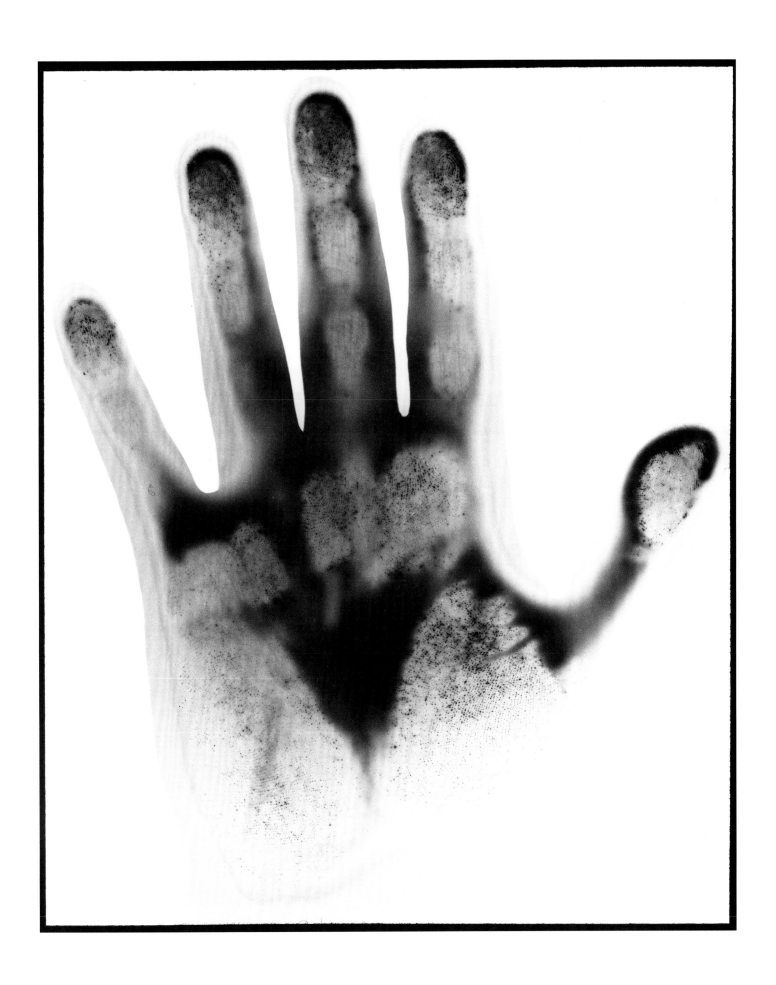

13
Adrien Majewski
Mr. Majewski's Right Hand, Posed
for 20 minutes, Room
Temperature c. 1895–1900

14
Gary Schneider
After Naomi 1993, printed 1994

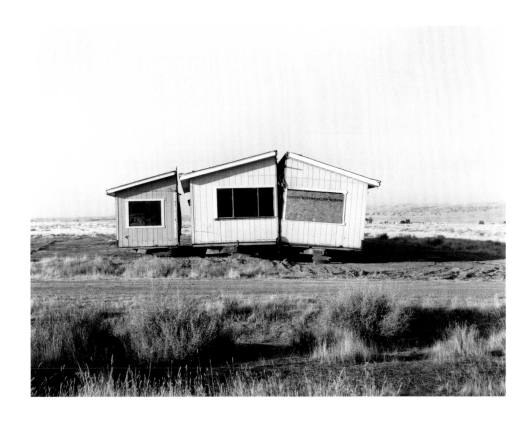

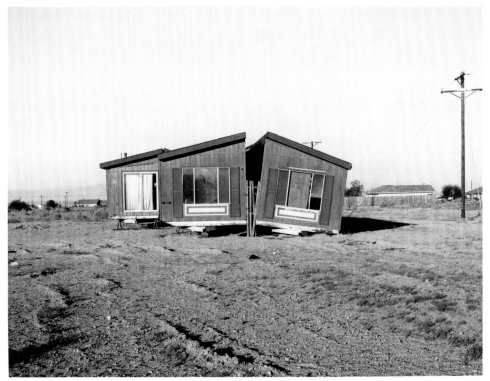

15
Walker Evans
Church of the Nazarene,
Tennessee 1936, printed later

16
Mark Ruwedel
Splitting (California Valley #7 and
Salton City #47B) 2009

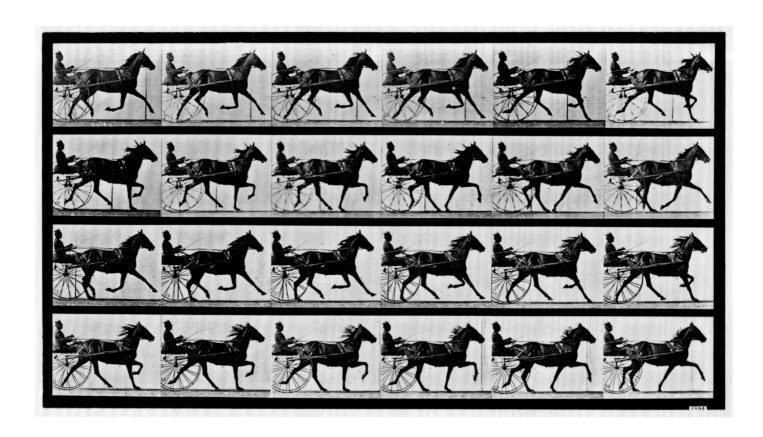

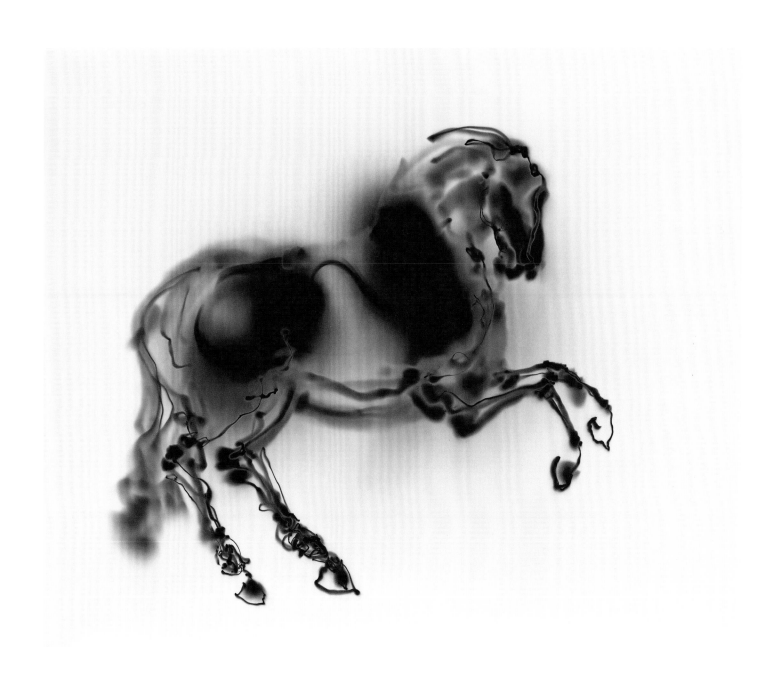

17
Eadweard Muybridge
"Lizzie M." trotting, harnessed to
sulky c. June 1884–11 May 1886,
printed November 1887

18
Alison Rossiter
Goya 2009
from the series *Light Horses*

The Art and Science of Invention

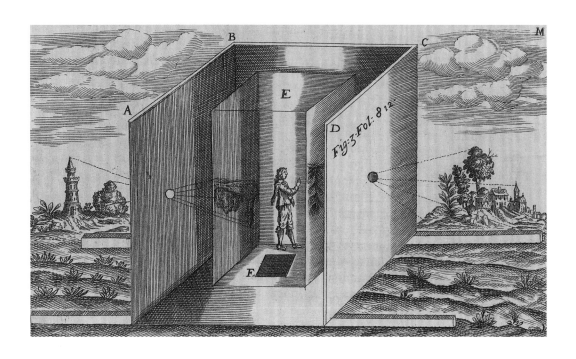

Artists on the lookout for quicker and more naturalistic ways to register the visual facts of nature on paper and canvas used the camera obscura (fig. 10),[1] the camera lucida (pl. 21) and the physionotrace technique (pl. 19) all of which predated photography.

It took lithographer Nicéphore Niépce, artist-entrepreneur, Louis-Jacques-Mandé Daguerre and polymath with limited drawing skills, William Henry Fox Talbot (fig. 11) to realize the invention of what we today call photography. Niépce and Daguerre were artists sufficiently conversant with the latest developments in chemistry and optics and the practice of these sciences to undertake experiments in photochemistry and enjoy productive results. In 1816 Niépce began experimenting with the various light-sensitive materials that would enable a more accurate and rapid transfer of drawings onto lithography stones; Daguerre launched his explorations into optics and chemistry with the idea of making further innovations in the visual-illusion business in which he had already gained celebrity. Talbot – the most advanced in science of the three – had already by 1834 produced what he called "photogenic drawings," (fig. 12) cameraless images made by placing objects in contact with salted paper sheets sensitized with silver nitrate (see "Salted Paper Print 1834 – c. 1860," p. 246). The daguerreotype process was monochromatic, slow and relatively cumbersome to carry out. Its products were neither easily nor effectively reproduced but their fidelity to nature, their precision and their uniform mirror-like surfaces astounded all who saw them.

Photography had a far-reaching impact on artists in both its conceptual and practical implications and they responded to its arrival by either satirizing it, such as in Théodore Maurisset's *Daguerreotypemania* (pl. 29), Honoré Daumier's *A New Process Used to Achieve Graceful Poses* (pl. 30) and an unknown nineteenth-century French artist's watercolour mocking the prancing photographer and his "prisoner" portrait subject (pl. 28) or using it as a convenient reproductive process (pls. 23, 24) and as an aide-mémoire (see pls. 149, 150). Many artists immediately recognized its potential for reproducing and disseminating artworks. Photography would also be responsible for shaping style and standards of realism in the decades following its invention. It was not rare for painters, Charles Nègre, for example (pl. 22), to finally adopt it as their chosen medium.[2]

New technologies and methods of securing and fixing photographic images abounded with the promise of increased speed of exposure, greater ease of execution and the potential of reproducibility demonstrated by William Henry Fox Talbot's negative positive process (pl. 25) and his publication *The Pencil of Nature*. Thus, from the outset photographers and a steadily increasing number of amateur practitioners demanded and inspired inventions that would accelerate the process of capturing images.

In 1888 Kodak issued its first "point and shoot" cameras, making the practice of photography available to a wider audience who were less inclined to abide by the established conventions of composition. The snapshot aesthetic would inspire professional photographers to be more informal (fig. 13). This more casual and sometimes accidental framing of subjects would be adopted in the mid twentieth century by photographers seeking a fresh, less self-conscious approach to image making. The twentieth

Fig. 10
Illustration of a camera obscura from Althanasius Kircher, *Ars Magna Lucis et Umbrae* (1646), book, ivory leather, with copper engravings and text, folio 31 × 24.5 cm, p. 806

Fig. 11
John Moffat, *William Henry Fox Talbot, English Pioneer of photography*, c. 1864

Fig. 12
William Henry Fox Talbot, *Shadow of a Flower*, 1839?, salted paper print, 11.1 × 7 cm

century witnessed a revolution in accessibility to picture making with the introduction of the hand-held Leica in 1926, to Edwin Land's Polaroid camera in 1947, to the Polaroid SX-70 in 1972 and to the digital camera in 1995.

Photographers thus learned the techniques and their limitations from their predecessors and determined needs for new processes that would be faster, have higher standards of definition and capacities of reproducibility, and formally more adaptable to changing aesthetics. And to make images that were more naturalistic they needed to conquer the issue of colour. Decades passed between the practice of hand colouring daguerreotypes and paper prints and the arrival of the autochrome, the first commercially viable colour process available to the public in 1907, the chromogenic print of the 1930s and today's digital inkjet prints.

Experimenting with newly available autochrome plates invented by the Lumière Brothers in 1903,[3] Heinrich Kühn made *Hans, Mary Warner, and Lotte* (pl. 35) in 1907. The photographer had already maximized painterly attributes of tonal harmony, even in his monochromatic gum and platinum prints, and had made photographic pigment prints, so working with an integral colour photography process was a natural stage in his artistic evolution.

From time to time photographers were forced to invent pictorial strategies to address or stretch the technical limitations of available processes. Collodion plates used in the 1850s, for instance, were highly sensitive to the blue end of the colour spectrum, making it impossible to expose for *both* sky and land. Gustave Le Gray's skilful combining of two negatives (one of the sea and the other of the sky) to produce

an apparently seamless single image not only resulted in impressive atmospheric pictures (pl. 39) but also pointed the way to more narrative uses of the technique. Henry Peach Robinson's *Hark! Hark! The Lark!* (pl. 41) probably combined about eight separate negatives. This intervention of the human hand in the photographic composition went a long way to redress the criticism that photography was merely a mechanical process lacking artistic skill. Even when technical limitations were resolved and panchromatic emulsion was available, photographers and artists found that combination printing, collage and montage allowed them to respond effectively to aesthetic and political issues of their time (pl. 43; see also pl. 102).

Likewise the departure from the concept of the photograph as a mirror of the world to the staging of scenes was an innovation that not only allowed nineteenth-century photographers to participate in prevailing painting genres but earned them a more elevated artistic status. While these early works ranged from modest re-arrangements to highly theatrical tableaux, none was on the scale of what we see today in the epic and almost cinematographic photographs of Vancouver artists Stan Douglas (fig. 14), Rodney Graham (fig. 15) and Jeff Wall (fig. 16).

Canadian painter, filmmaker and photographer Charles Gagnon made unique investigations into personal time and space with the SX-70 camera utilizing the grid (pl. 47).

Few could have imagined that almost 180 years after the invention of photography, the basic chemical properties of the medium would become the subject of the image itself. Alison Rossiter's *Lament* series explores and reflects on the light-sensitive materials used in what we now call analogue

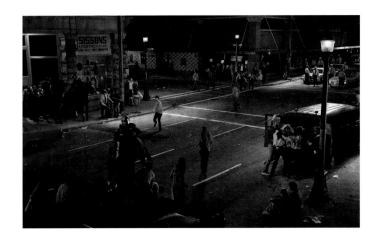

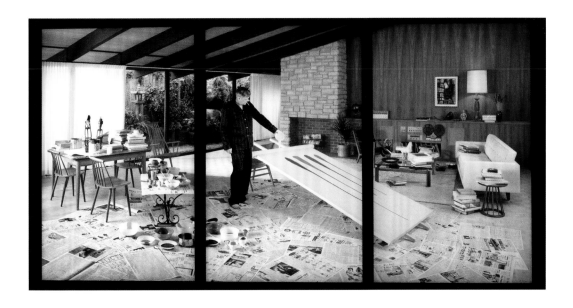

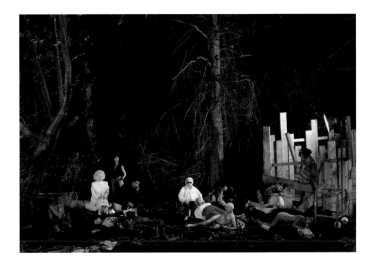

Fig. 13
Gertrude Käsebier, *Thanksgiving, Oceanside*, c. 1905–09, platinum print, heightened with watercolour, 11.2 × 21.4 cm

Fig. 14
Stan Douglas, *Abbott & Cordova 7 August, 1971*, 2008, digital C-print mounted on aluminum

Fig. 15
Rodney Graham, *The Gifted Amateur, Nov. 10th, 1962*, 2007, dye coupler transparency in fluorescent lightbox, 286.1 × 556 × 17.8 cm installed

Fig. 16
Jeff Wall, *The Vampires' Picnic*, 1991, Cibachrome transparency in fluorescent lightbox, 248.4 × 353.8 × 20.2 cm; image: 229 × 335.2 cm

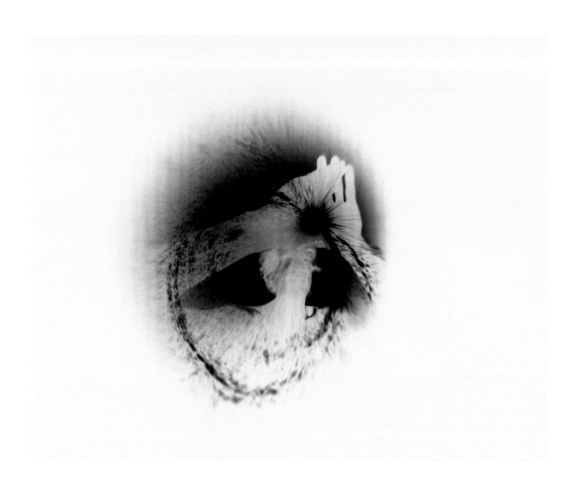

photography (pl. 45). Setting out to acquire samples of unexposed papers from every year of the twentieth century, she proceeded to develop the papers and reveal accidental leakages and the molecular deterioration of the paper over time. These minimalist markings not only evoke the simple magic of the chemical-analogue photographic process but reunite us with William Henry Fox Talbot's earliest effort to fix the image with one of his "mousetrap" cameras.

Also fascinated by the chemical-physical nature of photographic process, Edgar Lissel sees a correspondence between silver salts reaction to light exposure and photo-tropic cyanobacteria, which, when placed in an environment of contrasting light and dark will migrate to the light and form clusters. He recruited these photosynthetic organisms to make his pictures by either projecting a black and white transparency onto the bacterial mass or placing an object with negative and positive characteristics over it. Over the course of hours or even days the bacteria migrated from the dark parts of the container towards the light areas, thus creating an image of the projection or object. This clustering would enjoy only a limited lifespan during which Lissel would photograph it, thus using this configuration as a template for his final impressionistic image (pl. 46). His subversion of the normal analogue photographic process, the authority of the scientific specimen as well as its presentation all make Lissel's images complex, intriguing and attractive to look at.

Technical and pictorial inventiveness went hand-in-hand from the simplest cameraless images like the photogram to more complex digital images made today. The arrival of born-digital images and digital output prints in the mid to late 1990s was superficially not as revolutionary as one might have expected. Connoisseurship weighed in with some hefty criticisms of the images' then discernibly low resolution and lack of volume. With time the technology evolved to produce crisper and slicker images and prints. The most innovative engagements with digitalization have disrupted or re-contextualized the encoding of the new medium, as in the work of Robin Collyer and Herwig Kempinger (pls. 48, 49).

From the late 1960s and into the 1970s, the revival of non-silver processes (Betty Hahn, see fig. 61b) and more primitive camera technologies (fig. 17), as well as the fascination with the snapshot image occurred, some twenty years before the introduction of digital photography. Practiced by a small number of photographers it was yet another way of keeping alive the discourse between photographers from very different eras.

Notes

1 Western artist usage of the camera obscura dates from the Italian Renaissance but attributed to the Chinese in the 10th century and to the Arabs in the 11th century.

2 Millet, Courbet, Corot, Degas, Toulouse-Lautrec, Gauguin, the Impressionists, Picasso, Marcel Duchamp and many others were influenced one way or another by the photograph.

3 The Lumière Brothers' autochrome plates – invented and patented in 1903 and registered as "Autochrome Lumière" – were first made commercially available in 1907. The Lumière Brothers were the sole manufacturers of the plates, which entailed a complex method of production that precluded individual photographers preparing their own plates.

Born in Besançon, France, the Lumière brothers, Auguste Marie Nicolas (1862–1954) and Louis Jean (1864–1948) were well placed to make the contributions for which they are still celebrated. After attending the largest technical school in Lyon Le Martinière, they would apply their considerable talents to saving their father's photographic plate-making factory from near bankruptcy by streamlining the production. They would go on to create new black-and-white negative plates, branded *Etiquettes bleue*, and in 1895 produced what was purportedly the first moving picture.

Fig. 17
Eric Renner, *Self-portrait Diffraction Through the Pinhole*, 7 June 1977, gelatin silver print, 40.4 × 50.4 cm

19
Gilles-Louis Chrétien
(after Jean Fouquet)
Brigadier General Tadeusz A. B.
Kosciuszko (1746–1817), after a
Portrait by Fouquet c. 1793

20
Southworth & Hawes
Portrait of a young girl with hand
on shoulder c. 1850

N° 460

JFW Herschel del. Cam. Luc. Oct. 1850. Interior View of the Ancient Theatre, Arles.

21
John Frederick Herschel
No. 460 Interior View of the
Ancient Theatre, Arles October
1850

22
Charles Nègre
Self portrait of the Artist (standing)
with his Family, Grasse c. 1852

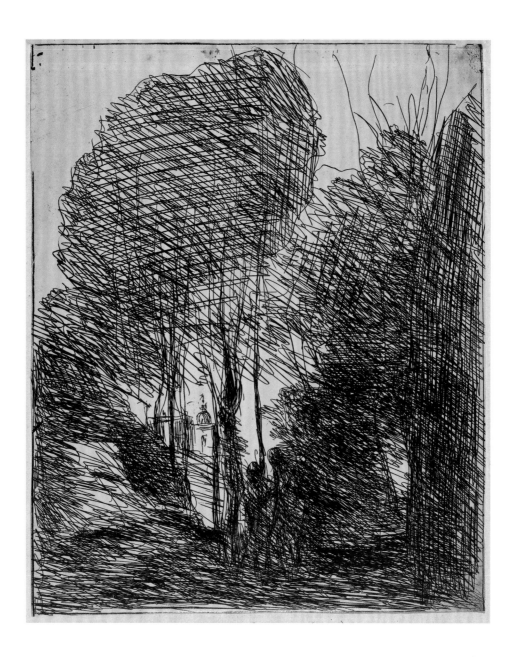

23
Camille Corot
Souvenir of the Villa Pamphili 1871

24
Eugène Cuvelier
Forest of Fontainebleau 1863

25
William Henry Fox Talbot
The Haystack April 1844

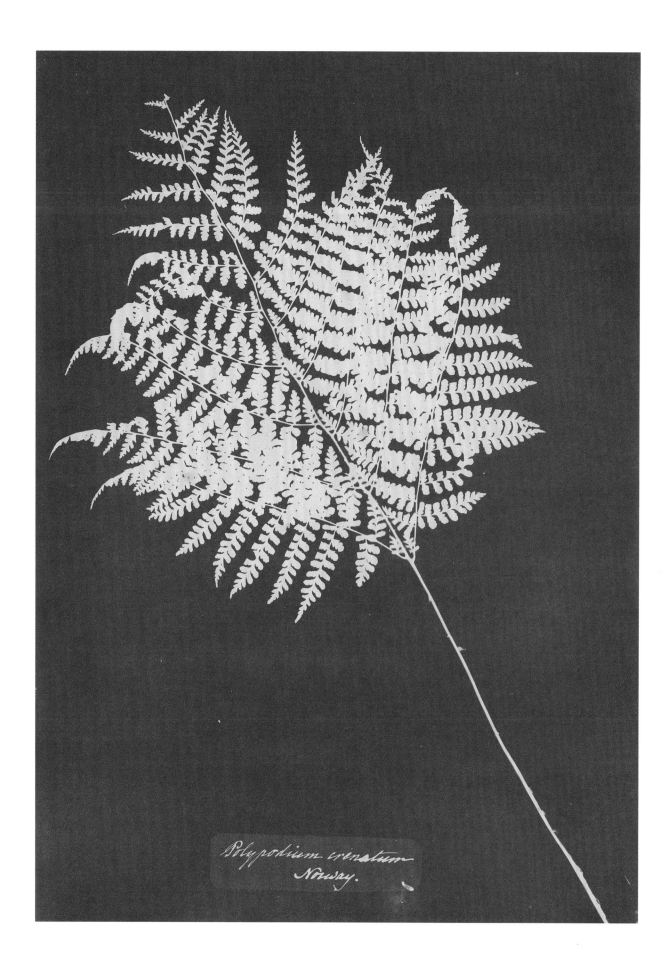

26
Anna Atkins
Polypodium crenatum, Norway
1854

27
Amanda Means
Leaf No. 12 1989

28
Unknown
The Photographer and his Model
c. 1875

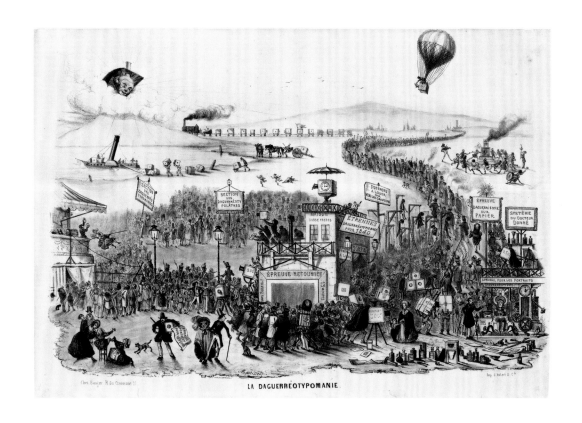

LA DAGUERRÉOTYPOMANIE.

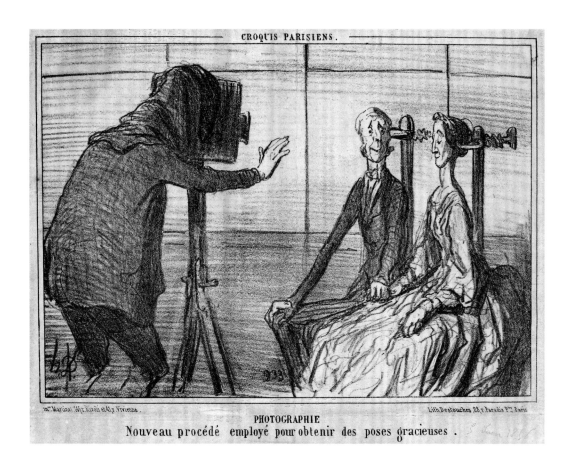

CROQUIS PARISIENS.

PHOTOGRAPHIE
Nouveau procédé employé pour obtenir des poses gracieuses.

29
Théodore Maurisset
Daguerreotypemania 1840

30
Honoré Daumier
A New Process Used to Achieve Graceful Poses before 5 June 1856

31
Unknown artist
Masked Balls: Photography c. 1869

32
Alfred Grévin
Pierre Petit, Horoscope after the Letter c. 1865

33
Attributed to Gabriel Lippmann
Faverol, Normandy 1914

34
Antoine François Jean Claudet
Young Boy with Curls after 1851

35
Heinrich Kühn
Hans, Mary Warner and Lotte 1907

36
Harold F. Kells
Hallowe'en Still-life 1933, probably
printed 1935

37
Fred Herzog
Jackpot 1961

38
Robert Walker
Times Square, New York 2009

39
Gustave Le Gray
Great Wave, Sète 1857

40
Edward Steichen
Nocturne – Orangerie Staircase,
Versailles 1908

41
Henry Peach Robinson
Hark! Hark! The Lark! 1882

42
William Notman and
Henry Sandham
The Terra Nova Snowshoe Club,
Montreal 1875

43
Georges Hugnet
Untitled 1947

44
Raoul Ubac
Reclining Nude 1941

45
Alison Rossiter
Acme Kruxo, Expiration c. 1940's
(Lament) 2009

46
Edgar Lissel
Bakterium Vanitas-3 c. 2000–01

47
Charles Gagnon
Untitled 1978

48
Robin Collyer
Yonge Street, Willowdale 1994

49
Herwig Kempinger
181099-271199 1999

Exploring and Discovering

Photography not only allowed the naturalistic picturing and the easy dissemination of what was near and dear, it gave travellers and scientists the opportunity to record their explorations whether geographic, cosmic or microcosmic. The camera replaced drawing aids such as the camera obscura and the camera lucida, and became a mandatory instrument for travellers. Travellers included wealthy individuals making the grand tour, colonial officials surveying boundaries of newly appropriated territories, and explorers keen to see and record what lay beyond the borders of their own countries.

On 19 August 1839, when informing members of the *Académie des Sciences* and the *Académie des beaux-arts* of Louis-Jacques-Mandé Daguerre's invention, Dominique François Jean Arago, Director of the Paris Observatory and member of and permanent secretary to the Académie des Sciences, pointed out the daguerreotype's superior ability to rapidly and precisely capture massive amounts of visual data such as Egyptian hieroglyphs of the first stable, easily repeatable photographic process, aptly named the Daguerreotype.

In the year following Arago's announcement, optician and daguerreotypist Noel Paymal Lerebours launched a publication of daguerreotype based images that would assemble notable monuments and sites across the globe in a pictorial album. A virtual Grand Tour, *Excursions daguerriennes, vues et monuments les plus remarquables du Globe*, brought together engravings made from daguerreotypes of European, Egyptian, Greek, Middle Eastern, and North American monuments and sites (fig. 18). The decades following the establishment of the National Gallery's photographs collection saw a proliferation in the acquisition of photographically illustrated publications chronicling the monuments of Egypt and the architecture of other North African countries.

Terra Firma

Cameras were part of the equipment that British engineers and surveyors in India and Canada used to document the boundaries, geology and topography of colonized territories (pl. 50). Although photography would have been but one of the tasks assigned along with map-making, report writing and compiling statistics it was soon realized that the camera provided a quick means to illustrating scale and quantification. A strategically placed surveyor's range pole is used in Captain John Burke's *Temple of Sugandheswara near Village of Pathan: View of South Face* from *Illustrations of Ancient Buildings in Kashmir* (pl. 71), while a yardstick indicates the size of the inscription in O'Sullivan's *Historic Spanish Record of the Conquest, South Side of Inscription Rock, New Mexico, No. 3* (fig. 19). Less intentional but nevertheless a record of relative scale appears in Teynard's *Rock-cut Architecture – Tomb of Amenemhat, Beni Hasan, Egypt* (pl. 60), where a walking cane leaning near the tomb entrance gives the viewer a sense of relative human proportion. It was also common for photographers to use people to indicate scale such as when Maxime Du Camp posed Hadji Ishmael on the thirty-ton sandstone sculpted head of Ramesses II in *Western Colossus of the Great Temple of Abu Simbel, Nubia* (pl. 54).

Fig. 18
Frédéric Salathé (after H.L. Pattinson), *Niagara. Horseshoe Falls*, 1840?, printed 1841, aquatint on paper, mounted on wove paper,
image: 14.5 × 20.2 cm; sheet: 21.7 × 25.4 cm

Fig. 19
Timothy H. O'Sullivan, *Historic Spanish Record of the Conquest, South Side of Inscription Rock, New Mexico, No. 3*, c. May – October 1873,
printed c. October 1873–75, albumen silver print, 20.3 × 27.6 cm

Photographers today continue to explore local and distant frontiers but the idea of travelling to faraway countries and sites and returning with unmediated photographic records is less appealing to them and more the realm of tourists – and drones. Contemporary photographers usually document these places with a purpose. Edward Burtynsky travels to witness and record the transformation of the environment due to mega projects from the construction of dams (pls. 68, 69) and other diversions of nature's waterways to the sundry effects of the depletion of natural resources. His aerial views of pivot irrigation in a suburb of Yuma, Arizona (pl. 75) takes the measure of one such operation. Thomas Joshua Cooper's *The Swelling of the Sea, West, The Atlantic Ocean, Point of Ardnamurchan, The Furthest West, Scotland* is one of the images from his large-scale project locating the most extreme points of land bearing out into the earth's major oceans (pl. 65). David Cowles' photographs assembled in multiple portfolios, trace once vibrant Jewish communities in North Africa, such as in *Ouezzane, Shrine of Amram Ben Diwane: Stones Beneath a Tree* (pl. 64).

While approaching their subjects with different formal strategies, Mark Ruwedel and Sophie Ristelhueber both take account of the ways in which human activity has left its markings on the surface of the earth and human habitats and constructions. Mark Ruwedel's explorations range from artists' earthworks to railway bed evidence of earlier colonial expansion such as in Westward the Course of Empire, evidence of pre-historic settlements, nuclear testing (pl. 66), itinerant and migrant life in the deserts of the southwestern United States.

In the spirit of the 1851 Mission Héliographique, which under the auspices of the Commission des monuments historiques sent five photographers to document the architectural patrimony of France, over 130 years later the French government's Mission photographique de la DATAR (Délégation interministérielle à l'aménagement du territoire et à l'attractivité régionale) once again deployed a group of photographers – the number this time being twelve – to document the French landscape. Sophie Ristelhueber was one of those photographers charged with this mission in 1984. Two years previous she had travelled to Lebanon and photographed the destroyed facades of Beirut (see pls. 110, 111), a body of work that transports us back to the photographs that were published of Paris in ruins after the Franco-Prussian war (see pl. 109).

Until the widespread availability of hand-held cameras, casual travellers to renowned sites like Niagara Falls relied on commercial photographers to supply them with images. *Niagara Falls from Prospect Point*, a whole-plate daguerreotype by Platt D. Babbitt is one such example (pl. 52).

Less epic and more intimate are the investigations photographers have made of personal habitats. Like Alfred Stieglitz's images of the hills, trees and skies of Lake George, Joseph Sudek's tireless, impassioned walks by day and night through a city he loved and of which he had intimate knowledge are legendary in the history of twentieth-century photography (pl. 62). Paul Strand's lovingly observed details of the flora of his adopted home in Orgeval, north central France, were a search for commonality and difference, an investigation of which the photographer never tired (pl. 63).

Microcosm and Cosmos

The study of the microcosm and the cosmos were among the other applications to which Arago envisioned photography might be put. Arthur Durham and J. Hickson's *Salicine by Polarized Light* (pl. 82) and Wilson A. Bentley's *Snow Crystal No. 2010,* 1911 (pls. 83, 86) are two such examples of revealing underlying structures through photography. As the technology developed and photography increasingly yielded more precise, permanent and reproducible images of things too small, too large, or too rapid for human perception, so the potential for this aspect of the medium grew. In the 1920s this fascination resulted in an appropriation of both the scientific presentation of images and of its techniques, most significantly photomicrography such as Karl Blossfeldt's *Valeriana allarifolia* (pl. 89) or Carl Strüwe's *Prototype of Individuality (Single Cells of Diatoms)* [fig. 20]. By the latter part of the twentieth century the type and quality of microcosmic information available to scientists, physicians and artists exceeded all expectations. Gary Schneider, Nicolas Baer and Claudia Fährenkemper are contemporary photographers whose work is inspired by the formal and conceptual promise revealed by photomicrography. A group of small entomological glass plate negatives were found objects that Schneider transformed into generously sized and rich prints. Schneider's fascination with the new pictorial information these slides offered is expressed in *Entomological Specimen No. 8* (pl. 93). Although he enjoys the abstract quality of photomicrographs, Nicolas Baier's interest in the brain's complex system of knowledge transmission has led him to transform his rigorously harvested microscopic images such as *Neurons* (pl. 91) into massive sculptural entities. Claudia Fährenkemper's *Feet of a Tadpole 25X* 2002 on the other hand responds to the sculptural nature of the microcosmic universe (pl. 92).

The landmark invention of X-rays in 1896 was transformative for medical science and just as the making visible of the invisible through photomicrography piqued the imaginations of artists, so did radiography. Scientists such as Josef Maria Eder and Eduard Valenta two Viennese chemists recognized the inherent beauty of these images in *"Versuche über Photographie mittelst der Röntgenschen Strahlen"* (Experiments in Photography Using Roentgen Rays) a portfolio of fifteen photogravures taken from radiographs. The publication's text is devoted to technical research and the sensitivity of certain materials to radiography. These elegantly composed images reproduce, among

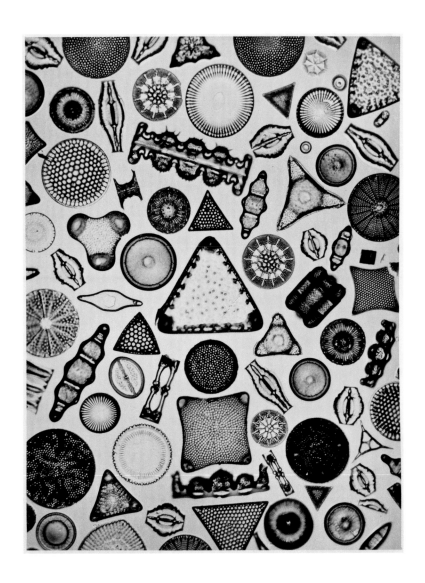

Fig. 20
Carl Strüwe, *Prototype of*
Individuality (Single Cells of
Diatoms), 1933, printed
c. 1956–88, gelatin silver print,

image: 23.2 × 17.5 cm; sheet:
23.9 × 18.1 cm

other subjects, the human hands of individuals of varying ages, a foot, fish, frogs, a rabbit and a snake (pl. 88). Both John Hall-Edwards and Dain L. Tasker were prominent figures in radiology at the beginning of the twentieth century who had a passion for photography and combined their professional and leisure time activities to produce prints from radiographic plates (pl. 87 and 90).

In their quest to use photography to assist in making visible the invisible or barely visible, it took no time at all for photographers to attach their photographic apparatuses to telescopes and direct them toward the heavens. Early daguerreotypes of celestial bodies were interesting records but did not serve astrophysicists' needs for precise detail. In 1872 a group of Lewis M. Rutherfurd's impressively sized and detailed albumen silver prints of the moon were presented to the Académie des sciences in Paris in an effort to persuade the academicians of the effectiveness of using photography to map the surface of the moon now that the dry plate process allowed for faster capture (pl. 94).

Pierre Jules César Janssen, Director of the Observatories of Meudon, saw the photographic plate as analogous to the retina of the scientist. From 1874 Janssen, who was familiar with the photographic process since the daguerreotype era, focused on recording the surface of the sun and tracking sunspot activity. His *Annales de l'observatoire d'astronomie physique de Paris* (Paris: Gauthier-Villars et Fils, 1896) is a compilation of a small number of woodburytypes, photogravures and one wood engraving dedicated to this study (see pl. 11).

Movement

Equally intriguing was the capture of bodies in motion and how photographic technology and chemistry could be adapted to quantify and analyze their trajectories and progressions. This could not be sensibly resolved until the late 1870s when the sensitivity of emulsions had increased and faster lenses were available. Among the pioneers in inventing ways of recording human and animal locomotion were Ètienne-Jules Marey and Edweard Muybridge. This field of photographic enterprise moved rapidly from instrumentalized experiments with time as seen in Marey's *Study in Motion by Chronophotography* (pl. 76) made in the latter part of the nineteenth century to using various forms of magnesium and other flash light substances and contraptions to enable the rapid firing of the camera's shutter in the 1930s, to the point of being able to capture a milk drop's morphology as its splash hit a hard surface. Muybridge (pl. 77; see also pl. 17) and other nineteenth-century pioneer photographers dedicated to the same mission, most often presented their sequential images in a grid. Twentieth-century Harold Edgerton was able to capture entire trajectories of a specific movement in a single frame as in his *Milk Drop Coronet* (pl. 97).

Metrics

Just as movement was the subject of quantification and comparison, the human body was also documented in photographs for medical, forensic and ethnographic purposes. For French police officer, Alphonse Bertillon photography was an indispensable tool for recording his biometric profiles of specific criminals and also criminal types (pl. 72). Contemporary photographer, Spring Hurlbut takes gentle measure of the shards of a human body by incorporating a metal ruler in her composition, *Scarlett #1* (pl. 73).

Exploration of Form

Photographers also explored formal issues. It was indeed radical to recognize that in addition to exploiting graphic abstract values of picture-making in a photograph – such as Frederick Evans, John Vanderpant and Paul Strand do in their respective works (pls. 105, 103 and 104) a photograph could be entirely abstract as in Alvin Langdon Coburn's *Vortograph* (pl. 98) and Man Ray and László Moholy-Nagy's photograms (pls. 99, 100). In an essay titled *The Future of Pictorial Photography* published in 1916, Alvin Langdon Coburn outlined his vision of what direction modern photography could take. Pondering the possibilities of a new kind of photography he asked:

"...why should not the camera also throw off the shackles of conventional representation and attempt something fresh and untried? Why should not its subtle rapidity be utilized to study movement? Why not repeated successive exposures of an object in motion on the same plate? ... Think of the joy of doing something which it would be impossible to classify, or to tell which was the top and which was the bottom!"[1]

Note

1 Alvin Langdon Coburn, "The Future of Pictorial Photography,"
Photograms of the Year, 1916, pp. 23–24, reprinted in *Photography Essays
& Images: Illustrated Readings in the History of Photography*, Beaumont
Newhall, ed. (New York: Museum of Modern Art, 1980), p. 205.

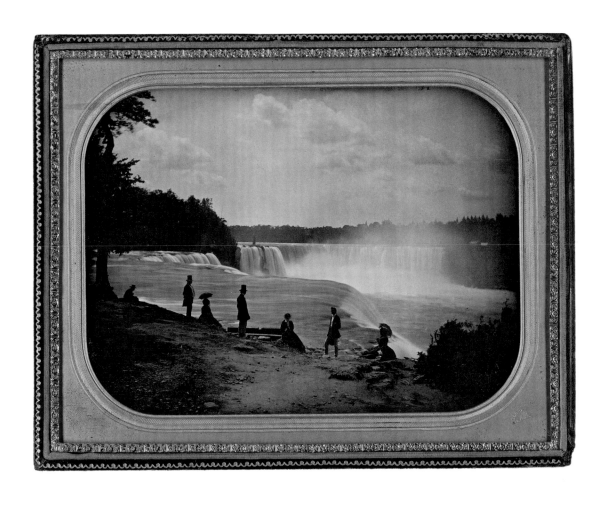

50
Humphrey Lloyd Hime
Hon. Hudson's Bay Company
Officers' Quarters: Lower or
Stone Fort c. September –
October 1858, printed after
January 1859

51
Frederick Dally
Zadoskis' Grave, with Family
Monuments Representing
Deceased Members and Relatives
of the Same Fraser River
c. 1867–68

52
Platt D. Babbitt
Niagara Falls from Prospect Point
c. 1855

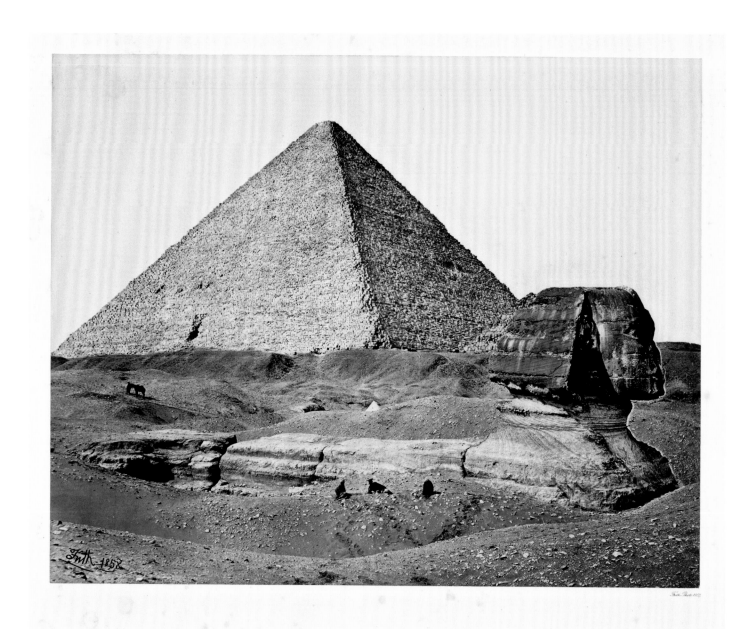

THE GREAT PYRAMID, AND THE GREAT SPHINX.

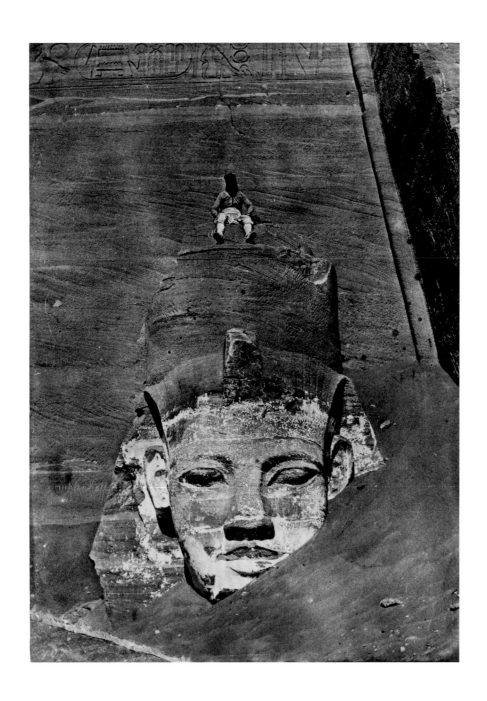

53
Francis Frith
The Great Pyramid and the Great
Sphinx 1858

54
Maxime Du Camp
Western Colossus of the Great
Temple, Abu Simbel, Nubia 1850

Trémaux. lithophot. Procédé Poitevin Lithophotm Lemercier & Cie r. de Seine 57, Paris

STELES TURQUES

55
Auguste Salzmann
Jerusalem. The Holy Sepulchre,
Main Entrance 1854, printed 1856

56
Pierre Trémaux
Turkish Steles, Greek Ephesus
c. 1862–68

57
Robert C. Tytler and
Harriet C. Tytler
Upper and Lower Sections of
Qutb Minar, Delhi c. 1857–58,
printed 1859

58
Robert C. Tytler and
Harriet C. Tytler
Upper and Lower Sections of Qutb
Minar, Delhi c. 1857–58

Photographié par J. Dieulafoy. Hélio&Typ. P. Dujardin

Imp.Phot.de H.de Fonteny et Cⁱᵉ à Paris en 1851, r. St Nicolas d'Antin, 72. Félix Teynard Publié par Goupil et Cⁱᵉ éditeurs, Paris, Londres, Berlin, New-York.

59
Jane Dieulafoy
Viçadahyu Portico after 1881,
printed 1889?

60
Félix Teynard
*Rock-cut Architecture – Tomb of
Amenemhat, Beni Hasan, Egypt*
c. 1851–52, printed 1853

61
Alexander Henderson
Spring Inundation 1865 – Bank of
St. Lawrence River 1865

62
Josef Sudek
Prague at Night 1950

63
Paul Strand
Big Leaf, The Garden, Orgeval
1974

64
D.R. Cowles
Ouezzane, Shrine of Amram Ben
Diwane: Stones Beneath a Tree
1995

65
Thomas Joshua Cooper
The Swelling of the Sea, West,
The Atlantic Ocean, Point of
Ardnamurchan, The Furthest
West, Scotland 1990

66
Mark Ruwedel
The Witnesses, Nevada Test Site
(Viewing area for 14 atmospheric
tests at Frenchman Flat,
1951–1962) 1995

67
Lorraine Gilbert
Shaping the New Forest 1990

68
Edward Burtynsky
Three Gorges Dam Project, Feng
Jie #3, Yangtze River, China 2002

69
Edward Burtynsky
Three Gorges Dam Project, Feng
Jie #4, Yangtze River, China 2002

Mensuration du pied.

70
Harvey G. Fetter
Portrait of E.M. Talbot, Robert Allen and W.A. Wilson 1853–54

71
John Burke
Temple of Sugandheswara near Village of Pathan: View of South Face 1868, printed 1869

72
Alphonse Bertillon
Measurement of the Foot before 1893

73
Spring Hurlbut
Scarlett #1 2005, printed 2007

74
Rosamond W. Purcell
Cyclops Skeleton against Uterine Cyst 1993, printed 1998

75
Edward Burtynsky
Pivot Irrigation / Suburb South of
Yuma, Arizona, USA 2011

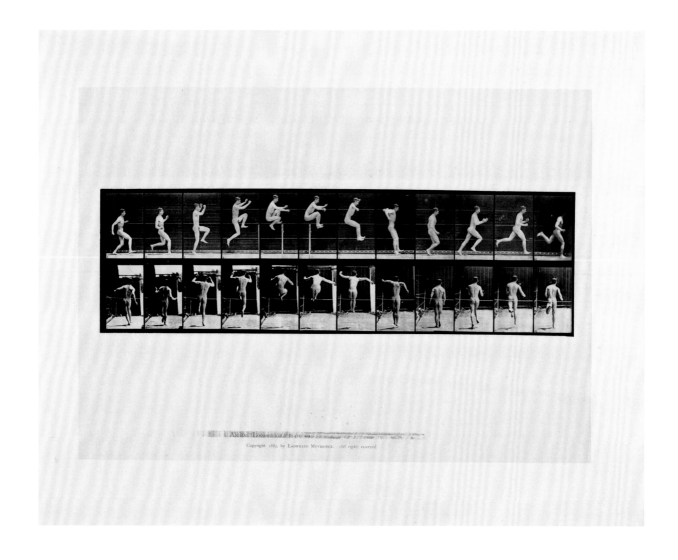

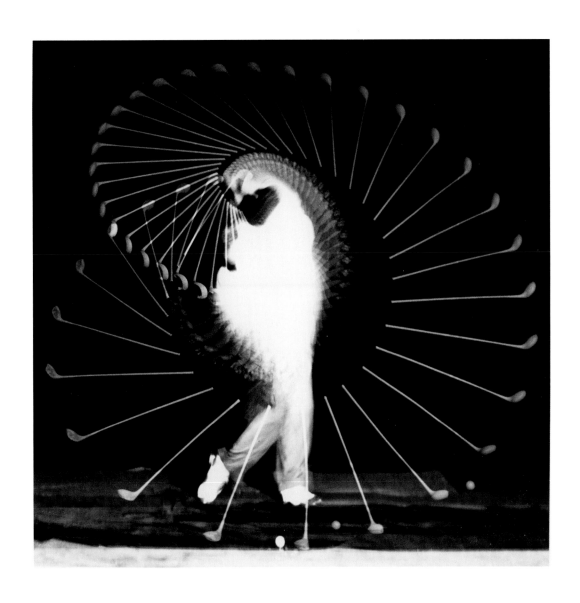

76
Étienne-Jules Marey
Study in Motion by
Chronophotography 1890, printed
before 1967

77
Eadweard Muybridge
Jumping, running straight high
jump c. June 1885 – 11 May 1886,
printed November 1887

78
Harold E. Edgerton
Golf Drive by Densmore Shute
1938, printed 1977

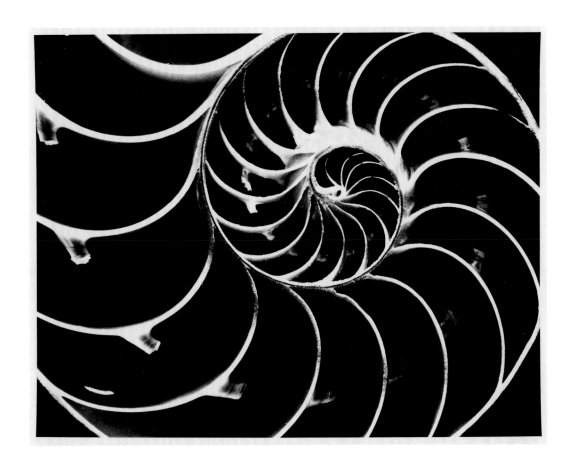

79
Konrad Cramer
Geometric Form Made by
Sympalmograph 20 October 1949

80
Andreas Feininger
Chambered Nautilus Shell 1948

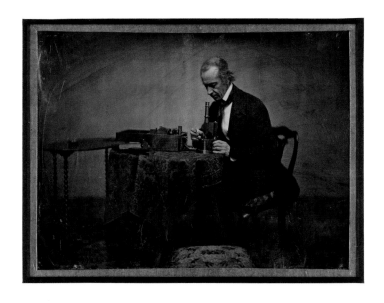

Salicine by Polarized Light

Ad nat: photomicrograph:
J. Mclean & Al. Denham,

81
Unknown photographer
Man with Microscope c. 1850

82
Arthur Edward Durham and
J. Hickson
Salicine by Polarized Light c. 1870

83
Wilson A. Bentley
Snow Crystal No. 3070
6 February 1918

84
Wilson A. Bentley
Snow Crystal No. 3837
17 December 1922

85
Wilson A. Bentley
Snow Crystal No. 2010
31 March 1911

86
Wilson A. Bentley
Snow Crystal No. 4271
2 February 1924

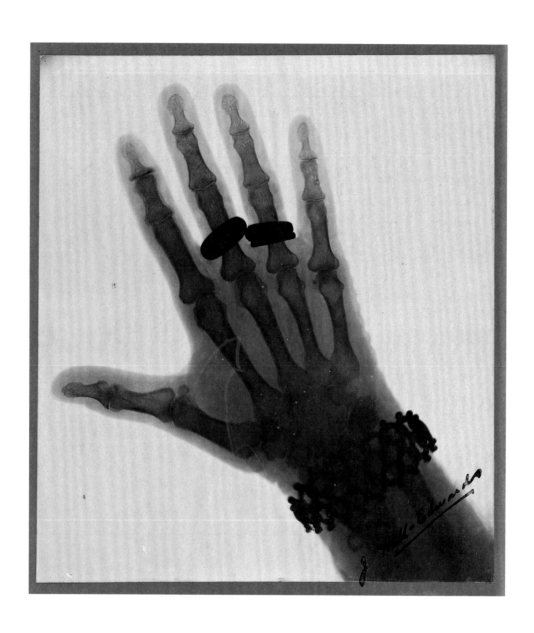

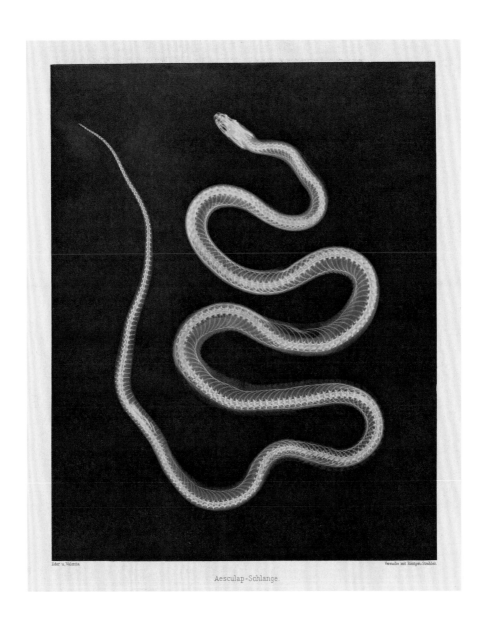

Eder u. Valenta. Versuche mit Röntgen-Strahlen.

Aesculap-Schlange.

87
John Hall-Edwards
X-ray of a woman's hand with two
rings and a bracelet c. 1900

88
Josef Maria Eder and
Eduard Valenta
Snake 1896

"Lily – An X-Ray" Dr. Dain L. Tasker 30

89
Karl Blossfeldt
Valeriana alliariifolia (Valerian)
1915–25

90
Dain L. Tasker
Lily – An X ray 1930

92
Claudia Fährenkemper
Feet of a Tadpole 25X 2002

93
Gary Schneider
Entomological Specimen No. 8
1992

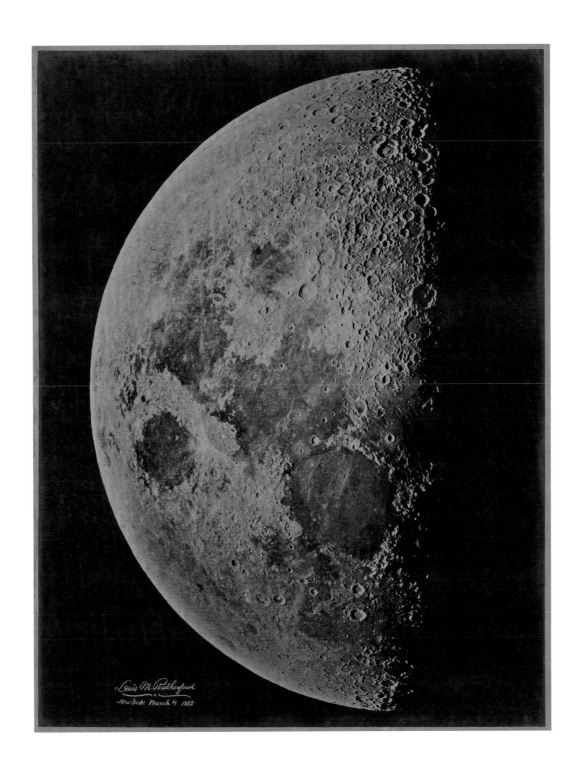

94
Lewis M. Rutherfurd
Moon 4 March 1865

95
Alison Rossiter
Principia No. 14 1997

96
Thomas Ruff
Constellations 1990, printed 1991

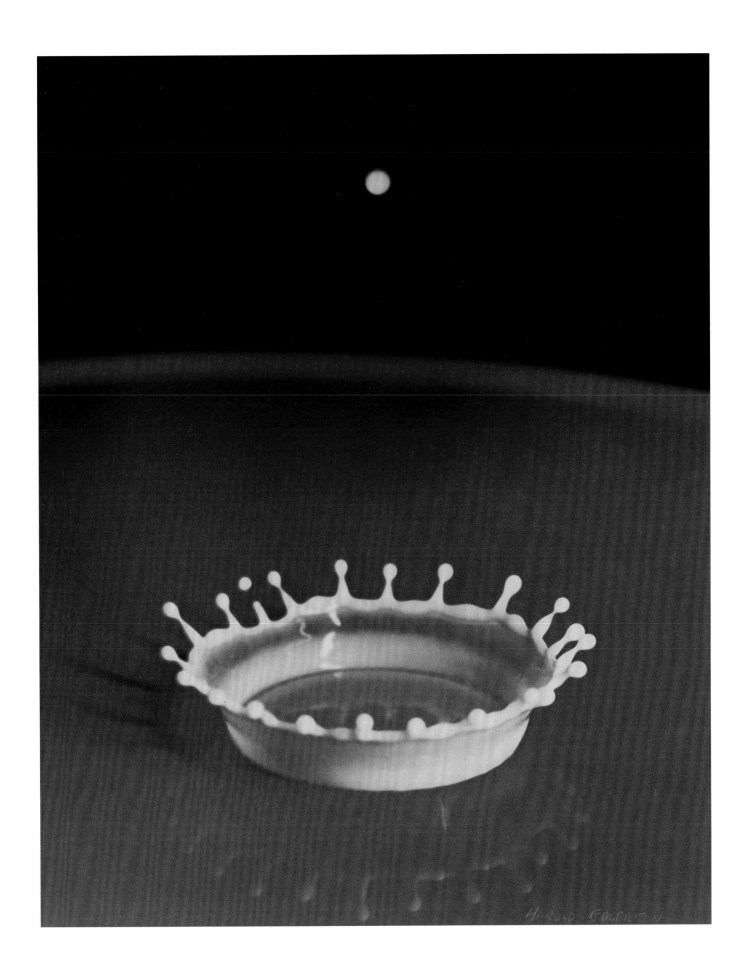

97
Harold E. Edgerton
Milk Drop Coronet 1957, printed
1984

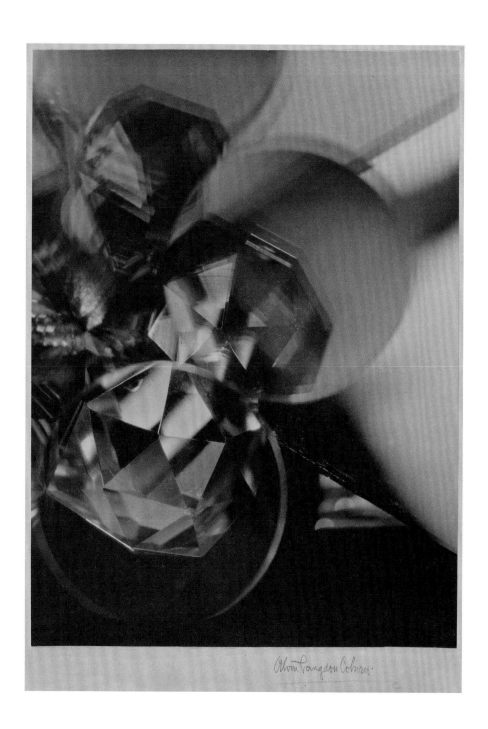

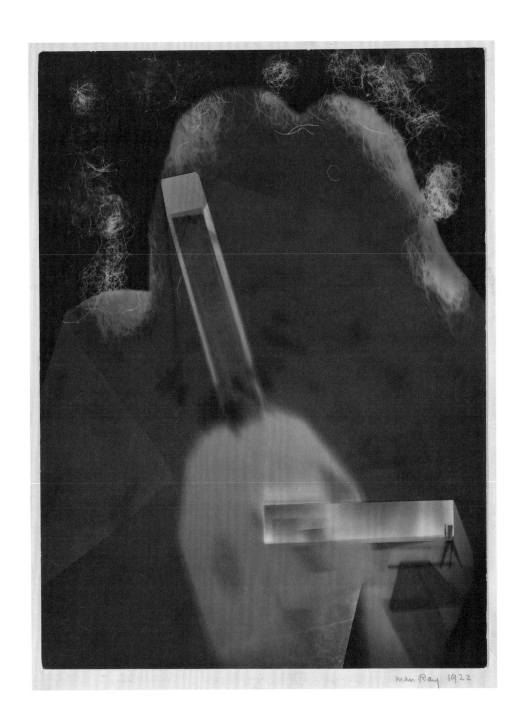

98
Alvin Langdon Coburn
Vortograph 1917

99
Man Ray
Rayograph 1922

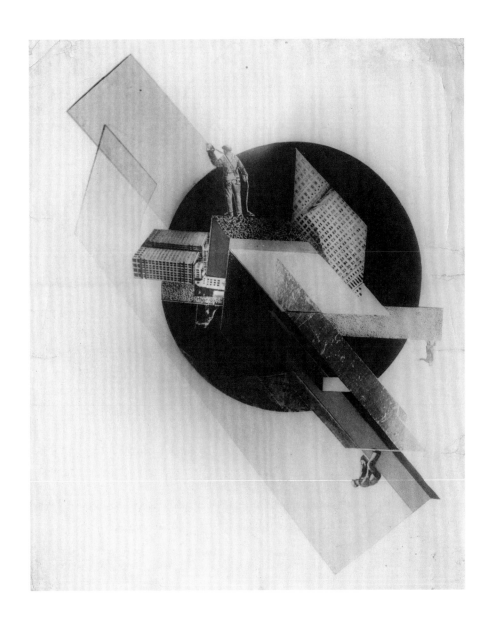

100
László Moholy-Nagy
Photogram c. 1925

101
Franz Roh
Untitled 1922–28

102
Gustav Klutsis
Dynamic City 1919

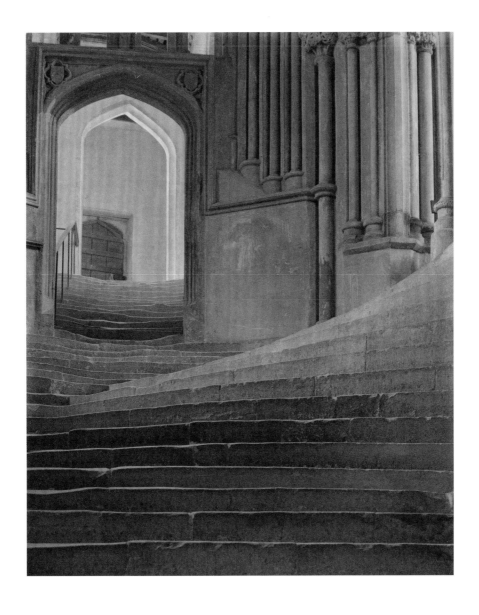

103
John Vanderpant
Untitled (Wire Fence and
Elevators) c. 1929–30

104
Paul Strand
Barn, Gaspé 1936

105
Frederick H. Evans
Wells Cathedral: A Sea of Steps
1903

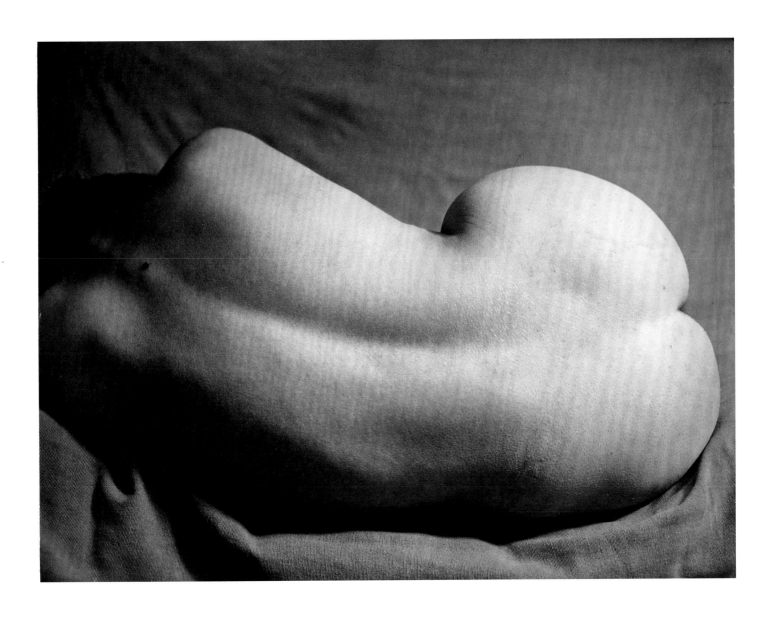

106
Brassaï
Nude c. 1932, printed c. 1950

An Instrument of Detection

Almost as quickly as cameras were directed toward taking portraits, they were removed from the studio settings and their lenses aimed at the external world. Buildings, streets, strangers, wars, and monuments all fell subject to the camera's prying "eye." It was used not only to record immediate observations of urban surroundings and people – what we now call "street photography" – but in time it was also seen as a convincing tool with which to document crime scenes, social injustice, forensic identification, social engineering, work flow, and political propaganda.

One hundred years separates Jacques-Louis-Mandé Daguerre's daguerreotype looking down at a corner of a Parisian boulevard where a man is having his shoes shined (fig. 21a–b) and Lisette Model's *New York* (fig. 22). In contrast to Model's deliberate choice of an interesting and potentially confrontational subject, Daguerre's capture of a similar scene was distant, accidental and purely serendipitous; the result of corresponding lengths of time it took to expose the plate and shine the shoes. By the time Model made her street photographs a relatively short but significant history of this genre had been established. Model called the camera "an instrument of detection," crediting it as the tool by which she came to know the streets and people of New York when she first arrived there in 1938 from Europe. German born Bill Brandt's photographing of English social classes (fig. 23) was also a way of better understanding the culture he found himself a part of and Swiss born film maker and photographer, Robert Frank's trip across the United States in 1955 might also be seen as being similarly inspired.

Photography has played an important and persuasive role in illustrating a variety of social and political agendas.

For John Thomson (fig. 24) and Lewis Hine (pl. 112) the street was the stage where scenes of class difference and social injustice played themselves out, while African American photographers like James Van Der Zee (pl. 121), Gordon Parks (pl. 113) and Roy DeCarava turned their lenses toward their own people, thus making visible an under-represented part of American society. Dorothea Lange's images evoke the social-political consciousness of post-Depression America (pl. 117) while Gustav Klutsis' *Let Us Fulfill the Plan of the Great Projects* (pl. 115) and John Heartfield's *When the World Is in Flames, Then We Shall Prove that Moscow Was the Arsonist* (pl. 114) speak to the political forces in play in 1930s Europe and the role of photographs in the production of propaganda and counter-propaganda.

The power of photography to illustrate socio-economic conditions is manifested in the role that it played in the establishment of government agencies such as the Farm Security Administration (created as the Resettlement Administration in 1935) in the United States and which employed Walker Evans among other photographers. In Canada the National Film Board founded in 1939 played a similar role.

Like social issues and political ideologies, war was a highly charged and newsworthy subject. War, crime and human condition stories illustrated by photographs with graphic power sold newspapers and affected popular perception of current issues. Photographs depicting battles, destruction of enemy targets, heroes and victims were consequently prone to manipulation. This included rearranging subjects and selectively composing what appeared within the photographic frame (pls. 107, 129). Photography's

Fig. 21a
Louis-Jacques-Mandé Daguerre,
Boulevard du Temple, Paris, 1838,
Bayerisches Nationalmuseum,
Munich

Fig. 21b
Louis-Jacques-Mandé Daguerre,
Boulevard du Temple, Paris, 1838
(detail)

Fig. 22
Lisette Model, *New York*,
c. 1939–45, gelatin silver print,
34.5 × 26.6 cm

effectiveness as propaganda was understood as early as the Crimean war. By the time of the Franco-Prussian war (1870–71) photographs of devastated street facades, buildings and bridges abounded, not only feeding a public thirst for information but also satisfying a curious contemporary taste for picturesque ruins (pl. 109). These photographs were often compiled in albums.

Avoiding perhaps the now-numbing pervasiveness of photographs depicting the public ruins of war, contemporary photographers, Hiromi Tsuchida (pl. 138) and Frauke Eigen (pl. 139) focused their lenses on the remains of personal artefacts. Their stark frontal capture of destroyed and grotesquely distorted everyday items force the viewer to confront war's assault on the ordinary lives of individuals. While Guy Tillim's *An Amputee's Grave, Kuito, Angola* (pl. 131) and Louis Palu's *U.S. Marine Cpl. Philip Pepper, Age 22, Garmsir, Helmand, Afghanistan* (pl. 128) speak to war's grim aftermath, Luc Delahaye's *The Milosevic Trial* 2002 (pl. 140) addresses the prosecution of its enablers.

Even though the technology permitting the printing of photographic images alongside accompanying text would take decades to master, the authority of the photograph was nonetheless invoked by describing some line drawing illustrations in magazines as being "after the photograph." Photojournalism, such as we know it today, did not become a genre until the half-tone printing process was perfected in the last decades of the nineteenth century. As the technology became available so half-tone photographic reproductions replaced hand-drawn illustrations in magazines and newspapers. By the time press photographers had gained professional status in the twentieth century, news photography was a thriving industry. The editorial choices governing the selection and representation of images illustrating news items often resulted in images being used in contexts unrelated to their original source or visually manipulated. As mentioned in the Introduction to this publication, the great advantage of an archive of press photographs dating from the analogue era is the editorial data and visual corrections inscribed and drawn on the rectos and versos of the photographs. This information is invaluable not only as an aid to identifying the subjects of the images but also to an appreciation of the transformation of the imagery as seen in the image of photographs of Che Guevara (pl. 133); a dirigible (pl. 136); crime scenes from *The Globe and Mail* archive (pl. 132) and the Haynes Archive (pl. 135). Although many earlier news photographs are known to us now only by the agency representing their makers or agencies who supplied their images to the press, this does not make the cultural record they have left us any less worthy of our attention.

There were those photographers who distinguished themselves in the fields of social documentary, war and news photography and who would become legendary figures in the history of photography. One of the most celebrated of twentieth-century American news photographers is Weegee (born Arthur Fellig). Known as an "ambulance chaser" he was a colourful personality who capitalized on the sensational aspects of photojournalistic images (pl. 134).

Even if Model's assertion that the camera was an instrument of detection seems somewhat naïve to those immersed in Photoshop and other image-editing programs and who recognize the malleability of the recorded image and the vulnerability of its veracity, street photographs, social documentary images and news images nevertheless continue to exercise power over the human imagination.

Fig. 23
Bill Brandt, *A Lyons Nippy (Miss Hibbott)*, 1939, gelatin silver print, 24.9 × 19.9 cm

Fig. 24
John Thomson, *The Crawlers*, before 1877, woodburytype, 11.6 × 8.8 cm

149

ALEX. GARDNER, Photographer, *Entered according to act of Congress, in the year 1866, by A. Gardner, in the Clerk's Office of the District Court of the District of Columbia.* 511 Seventh Street, Washington.

Home of a Rebel Sharpshooter, Gettysburg.

107
Alexander Gardner
Home of a Rebel Sharpshooter,
Gettysburg July 1863, printed
1866?

108
Felice Beato
Interior of the Angle of North Fort
21 August 1860

109
Jules Andrieu
Disasters of the War: City Hall,
Galerie des Fêtes c. 1870–71

110
Sophie Ristelhueber
Beirut printed 1984

111
Sophie Ristelhueber
Beirut printed 1984

112
Lewis W. Hine
Sanford Cotton Mill. Accident Case, Carl Thornburg Twelve-year-old Boy, ... Sanford, North Carolina November 1914

113
Gordon Parks
Emerging Man 1952, printed later

114
John Heartfield
When the World Is in Flames, Then
We Shall Prove that Moscow Was
the Arsonist before 28 February
1935, printed before 1942

115
Gustav Klutsis
Let Us Fulfill the Plan of the Great
Projects 1930

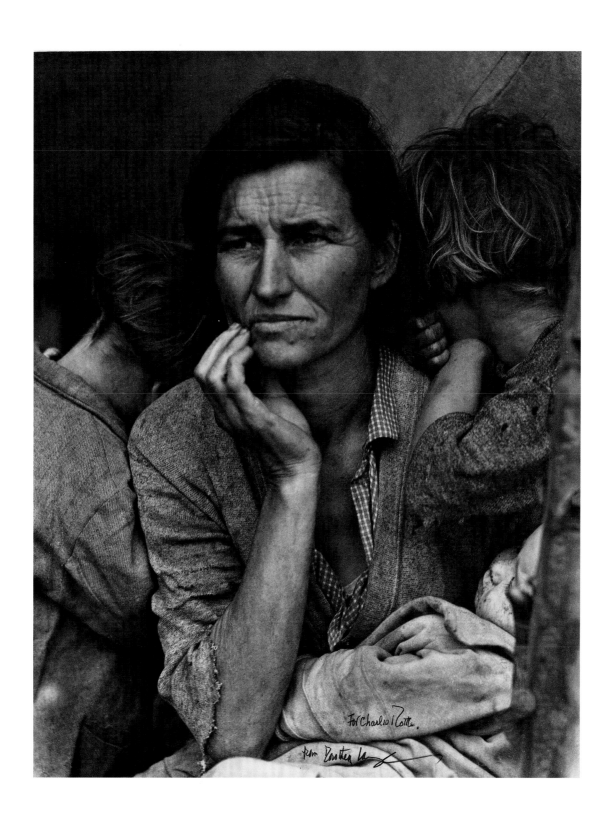

116
Bernard Cole
Shoemaker's Lunch, Newark,
New Jersey 1944, printed before
March 1978

117
Dorothea Lange
Migrant Mother March 1936,
printed c. 1950–59

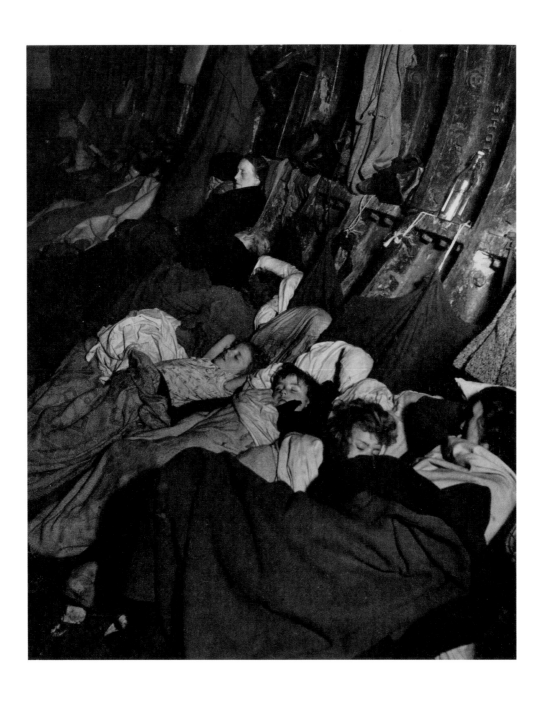

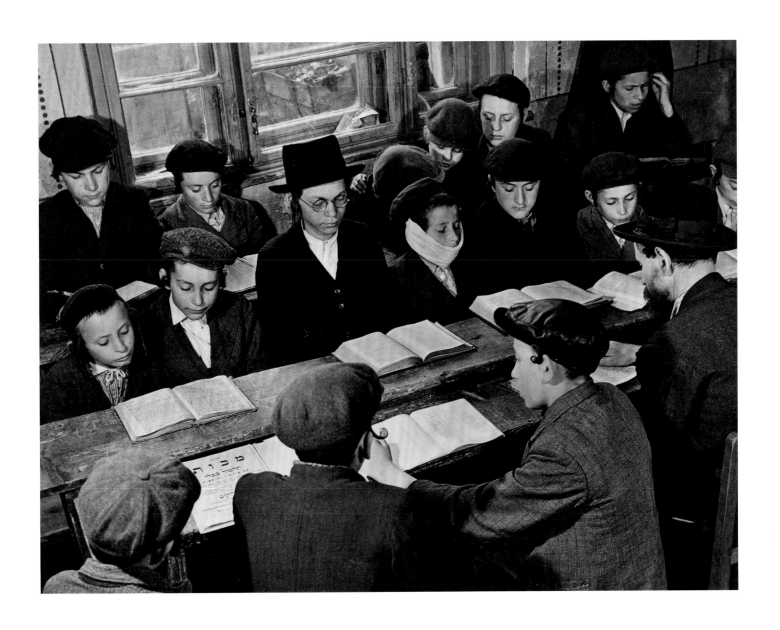

118
Bill Brandt
Crowded, Improvised Air Raid
Shelter in a Liverpool Street Tube
Tunnel 1940, printed c. 1940

119
Margaret Bourke-White
Boys Studying Talmud, Orthodox
Jewish School, Uzhorod 1938

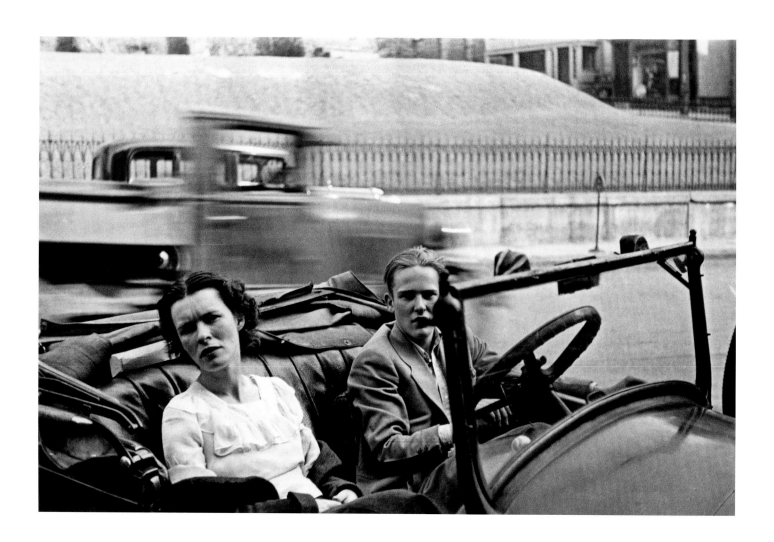

120
Walker Evans
Parked Car, Small Town, Main
Street 1932, printed later

121
James Van Der Zee
Couple Wearing Racoon Coats
with a Cadillac, Taken on West
127th Street 1932, printed c. 1960

122
Henri Cartier Bresson
Valencia, Spain 1933, printed
before 1947

123
Lutz Dille
New York City 1959, printed 1995

124
Shelby Lee Adams
Brother Shell Firehandling 1987,
printed 1990

125
O. Winston Link
Gooseneck Dam and No. 2,
Natural Bridge, Virginia 1956,
printed 1996

126
Dave Heath
Toronto, 26 August 2004
26 August 2004

127
Robert Capa
Spain 5 September 1936

128
Louie Palu
U.S. Marine Cpl. Philip Pepper,
Age 22, Garmsir, Helmand,
Afghanistan 2008

129
Photographic News Agencies Ltd.
Soldiers of the Northern Ireland
Infantry in Training 4 June 1941

130
Larry Towell
Office, Mothers of the
"Disappeared", San Salvador,
El Salvador 1987

131
Guy Tillim
An Amputee's Grave, Kuito,
Angola 2000, printed 2005?

132
Unidentified photographer
*Dead Body of William Poole after
he was shot by police while trying
to open safe Toronto Florist
Co-Operative* c. 1948

133
Unidentified photographer
Photographs of Che Guevara
c. 1967 ?

134
Weegee
*Mrs. Patricia Ryan who Shot and
Killed her Husband, a Cop. She is
Shown about to be Brought into
the Magistrate's Court in the Bronx*
c. 1936–38

135
Unidentified photographer
Crime – Dead Gunman 1961

136
Unidentified Photographer
LZ 127 Graf Zeppelin n.d.

137
Wide World Photos
Target for bomb manoeuvres,
California desert 5 April 1936

弁 当 箱
寄贈―昭和45年6月25日　寄贈者―渡辺茂(渡辺玲子さんの父親)

渡辺玲子さん(当時高女1年)は動員学徒として材木町(500m)で建物疎開作業中に被爆。
数日後、誓願寺南側の倒れた土壁の下から学校側が掘り出したもの。エンドウ豆の煮物に白米という当時にし
てはぜいたくな弁当だが、完全に炭化している。遺体は行方不明。

Lunch box

Reiko Watanabe (15 at the time) was doing fire prevention work under the Student
Mobilization Order, at a place 500 meters from the hypocenter. Her lunch box was found
by school authorities under a fallen mud wall. Its contents of boiled peas and rice, a rare
feast at the time, were completely carbonized. Her body was not found.

138
Hiromi Tsuchida
Lunch Box c. 1979–82, printed
1994

139
Frauke Eigen
Shirt (2) 2000, printed 2001

Advertising

With the ability in the late nineteenth century to transfer photographic images to printing plates and then print them as illustrations in magazines and newspapers came the dawning realization of their potential usefulness to advertisers.

By the 1920s with significant technical advances having been made in the mass printing industry, advertising's increasing reliance on photography to sell its products prompted one observer to note:

> ... this field is steadily growing, and it is impossible to say what may come from the use of photographs in the future. However, it is obvious that they have added much to advertising on the side of truth and verisimilitude, and it is difficult to foresee any limit to the good that may result from their increased use.[1]

Aware that photographs of products had apparent truth and verisimilitude on their side and that suggestible customers would therefore view what they were promoting not only as desirable but also credible, enlightened art directors in advertising agencies upped the ante by innovating in styles of layout, the relationship of text to photograph and boldness of images. To grab attention and give a modern look to their pages they borrowed graphic elements of modern photography – innovative compositions that were often of a surrealist nature, sharp focus, smooth surfaces and carefully calibrated contrast to suit the content.

As exemplified by Horst P. Horst's *Mainbocher Corset, Paris*, 1939 (pl. 144) the period spanning the 1920s into the 1940s was a golden age for advertising. While some of the most accomplished fashion and advertising photographers were initially trained in photography, others came to the field as artists or architects. Brilliant use of lighting, innovative compositions, superb technical knowledge of craft and smartly incorporated iconography from well-known paintings guaranteed these images a future in the history of image-making and their eventual display on the walls of art galleries and museums.

So successful were photographers at crossing the domains of art and advertising that it is often forgotten that such iconic images in the history of photography as Margaret Watkins' *Domestic Symphony* (pl. 141), Andre Kertesz's *Fork* (pl. 142), Paul Outerbridge's *Knife and Cheese* (fig. 25) were made for advertising.

New technologies such as back-lit billboard transparencies advanced advertising imagery in the last decades of the twentieth century. Quickly recognizing the art potential of these objects, artist-photographers appropriated both the technology and the scale. In adapting the properties of seductively uniform and cool radiant surfaces of rear-lit images to purely artistic purposes, artists like Jeff Wall often introduced what could be called anti-advertising subject matter: a destroyed room or staged images of a vampires'

picnic, while Ken Lum incorporated logos into large scale photographs mounted on acrylic or aluminum (fig. 26).

Both Ed Burtynsky and Robert Walker respond to advertising's dominance and integration into – or even creation of – the urban landscape. A found montage of competing logos, gas stations signs, fast food chains and multi-lane throughways, Burtynsky's *Breezewood, Pennsylvania* (pl. 146) describes with graphic power and seductive colour an environment of corporate bombardment. It is the capitalist retort to the thirties Soviet ideal of the dynamic city as seen in Klutsis' eponymous montage (pl. 102) where the workers preside over a future utopia.

What is Times Square if not the prime visual paean to commerce: a jungle of back-lit and digital billboards and posters, corporate brand names announced in incandescent bulbs, neon signs, and fluorescent, LED and HID lighting. Seduced by the explosion of saturated colours, monstrously sized brand names, the exploitation of sexual tropes and insistent promotion of food, news and sundry products, Robert Walker (pl. 147) pictures the visual onslaught that Collyer so painstakingly deconstructs.

Also in an anti-consumerist mode, Robin Collyer's work heralds some of the most interesting work done with the new digital technology. Photographing mundane urban street scenes cluttered with billboards advertising everything from fast-food outlets to clothing manufacturers, discarded cigarette packages, pop cans and other such assaults on the eye, he extracts, pixel-by-pixel, brands, trademarks, logos and declamatory messages (pl. 148).

Note

1 Leonard A. Williams, *Illustrative Photography in Advertising* (San Francisco: Camera Craft Publishing Company, 1929), p. 9.

Fig. 25
Paul Outerbridge, Jr., *Knife and Cheese*, 1922, printed later, platinum print, image: 12.2 × 9.6 cm; sheet: 12.7 × 10.2 cm

Fig. 26
Ken Lum, *Amrita and Mrs. Sondhi*, 1986, dye coupler print and acrylic paint on opaque Plexiglas, 102.0 × 225.9 × 6.3 cm irregular

141
Margaret Watkins
Domestic Symphony 1919

142
André Kertész
Fork, Paris 1928

143
Horst P. Horst
Untitled c. 1935

144
Horst P. Horst
Mainbocher Corset, Paris 1939,
printed later

145
Horst P. Horst
Untitled c. 1931–35

146
Edward Burtynsky
Breezewood, Pennsylvania 2008,
printed 2010

147
Robert Walker
Times Square, New York 2002

148
Robin Collyer
Yonge Street, Willowdale 1995

Portraying

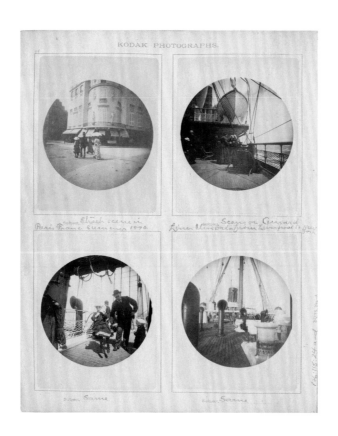

This selection represents just a small fraction of tens of thousands of portraits in the collection ranging from simple likenesses of friends and family members, self-portraits, apparently casual captures of strangers' faces, to sophisticated stagings of celebrated individuals and the adoption of personae.

In contrast with today's fast and easy production of "selfies," the earliest photographic portraits were made under circumstances that were formal, technically demanding and often gruelling. To make photographic portraits, operators had to know something about chemistry and optics and as they posed, sitters had to brace their heads in iron posing stands to make them immobile as they endured long exposures. It is miraculous that these intimate images, housed in cases and viewed as hand-held objects, appear so engagingly fresh and direct.

Hermann Biewend's private passion was the recording of his immediate and extended families (see pl. 3) while photographers Albert Sands Southworth and Josiah Johnson Hawes ran a prosperous portrait studio in Boston. Like most nineteenth-century portraitists, Southworth & Hawes modelled their photographs after masterpiece paintings of the past. When they made the extraordinary Raphaelesque portrait of an unidentified young woman with her hand raised to her shoulder (pl. 20) they recognized that they had established a new standard for the daguerreotype portrait, insuring it for the grand sum of $10,000 USD in 1850.

Over the course of a century-and-a-half significant changes occurred in both the art and industry of photographic portraiture. From small artful recordings on copper and reproductive prints on paper to images glowing on hand-held screens, the genre would evolve to embrace all technical, technological and conceptual innovations.

As in all areas of artistic expression, both continuities and disruptions to the conventions governing portraiture occurred over time.

The arrival of the Kodak camera in 1888 revolutionized the look of photographic portraits. Box-shaped, portable and simple to use, it signalled the rise of an amateur photographer class who bought their cameras already loaded with film and when the 100 or so shots had been exposed they returned the camera with film for processing.[1] This genre of spontaneously composed and quickly captured images was dubbed the "snapshot" (fig. 27) after a hunting term denoting random and quick shots. Its homespun aesthetic of casual compositions, inconsistent focus and unexpected juxtapositions influenced a later generation of photographer eager to cast off the strict formality of the studio portrait.

The single photographic portrait would evolve from a "faithful likeness" of a specially attired individual posing in a studio surrounded by backdrops and props to portraits that consciously broke rules and redefined the genre either by way of informal snapshots (analogue or digital) or radically re-determining what constituted individual identity.

The first profound rupture with photography's traditional ways in all genres occurred with the advent of the avant-garde movements of the early twentieth century. The world was changing and the old ways of representation no longer spoke to the circumstances of the times. This was no less true for portraiture than other genres.

Fig. 27
Unknown photographer, *Scenes in Paris and on the Cunard Liner "Umbria"* 1890, gelatin silver prints, 12.3 × 9.9 cm

Fig. 28
Lucia Moholy, *Lily Fischel*, c. 1928–32, gelatin silver print, image: 37.5 × 27.6 cm; sheet: 39 × 29.4 cm

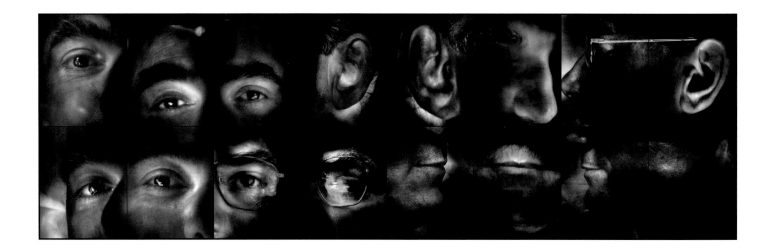

Cutting through the romanticism or even sentimentality of Pictorialist portraits, Lucia Moholy broke the cardinal rule that portraits be composed in pre-ordained ways, presenting instead Lily Fischel's face partly obscured by a lock of hair (fig. 28) or the face of art historian, Franz Roh, visibly pained by a blast of light (pl. 163).

The question of the boundaries of the portrait genre has been the subject of revision since the mid twentieth century and continues to be challenged in contemporary times. We see this in Gary Schneider's *John in Sixteen Parts* (fig. 29; pl. 174) and in his hand prints (see pl. 14), and particularly in his *Genetic Self Portrait.*

Spring Hurlbut's *A Fine Line: Arnaud #4* (pl. 179) brings a new perspective to the *memento mori*. A composition based on her photographer husband's ashes arranged within seven evenly spaced lines and then photographed, this work evokes both his embrace of geometric order and his unbridled imagination.

Arnaud Maggs developed a distinctive style that extended the time frame of portrait sittings by asking sitters to hold a pose for a specific length of time while he made multiple exposures or had them rotate their positions fractionally in a circle at a circumscribed distance from the camera lens and stand motionless before the camera at certain points when he triggered the shutter.[1] He applied this methodology to his twelve-element self-portrait in 1983 (pl. 178).

For decades the convention of arranging people according to rank in military or corporate group portraits and by generations in family groups was observed. August Sander's portraits (pl. 170) with their strict frontal compositions and attention to detail shared the formal presentation of daguerreotypes demonstrated by Jean-Gabriel Eynard nearly a century earlier (pl. 169).

Diane Arbus' couple in a nudist camp (pl. 172) first shown at the Museum of Modern Art, New York, 1967, in the landmark exhibition *New Documents*, like other pieces in the exhibition broke from the conventions observed in group family portraits since the beginning of photography.

Garry Winogrand and Lee Friedlander would also bring new insights into what form photographic portraits and self-portraits might take. Friedlander's versatile and witty series, dating back to the 1960s, stretched the notions of what this genre could be by adopting the informality of the twentieth-century snapshot aesthetic while bringing to his images a keen visual complexity and conundrum entirely absent in casual picture taking. His early and more recent self-portraits (fig. 30, pl. 175) raise the level of depth, daring and honesty to which modern-day selfies do not appear to aspire. His self-portrait titled *Finland* shows the shadow cast by his tripod-mounted camera cascading over the folds of a sheet enshrouding his body. The visual presence of devices that pace the passage of time and consciousness – a digital alarm clock and a telephone on the side table – speak to the photographer's unsurpassed mastery of modern iconography. While the embrace of banality in this series of self-portraits owes a debt to the informality of the vernacular or snapshot photograph, it is as studied and rich in its depth as a Renaissance portrait.

Jeff Wall's *Stereo*, a back-lit colour transparency (fig. 31) showing himself as a young naked man riffing off of Eduard Manet's *Olympia*, and John Coplans' series (pl. 173)

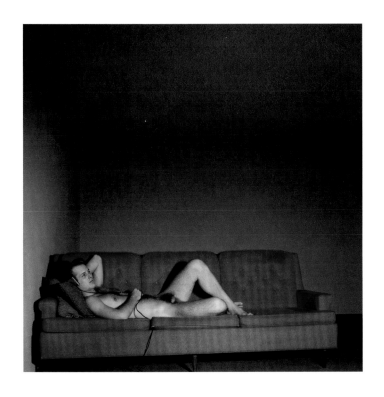

Fig. 29
Gary Schneider, *John in Sixteen Parts* (installation view), 1996

Fig. 30
Lee Friedlander, *New York City*, 1966, printed 1973, gelatin silver print, 16 × 24 cm

Fig. 31
Jeff Wall, *Stereo*, 1980, Cibachrome transparency, serigraph on plexiglas, two fluorescent lightboxes, 245.7 × 245.6 × 27.2 cm each; image: 220.7 × 220.9 cm each

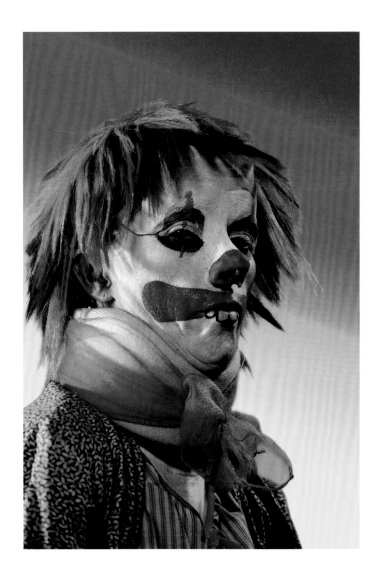

picturing himself as a naked aging male both acknowledge the body as integral to the notion of the self-portrait.

Adopting identities in photographic portraiture is a popular practice in contemporary art and photography as can be seen in Zanele Muholi's *ZaVa, Amsterdam* (pl. 168), Cindy Sherman's *Untitled #411* (fig. 32), Yasumasa Morimura's *To My Little Sister: For Cindy Sherman* 1998 (pl. 167), George Steeves' *George David Steeves* (fig. 33) and in Rafael Goldchain's *Self-portrait as Reizl Goldszajn (Poland 1905–Buenos Aires, Argentina, 1975)* [fig. 34] but, like most sub-genres, it has a substantial history. An early example of role-playing can be seen in a daguerreotype (pl. 166) by an unknown maker of three women impersonating men.

Note

1 The processing plant then returned it to the owner supplied with a fresh roll of loaded film.

Fig. 32
Cindy Sherman, *Untitled #411*,
2003, dye coupler print,
111.8 × 76.1 cm

Fig. 33
George Steeves, *George David
Steeves*, 3 July 1992, printed
27 June 1996, gelatin silver print,
image: 45.5 × 30.4 cm;
sheet: 50.6 × 40.5 cm

Fig. 34
Rafael Goldchain, *Self-portrait as
Reizl Goldszajn (Poland 1905 –
Buenos Aires, Argentina, 1975)*,
1999–2001, chromogenic print,
99 × 79.5 cm

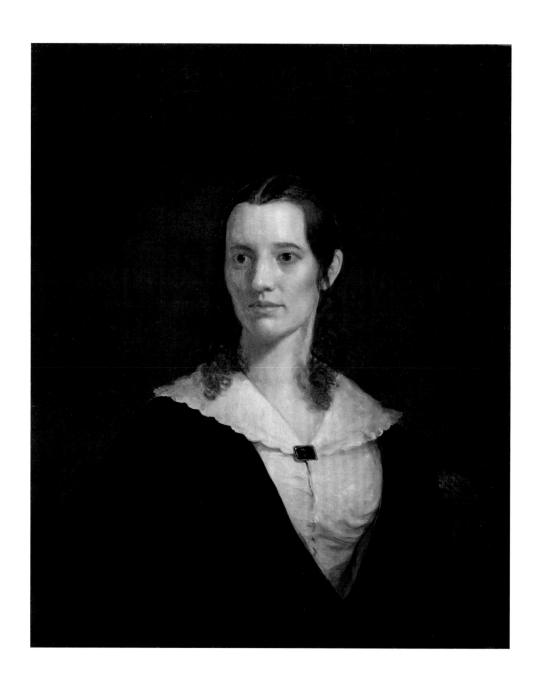

149
Albert Gallatin Hoit
Portrait of Nancy Southworth
Hawes c. 1836

150
Southworth & Hawes
Portrait of Nancy Southworth with
Painted Portrait c. 1842–43

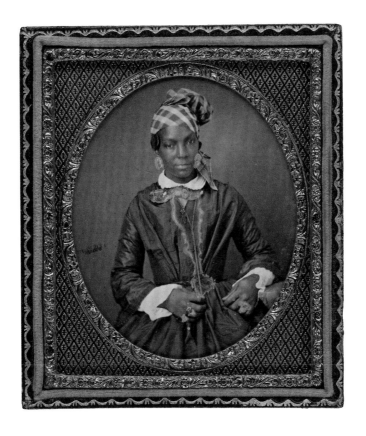

151
John Benjamin Dancer
Self-portrait with Scientific
Apparatus ? c. 1853

152
Bertha Wehnert
Uncle (Sali) Salomon Hirzel,
Bookseller in Leipzig after 1847

153
Unidentified photographer
Portrait of an Unidentified Woman
c. 1850

154
Julia Margaret Cameron
Alethia (Alice Liddell) October
1872

155
Louis-Rémy Robert
Henriette Caroline Robert
(1834–1933) c. 1851

156
Louis-Rémy Robert
Henriette Caroline Robert
(1834–1933) c. 1851

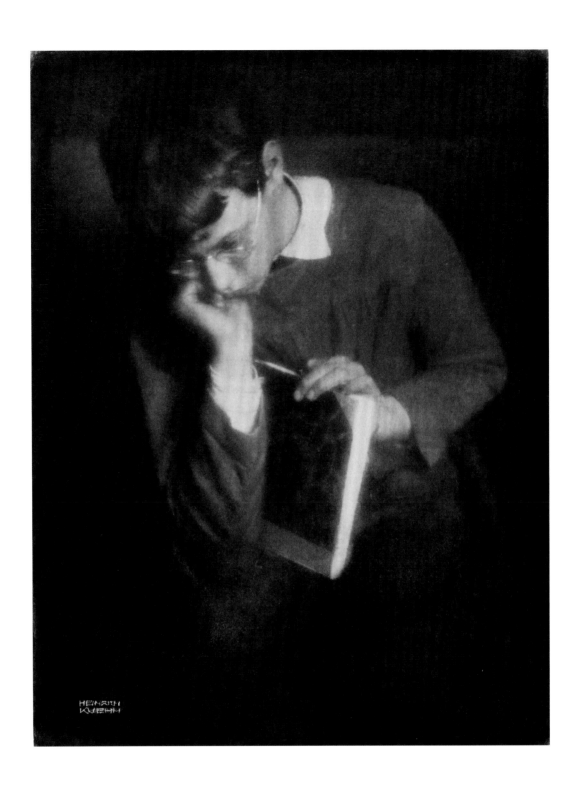

157
Heinrich Kühn
Study of a Youth (Walter Kuhn ?)
c. 1908

158
John Vanderpant
The Ebony Mask 1936

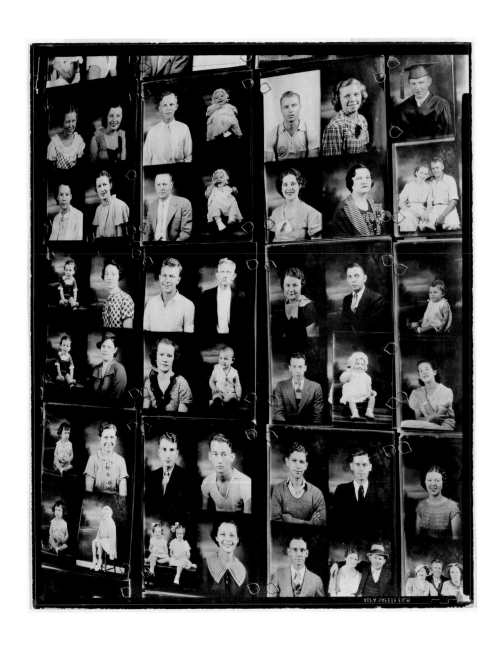

159
Walker Evans
*Family Snap Shots in Frank
Tengle's Home, Hale County,
Alabama* July–August 1936,
printed April 1969

160
Walker Evans
Penny picture Display, Savannah
March 1936 ?, printed April 1969

161
Walker Evans
Photographer's Display c. 1936

162
John Max
Untitled March 1963, printed
before July 1968

163
Lucia Moholy
Franz Roh (1890–1965) 1926,
printed later

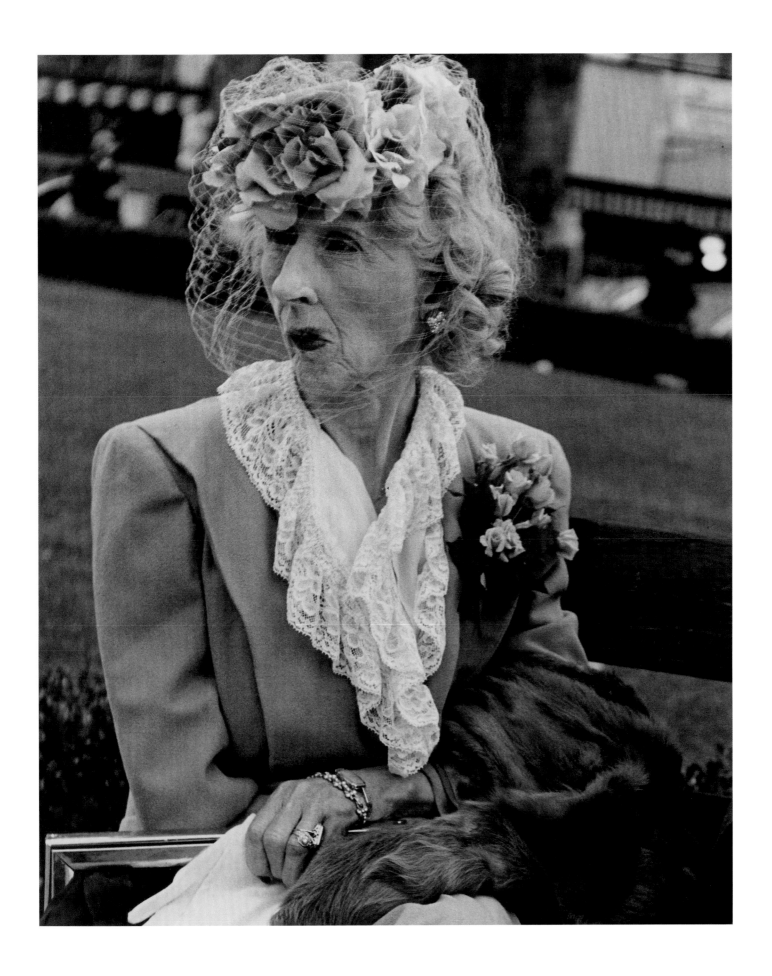

164
Edward Steichen
Sunburn, New York 1925

165
Lisette Model
Woman with Veil, San Francisco
1949

166
Unknown photographer
Unidentified Portrait of Three
Women Dressed as Men c. 1845

167
Yasumasa Morimura
To My Little Sister: For Cindy
Sherman 1998

168
Zanele Muholi
ZaVa, Amsterdam 2014
from the series *Somnyama*
Ngonyama [Hail the Dark Lioness]

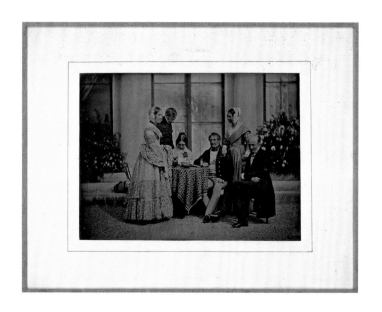

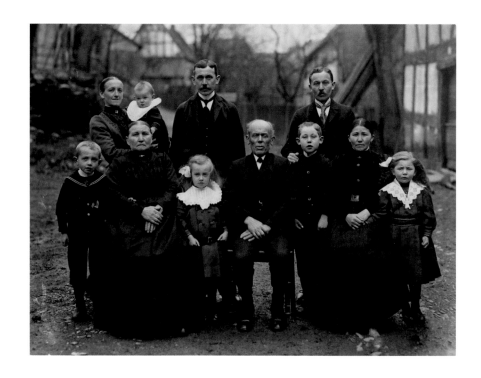

169
Jean-Gabriel Eynard
Self portrait (Fourth from Left)
with Friends 1841 ?

170
August Sander
Farmer's Family, Westerwald
c. 1910–20

171
John Benson
Untitled 1969

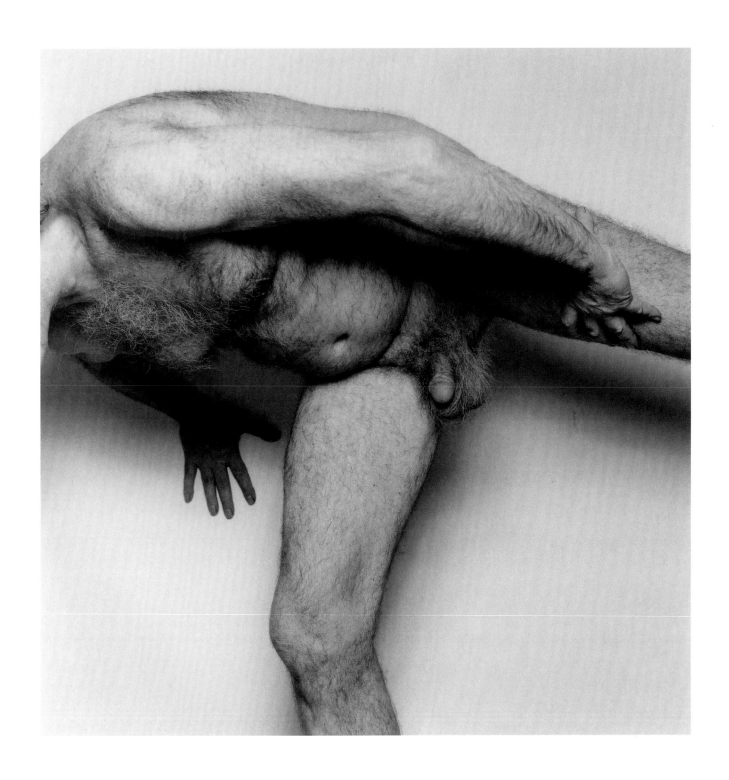

172
Diane Arbus
*Retired man and his wife at home
in a nudist camp one morning, N.J.,
1963* 1963, printed 1973

173
John Coplans
Self-portrait 1985

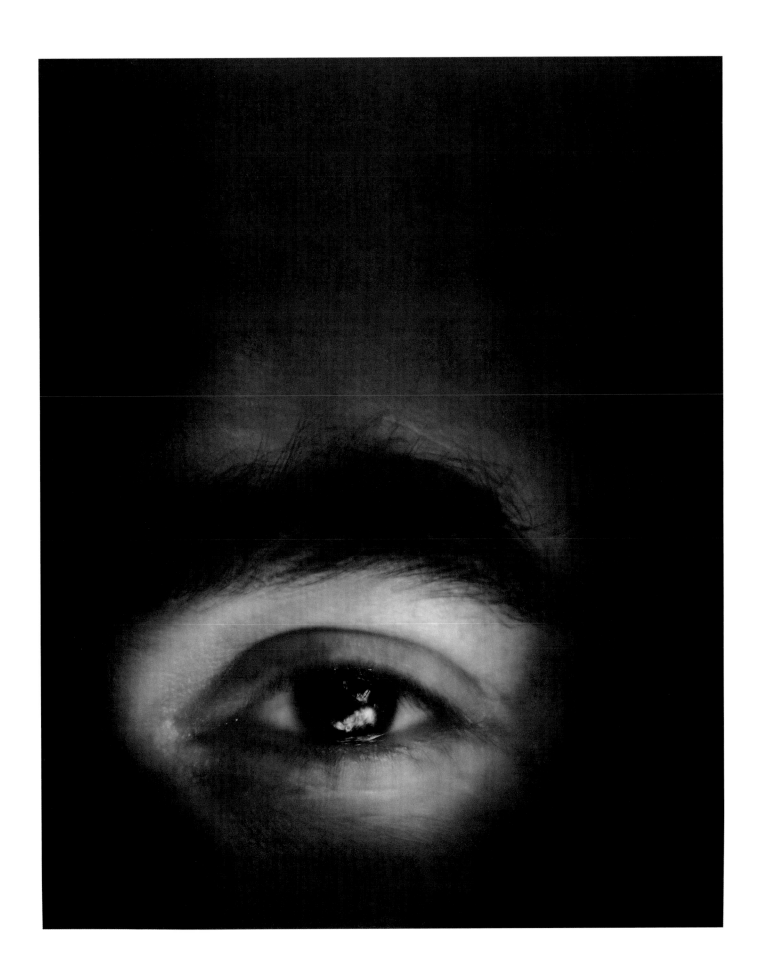

174
Gary Schneider
John in Sixteen Parts, V 1996,
printed 1997

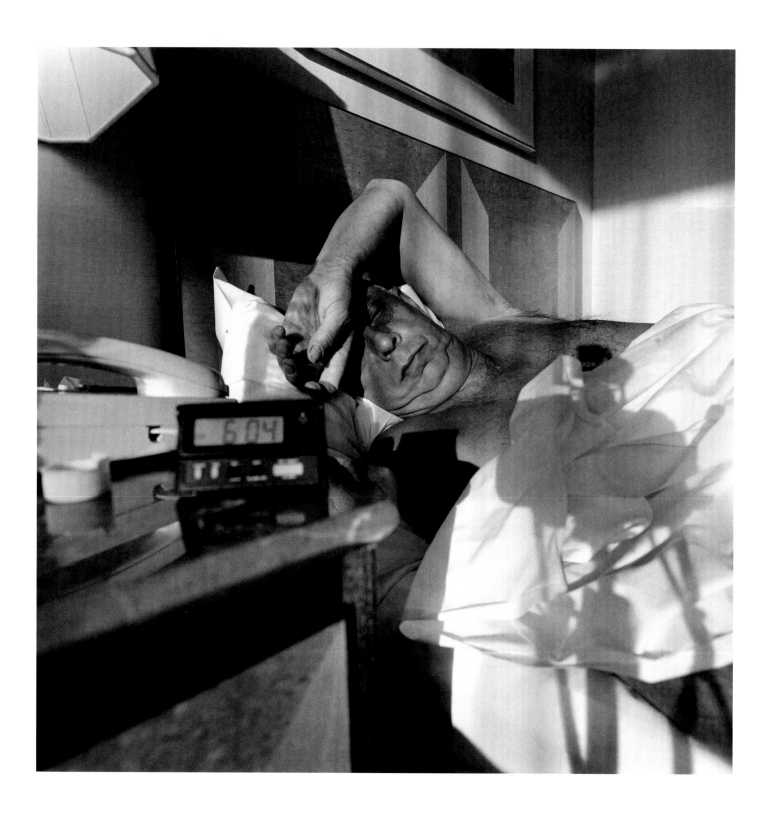

175
Lee Friedlander
Finland 1995, printed 2001

176
Robert Mapplethorpe
Donald Sutherland 1983

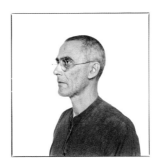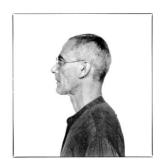
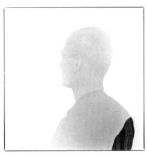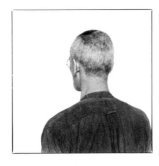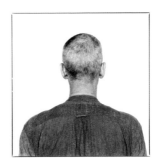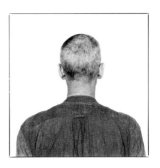
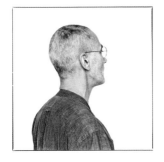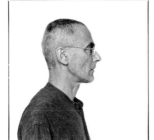

177
Pascal Grandmaison
Glass 6 2004–05

178
Arnaud Maggs
Self-portrait 1983

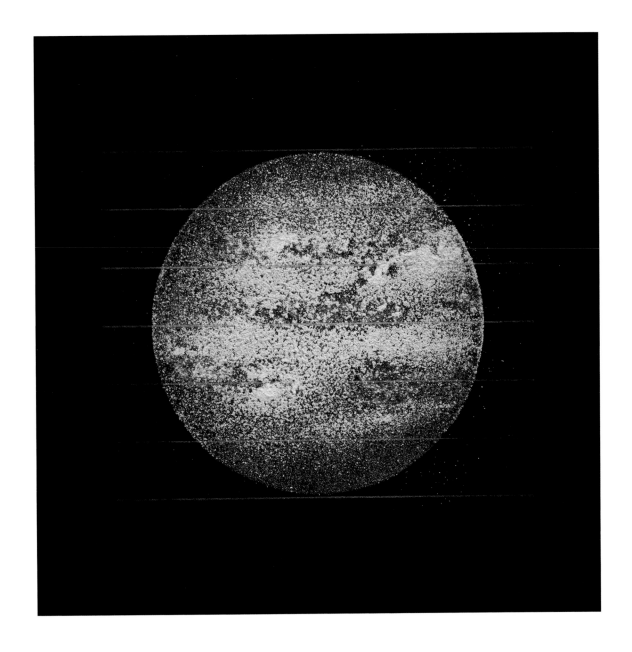

179
Spring Hurlbut
A Fine Line: Arnaud #4 2016

Creating New Narratives

Three departments acquire photographs at the National Gallery of Canada – the Canadian Photography Institute (CPI), Contemporary Art and Indigenous Art. The CPI at the National Gallery of Canada is, however, the only collecting area devoted exclusively to medium.[1] It covers the history of photography from its beginnings to today representing its changing aesthetic, vocabularies and cultural significance.

The relationship between photography and art has a rich and complex history. The blurring of medium boundaries that we see in contemporary art is arguably more extreme today than in the past. As a relative newcomer to visual expression, the medium of photography has played an ambiguous role in the history of art-making from its inception in the late 1830s until the mid twentieth century. It evolved from serving artists as a mnemonic tool, as a means to documenting paintings and sculptures and as a drawing tool[2] to become a medium of choice for artists.

Many of the pictorial strategies such as staging, combination printing, collage, montage, sequencing and the incorporation of found photographic elements used by contemporary artists and photographers today have their origins in the past. But as these techniques and enabling technologies have evolved so contemporary picture makers have redefined the terms by which we see, decode and represent our world to a point where the links with past technical and conceptual practices are often barely recognizable.

Zhang Huan's *To Raise the Water Level of a Fish Pond (Close up)* (pl. 189) for instance, is one in a sequence of three staged photographs made as part of a performance piece, a practice far removed from earlier staged photography.

Today's staged photographic images are influenced by the characteristics and values of feature filmmaking with elaborate scenography and implied narratives recorded with sophisticated lighting. Photography, as practised by Stan Douglas and Jeff Wall (fig. 35) is epic in both production and physical scale. If traditional staged pictorialist photography of the late nineteenth century can be described as being on the scale and formats of books, this new narrative photography transforms the genre into the cinematographic and "big screen." The ambitions of the contemporary staged photograph heralded the era of "big picture" photography.

Likewise, the labour-intensive and often complex techniques of nineteenth-century combination printing, collage and montage practices[3] have all but been rendered obsolete by the availability of sophisticated photographic digital editing software. This software has permitted more seamless combining or eliminating of compositional elements such as in Herwig Kempinger or Robin Collyer's works (see pls. 48, 49) Realized today by more sophisticated technical means such as Photoshop and in larger-scale works they are in general more complex in meaning if not in technical execution than before. This technology was not an option at the time David Wojnarowicz laid down multiple images on a single sheet in *Silence through Economics* (pl. 180) giving the collage a tactility and raw urgency.

With the ascendency of Conceptual art, Pop Art, Minimal Art, and Post Modernism over the fifty-year growth of this collection we have seen not only the techniques, the vocabulary and syntax of photography change but also the introduction of new narratives.

What photographers and artists want to say about the world today is varied and complex. Like contemporary art itself there is no "avant-garde" in photography as it existed in the early decades of the twentieth century but a slow re-evaluation of the limits of the medium and the genres associated with it.

In the work of Lynne Cohen (pl. 181) the influences were not strictly photographic but rather inspired by the art practices of the 1960s such as Guillame Bijl's ready-made installations and Richard Artschwager's sculptural incorporation of popular industrial materials. As mentioned earlier, Walker Evans was Cohen's introduction to photography and one of the avenues that allowed her to create art that addressed many levels of human experience in the contemporary world. At the time that Cohen was developing her thoughts about her art-making, the idea of what constituted a documentary photograph was being significantly transformed by landmark exhibitions such as *Toward a Social Landscape* (1966), *New Documents* (1967) and *New Topographics* (1975).

Both *Toward a Social Landscape* and *New Documents* questioned the association of realism with photographic picture-making and advocated against literal readings of photographs. John Szarkowski saw Lee Friedlander, Garry Winogrand and Diane Arbus as embracing the banal world "in spite of its terrors, as the source of all wonder and fascination and value – no less precious for being irrational."[4]

In this climate of expanded opportunity for photographers to explore the everyday, contemporary vernacular, and in fact almost any subject, the *New Topographics* exhibition offered keenly seen and immaculately made small black-and-white gelatin silver prints, the subjects of which appeared deceptively empty. Extremely important to Mark Ruwedel's practice was the approach of photographers Lewis Baltz, Joe Deal, Robert Adams, Henry Wessel, Jr., Frank Gohlke, Robert Adams and others. Their work made it clear that "the landscape was a suitable place for social inquisition" and it marked one of "... the first instances of the kind of art photography that generated interest in the larger contemporary art world."[5] The single graphic image was only one way of presenting photographs. Typologies of photographic images arranged in grids, sequencing, as well as the citation of other photographs – sometimes iconic and sometimes archival – were part of the new syntax for the creation of new narratives.

An awareness of the photographic artefact as historical evidence has also formed a stream of contemporary photographic practice. We see this in the work of such artists as Hans Haacke in *Voici Alcan*, in which stock photographs form a component. Sammy Baloji's *Essay on Urban Planning*

Fig. 35
Jeff Wall, *The Destroyed Room*,
1978, printed 1987, Cibachrome
transparency in fluorescent
lightbox, 179 × 249 × 20.6 cm;
image: 158.8 × 229 cm

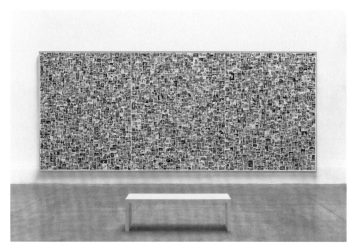

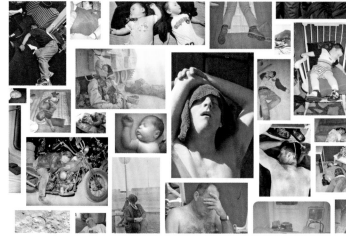

(pl. 184) reflecting on the still visible traces of colonial practices in his country, is intensified by the incorporation of a copy of a 1929 photograph depicting the bizarre and humiliating practice that required workers to capture and kill 50 flies per day in order to receive their rations. Indigenous Canadian artist Carl Beam used photo serigraphy in his powerful mixed-media works to address colonialism and the history of his people.

Artists like Steven Shearer and Geoffrey Farmer (figs. 36, 37) cull photographic images from the internet and popular illustrated press to create epic narratives about human culture and conditions. This is in contrast to Isabelle Hayeur's *Mississippi 2* (pl. 186) taken with an underwater camera, Benoit Aquin's *The Motorcycle Inner Mongolia, China* (pl. 190) and Kay Hassan's *Untitled* (pl. 188) all of which share Shearer and Farmer's cultural and environmental relevance but do so through authored single images.

We have also witnessed a reconsideration – one might even say a re-reconsideration – of the medium as it has evolved from analogue to digital. Michel Campeau (pl. 191), Robert Burley (pl. 193), and Alison Rossiter (pl. 45) reflect the phasing out as well as the continuing life of old technologies as they yield to the introduction of the new.

Just as renderings of artists' studios in other media have captured our imaginations, so have images of photographers' darkrooms over many decades. They offer the opportunity to see just where the decisions, the successes, the failures, and ultimately the magic happened. Michel Campeau's series *The Demise of the Darkroom*, marks the dying days of the places – including North Africa, Japan, Cuba and North America – where photographers processed their film and

made their prints. Campeau is aware of the personal motivation lying at the heart of this mission, noting that "Both an actor in and a witness of this pivotal period in the history of art and photography, caught between analogue and digital processes, I wished to record the iconic nature of these post-industrial ruins and the remains strewn among them."[6]

Robert Burley also turned his lens on this transformative development in photography and by chronicling the dramatic and banal moments of the last days of a once thriving industry, he captured the landmark shift from film based processing to digital in his epic body of work, *Disappearance of Darkness: the End of the Analog Era. Implosions of Buildings 65 and 69, Kodak Park, Rochester* (pl. 193) documents an epic moment in the creation of the post-industrial ruins to which Campeau alludes.

Pictures and their representation in pictorial form is another photographic narrative of our time. Andrew Moore's *Restoration Studio* (pl. 183) depicting a group of easel paintings in the E. Repin St. Petersburg State Academic Institute of Painting, Architecture and Sculpture, considered one the finest art colleges. The paintings we see are copies of famous works in the Hermitage collection representing a wide range of periods and styles made by student conservators. Moore was inspired to photograph this assemblage of paintings partly because of the "the overwrought expanse of historical styles," its revelation of the banality of the behind-the-scenes of museums and "the story behind the image that hints at the blurred line between the original and the copy, authenticity and forgery, inspiration and craft."[7]

Explored with wit and elegance Angela Grauerholz also looks behind-the-scenes of the museum, responding to the

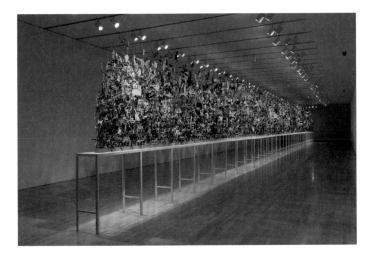

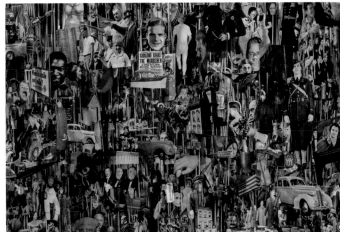

element of anticipation in *Viewing Room* (pl. 182), with its blank cardboard sheets laid out on the viewing rail of the National Gallery's Print Study Room. Grauerholz proposes that her photograph is not about subject matter so much as it is a screen for viewers to "project ideas, emotions and expectations."

Arguably, the diverse and deep range of new narratives created by contemporary photographers and artists through their use of photography – a subject far greater than the confines of this short introduction allows – surpasses that of any time in the past. Whether this is true or not is less important than the wealth of insight, the introduction to uncommon experience and sharing of world views that they make available to us.

Notes

1 Today, artists do not necessarily commit to working in or define themselves as being limited to one medium, be it sculpture, painting or installation. Logically, to properly represent the spectrum of contemporary art practice, photo-based works would also be included in contemporary art collections. Indigenous art focuses on representing works by Indigenous artists in all media including photographers who often address issues of cultural identity and marginalization such as we see in the work of KC Adams and Jeff Thomas.

2 It was not uncommon for artists to project a photographic image onto a sensitized canvas, effectively using it as an outline, and paint over it.

3 Oscar G. Rejlander's *Two Ways of Life*, involving the composing of more than thirty negatives in a theatrical morality tale of the struggle between good and evil attests to the complex and labour-intensive technique of this particular nineteenth-century practice.

4 These photographers "redirected the technique and aesthetic of documentary photography to more personal ends. Their aim has been not to reform life but to know it." John Szarkowski, Director, Department of Photography, Museum of Modern Art, in press release for *New Documents* exhibition 28 February – 7 May 1967, Museum of Modern Art, New York City. Online at: www.moma.org/momaorg/shared/pdfs/docs/press_archives/3860/releases/MOMA_1967_Jan-June_0034_21.pdf [accessed 19 December 2017].

5 Artist's biography, Mark Ruwedel, online at: www.gallery.ca/collection/artist/mark-ruwedel [accessed 19 December 2017].

6 "Michael Campeau captures demise of the dark room," *Phaidon*, online at: ca.phaidon.com/agenda/photography/articles/2013/november/25/michel-campeau-captures-demise-of-the-dark-room/ [accessed 15 January 2018].

7 Email correspondence, Andrew Moore to author, 19 January 2018.

Fig. 36a
Steven Shearer, *Sleep II* (installation view), 2015, inkjet print on canvas, 286 × 691 cm

Fig. 36b
Steven Shearer, *Sleep II* (detail), 2015

Fig. 37a
Geoffrey Farmer, *Leaves of Grass* (installation view), 2012, cut-out images from *LIFE* magazines, archival glue, miscanthus grass, floral foam and wooden table, installation dimensions variable

Fig. 37b
Geoffrey Farmer, *Leaves of Grass* (detail), 2012

180
David Wojnarowicz
Silence through Economics
c. 1980−88, printed 1988−89

181
Lynne Cohen
Untitled (easel) 2007

182
Angela Grauerholz
Viewing Room 2016

183
Andrew Moore
Restoration Studio 2002

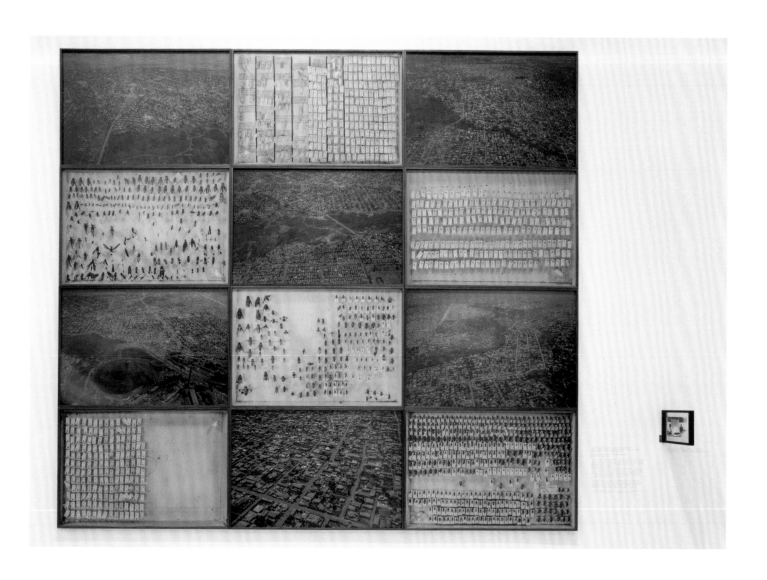

184
Sammy Baloji
Essay on Urban Planning from
1910 to the Present Day City of
Lubumbashi 2013

185
Leonce Raphael Agbodjélou
Untitled 2012

186
Isabelle Hayeur
Mississippi 2 2013

187
Mark Ruwedel
Wonder Valley Survey 2013–14

188
Kay Hassan
Untitled 2008

189
Zhang Huan
To Raise the Water Level in a Fish
Pond (Close Up) 1997

190
Benoit Aquin
The Motorcycle, Inner Mongolia,
China 2006

191
Michel Campeau
Untitled 6778 (Niamey, Niger)
2005–10

192
Jakub Dolejs
Escape to West Germany, 1972
2002

193
Robert Burley
Implosions of Buildings 65 and 69,
Kodak Park, Rochester, New York
6 October 2007, printed 2013

Processes and Formats John McElhone

I have often said that the negative is similar to a musician's score, and the print to the performance of that score. The negative comes to life only when 'performed' as a print.

Ansel Adams, *The Print*, 1983

Introduction

At the very first appearance of practical photography in 1839, the world was presented with two competing processes, both of which could be used to capture and keep an image on a material support: Louis Daguerre's daguerreotype and William Henry Fox Talbot's photogenic drawing. These two processes were radically different from one another, having completely different support material, process manipulation, image quality and physical presence. They found distinct audiences. And things just got more complicated from there. The 180-year-long history of photography has been marked by technical developments, large and small, that continually modified and diversified the idea of what a "normal" photograph looked like. These developments were driven by photographers themselves in the early days, and later by ever-larger commercial interests and industrial research. The most revolutionary of these changes – moving from the photochemical silverhalide image to the electronically mediated digital image – is currently happening around us.

As media for making photographic prints evolved – from plain paper to albumen- and gelatin-coated papers, from monochrome to full colour, from small formats to larger ones – photographers have made their choices based on both practical and aesthetic concerns. Sometimes photographers have resurrected outmoded printing technologies to find media that meet their aesthetic and technical ambitions, as with the "salted paper revival" of the 1880s, or the "alternative processes movement" of the 1960s. In the age of the cell-phone image, daguerreotypy, salted paper and platinum printing are all lively techniques currently being practiced.

Since collecting of photographs began at the National Gallery of Canada, the rich technical evolution in photographic printing has been represented in the collection as a natural consequence of the mandate to illustrate the breadth of the history of photography as an image-making process. The first acquisitions included salted paper prints from the 1840s, platinum prints from the 1890s and toned gelatin silver prints made a year before their purchase.

The following entries, presented more or less chronologically, aim to give a brief summary of the historical context and technical basis for each of the major categories of print medium and format represented in the collection, along with a few of the more exotic outliers. Most importantly, the entries describe the variety of visual qualities achievable with different media and point to how the expression of an artist's vision and intent is facilitated by his or her choice of medium.

Salted Paper Print 1834 – c. 1860

When William Henry Fox Talbot began, in 1834, to use paper impregnated with silver chloride to make (camera-less) photograms and small paper negatives in a camera obscura, he referred to them as photogenic drawings. By 1841, when he was using an improved version of the process to make multiple positives from his chemically developed calotype negatives, they were commonly referred to as salt prints or plain paper prints; in our current usage they are called salted paper prints.

The salt in question is common table salt – sodium chloride – a solution of which was soaked into a sheet of paper as a first preparatory step; when this "salted" paper had dried it was coated with a solution of silver nitrate that deposited flakes of insoluble silver chloride into the tiny crevices between the paper fibres. The light-sensitive silver chloride would darken when exposed to sunlight, whether through a camera lens or in contact with a paper negative or a translucent object pressed over it (see pls. 100, 101) for an example of this kind of photogram). Talbot spoke of the wonder of finding a permanent impression of the natural world when he removed the sheet from the camera or from the printing frame.

Scottish photographer Robert Adamson and his partner, the painter David Octavius Hill, used their version of the salted paper process to print the calotype negative portrait of Elizabeth Rigby (fig. 38a), later Lady Eastlake, one of the earliest critical essayists writing on photography. The photomicrograph of a highlight/shadow area of the print (fig. 38b) shows how the silver image particles are deeply embedded between the fibres of the paper support.

Some saw the soft rendition of the salted paper process as a clear advantage, allowing an artistic, mezzotint-like atmosphere to be conveyed. Others saw this same characteristic as an inherent flaw – the prints lacking the clarity and resolution of the daguerreotype and, later, the albumen print. By 1860, the process had been largely superseded by albumen.

Photography on paper was plagued by unpredictable deterioration in its early years. The first photogenic drawings were only "stabilized" in salt baths rather than being fully fixed in thiosulphate (or "hypo"). This left them subject to gradual darkening if exposed to light. Later processing procedures left residual sulphur compounds in the paper, which gradually discoloured and then faded the silver images. And salted paper prints, unlike albumen or gelatin prints, have no substantial protein binder enveloping the silver particles and are thus subject to accelerated fading by exposure to pollutants in the air. Many salt prints were seriously damaged by these deterioration mechanisms, often within a few years of their production. But those that have come down to us in good condition show evidence of both inherent stability and careful custodianship. They can be expected to remain as they are long into the future if stored and displayed wisely.

The Canadian Photography Institute (CPI) holds close to 1000 salt prints. The earliest Talbot material dates from 1839. A group of forty-nine exceptional Talbot prints are in the *Bath Photographic Society Album*, assembled in 1899 by Talbot's son Charles and acquired by the Gallery in 1975. In addition to Talbot and Hill and Adamson, the strength of the collection extends to key figures in early paper photography in Britain and France, including substantial representation of prints made by Roger Fenton, Maxime Du Camp, Charles Marville, Pierre Trémaux, Charles Nègre, Auguste Salzmann and J.B. Greene.

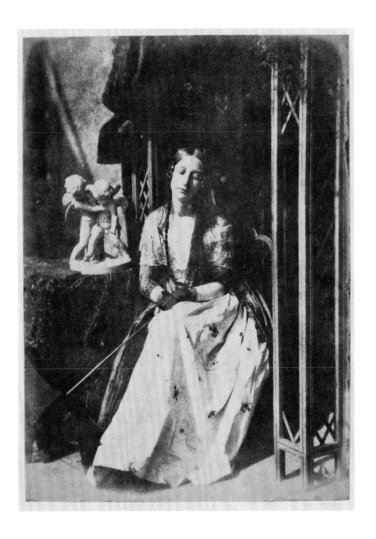

Fig. 38a
Robert Adamson and David
Octavius Hill, *Elizabeth Rigby
(Lady Eastlake)*, 1849, salted
paper print, 19.5 × 14.0 cm

Fig. 38b
Photomicrograph detail showing
the silver image embedded in the
fibres of the support paper.

Stereograph 1838 – present

In 1838 physicist Charles Wheatstone described the principle of stereopsis – the perception of depth and three-dimensionality through binocular vision – and demonstrated the phenomenon by constructing a mirror stereoscope equipped with pairs of stereo drawings ... photography being, as yet, confined to the workshops of William Fox Henry Talbot and Louis Daguerre.

But as soon as it was announced, photography was enlisted in the production of stereographs (or stereograms), made with dual-lens stereoscopic cameras and designed to be viewed in a stereoscope (of which there were various types). The procedure, regardless of the medium of the stereograph or the design of the stereoscope, is to make two separate and simultaneous images of a scene from points of view that are horizontally displaced from one another by a small distance – in fact, a distance similar to that between a pair of human eyes. The resulting prints are mounted and placed in a viewer constructed so that each eye is restricted to seeing only one or the other print, mimicking the process of binocular vision, where each eye sees only the view from its unique lateral position. The brain processes these subtly different stimuli to produce a visual sensation in which spatial depth is perceived.

Stereoscopy was, along with photography, a wonder of the nineteenth century. In an era in which few visual diversions were available, examining stereo views became a source of domestic entertainment and edification. Many middle-class parlours were equipped with sets of stereo cards and viewers (figs. 39a–b). Subject matter emphasized picturesque or exotic landscapes and architecture along with image sequences that illustrated genre narratives, often comic, sometimes gently risqué. These provided hours of diversion for those with leisure time to fill. The "views" were purchased from specialized stereograph publishers including the Canada View Company, James Esson (Canada), B.W. Kilburn and Co. (USA), the London Stereoscopic Co. (Britain), J.G. Parks (Canada), Strohmeyer & Wyman (USA) and Underwood & Underwood (USA), and are all well represented in the collections of the Canadian Photography nstitute (CPI). The most common stereograph format is a $3\frac{1}{2} \times 7$-inch card, often with a concave form intended to reduce distracting reflections.

The CPI holds close to 3000 stereo images, more than half of which came with the Origins of Photography Collection gift in 2015. The majority are stereo cards with pairs of mounted albumen prints. Other media include stereo-daguerreotypes, salt prints, collodion and gelatin glass transparencies, collodion and gelatin prints, autochromes and photolithographs.

Fig. 39a
C.R. Chisholm & Bros., *Falls of Montmorency, Quebec*, c. 1865–70, stereograph card with two albumen silver prints, 8.6 × 17.6 cm (1:1 reproduction)

Fig. 39b
Stereoscope with stereograph inserted for viewing.

Daguerreotype 1839 – c. 1860

The daguerreotype was the first commercialized photographic process. With few exceptions, the first time that people ever saw a permanent image made from nature using a mechanical-optical device, they were looking at a daguerreotype. The wonder of the age in the 1840s, daguerreotypes remained the predominant photographic medium for more than a decade. They created, almost overnight, the new profession of "photographer," along with manufacturing ventures dedicated to making the silvered copper plates on which the image is produced; the equipment used to prepare the plates for exposure; the highly engineered camera boxes and lenses in which the plates were exposed; and the decorated cases that protected the plates after processing. These were the first appearances of what would become huge imaging industries.

As it happens, the final product of all this industry and activity – the daguerreotype – proved to be one of the more refined and powerful imaging processes ever devised. The image resolution – a measure of how close image features can be to one another and still be visibly distinct and separable from one another – of a daguerreotype turns out to be hugely superior to that of any of the photographic processes that would be developed over the next century and a half. Scientists recording the transit of Venus in the 1870s – more than a decade after the daguerreotype became obsolescent – used daguerreotype plates because of their superior accuracy and precision. The photomicrograph shown here of a tiny portion of the illustrated portrait (figs. 40a–b) gives an indication of the fineness of the daguerreotype image. Also evident in this example is the practice of hand-colouring parts of the image with coloured powders.

This resolving power is based on the daguerreotype image particle, a mercury-silver-gold amalgam structure located on the polished silver surface of the daguerreotype plate in numbers proportional to the lightness or brightness of the image at that point. The particles, which tend to diffuse the light reflected off the plate, measure in the range of hundreds of nanometres in diameter. Where few of the particles occur on the polished silver plate, reflection is direct and not diffuse. When the plate is positioned to reflect a black surface, an image of startling clarity and spectacularly fine detail is revealed.

But daguerreotypes had their difficulties; they only produced one copy – the same plate that was placed in the camera for exposure; they were generally small – the largest "full" plate measured only $8^1/2 \times 6^1/2$ inches (21.6 × 16.5 cm) and most daguerreotypes were fractions of this size; they were fragile, subject to being easily scratched and tarnished; and they were very difficult to make. By 1860, the more versatile combination of the wet collodion on glass negative and the albumen silver print had overtaken the daguerreotype in popularity with photographers and consumers.

The Canadian Photography Institute holds more than 2700 daguerreotypes. Prior to 1988 the collection included just over 100 plates. This group was supplemented by Phyllis Lambert's generous gift of 129 plates to celebrate the opening of the new NGC building in 1988. The gift of the Origins of Photography Collection in 2015 added nearly 2500 daguerreotypes to the collection. These include some of the masterpieces of American daguerreotype practice, such as portraits by the Boston photographers Albert S. Southworth and Josiah J. Hawes (see pls. 20 and 150).

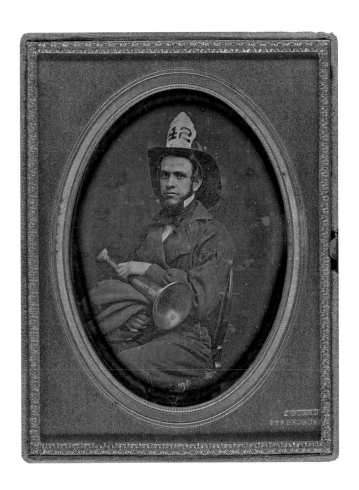

Fig. 40a
Jeremiah Gurney, *Fireman, New York City*, c. 1853, daguerreotype with applied colour, 10.2 × 8.0 cm (quarter plate) (1:1 reproduction)

Fig. 40b
Photomicrograph detail showing the daguerreotype image particles densely packed in the highlights and sparsely distributed in the darker areas.

Paper Negative 1840 – c. 1860

William Henry Fox Talbot had realized well before 1840 that his photogenic drawings could be reversed – both in their lateral orientation and their tonalities – by making a second-generation print in contact with the first in a printing frame. This printing step could be repeated several times to make multiple positive copies. But it was only in 1840 that he began to work in earnest on a paper process specifically geared to making camera negatives to be used for producing positive prints. The end result of this work was the calotype process in which a relatively brief exposure in the camera – producing no visible change in the sensitized paper – was amplified and made visible by a subsequent chemical development in gallic acid. Talbot patented this new process in 1841.

Improvements to the calotype process were hampered, at first, by the restrictive terms of the patent; there were few licensees in England and France and virtually none in North America. But in Scotland John and Robert Adamson fine-tuned the process for making portraits. In France Louis-Désiré Blanquart-Évrard published a simplified version of the process in 1847, essentially breaking the Talbot patent. Gustave Le Gray published his waxed paper negative variant in 1851, which produced paper negatives with improved resolution and allowed sensitized materials to be prepared several days in advance of exposure, essential for travel photography as it was about to be practiced in France and elsewhere by French photographers. Many other improvements were published in the years following.

The Baldus negative illustrated here (fig. 41a) has certainly been coated with wax, which has now yellowed to a degree. The precise delineation of the sculptures in this gallery of the Louvre suggests that it was made using Le Gray's recently published "dry" or waxed paper negative process in which the paper was waxed prior to salting and sensitization. Prior to this, it had been the practice to apply molten wax only after the negative had been fully processed, to improve its translucency in the printing step (fig. 41b).

The Canadian Photography Institute holds some forty paper negatives, all made before 1860. These include a group of very large sheets produced by Robert and Harriet Tytler in India in the late 1850s, the most impressive of which is illustrated in (pl. 58).

Fig. 41a
Édouard Baldus, *Interior of the Louvre*, 1852, waxed paper negative [by transmitted light], 26.2 × 19.7 cm

Fig. 41b
Édouard Baldus, *Interior of the Louvre*, 1852, salted paper print from a waxed paper negative, 25.6 × 19.0 cm

Cyanotype 1842 – present

Inspired to explore other light-sensitive chemical systems by his friend William Henry Fox Talbot's photographic discoveries, the scientist John Herschel described a photographic system in 1842 that used the light sensitivity of iron salts to produce a blue-coloured print image in which the image forming material is the pigment Prussian blue. He named this the cyanotype, although it is occasionally referred to as the ferro-prussiate process or, simply, the blueprint.

The most famous practitioner of the process was the English botanist Anna Atkins, a family friend of Herschel. Atkins set out in 1843 to make a scientifically informed visual survey of the various species of algae drawn from her specimen collection. The result was the self-published *Photographs of British Algae: Cyanotype Impressions* (1843–1853), widely considered to be the first photographically illustrated publication.

The process was simple: it required only a few readily available and innocuous ingredients, the image source material could be something as readily available as a dried flower, and it could be carried out without the need of a darkroom since the sensitized paper is not highly light-sensitive. All these factors made cyanotype prints a perennially popular choice for making photograms throughout the nineteenth and early twentieth centuries. As evidenced by the examples shown here (figs. 42, 43a–b), they could also be readily made through contact printing using negatives. The process found its most intensive application in the first half of the twentieth century as a means of making copies ("blueprints") of technical drawings. And it found new popularity in the 1960s with the "alternative process" movement where it was used by artists, photography students and also by generations of children whose introduction to the magic of light-sensitive imaging materials comes with the making of a cyanotype photogram.

The Canadian Photography Institute holds about seventy cyanotypes, including a single fern image made by Anna Atkins (pl. 26); after the "British Algae" project, Atkins collaborated with her friend Anne Dixon on several other botanical documentation projects, notably recording fern fronds. But most of the cyanotypes in the collection were made in the 1970s, produced by that generation of "alternative process" photographers. In that era, cyanotype printing was often combined with other photographic and non-photographic media to bring a range of colours to monochrome photography.

Fig. 42
Stephen Livick, *Untitled*, 1974,
cyanotype with applied colour,
image: 41.7 × 34.2 cm; sheet:
60.7 × 50.5 cm

255

Fig. 43a
Photomicrograph detail showing
the Prussian blue image embedded
in the fibres of the support paper.

Fig. 43b
Edward S. Curtis, *Piegan*,
c. 1900–13, cyanotype,
20.1 × 15.4 cm (1:1 reproduction)

The possibility of producing multiple copies of groups of images and of illustrating texts with photographs was evident soon after Talbot outlined his negative-positive system for printing positives. Indeed, Talbot himself was responsible for the first commercially published book illustrated with photographs – *The Pencil of Nature*, 1844–1846. One year before that the botanist Anna Atkins privately circulated the very first book illustrated with photographs – *Photographs of British Algae: Cyanotype Impressions*, 1843. In France through the 1850s, commercial printing establishments were created to serve the needs of the ambitious photographic publishing projects supported by both the state and by wealthy patrons; the best known names of French photographic printing houses are Blanquart-Évrard in Lille and Hubert de Fonteny and Lemercier in Paris. Albums that combined texts with original photographs mounted in a book structure became useful for science, engineering and industry. In the early years of the twentieth century the influential art photography periodical *Camera Work*, published by Alfred Stieglitz, was richly illustrated with tipped-in photogravures – the CPI holds a full run of all fifty-three issues. Personal photograph albums – assembled by individuals to document families, travels, picturesque scenery, etc. – became common, especially following the success of the Eastman Kodak company in bringing amateur photography to a wide group of consumers (see fig. 57, p. 285).

As offset lithographic printing of both black-and-white and colour photographs evolved through the twentieth century, it was no longer necessary to individually make all the prints required to illustrate each copy of a publication. Photographers such as Brassaï, Weegee and Robert Frank pioneered the monographic photo-book using lithographically reproduced images. *LIFE Magazine* provided a high profile venue for the photo-essay form.

The album illustrated here (fig. 44) was published by the Photographic Society Club. The Club's members were a select group drawn from the membership of the Photographic Society of London. These wealthier and socially homogeneous men would take part in social occasions and photographic expeditions and collaborated, twice, to produce a "Photographic Album" for the year. The original *Photographic Album for the Year 1855* contained forty-four plates; each of the participating photographers supplied a sufficient number of finished prints of one of their own images to create a collated and bound assemblage of all of the images, copies of which were then distributed to the Club members, the photographers represented, and beyond. The original mounted prints were accompanied by texts chosen by the photographers as well as technical information about the making of the negatives.

The Canadian Photography Institute holds some 230 photographically illustrated books and albums of photographs, approximately three quarters of which date from the nineteenth century. The books published as a result of the great French photographic expeditions of the 1850s are well represented. The National Gallery of Canada Library and Archives holds many times this number of bound books, periodicals and albums that contain original photographs and photomechanically reproduced images.

Fig. 44
Various photographers, *The Photographic Album for the Year 1855* (published 1856), album, in green half-leather binding, leather corners and brown cloth, with gold-embossed title, containing 40 photographs and letterpress, 45.1 × 32.3 × 4.0 cm

Albumen Silver Print 1850 – c. 1900

Although some artist-practitioners valued this very characteristic, most photographers were dissatisfied with the poor resolution inherent in salted paper prints. Even when printed from the precise image of the wet collodion on glass negative, which became widely known in 1851, the salt print lacked the crispness and contrast that was admired in the best daguerreotypes. This stemmed from the fact that the silver image particles were diffused through the top layers of paper fibres, rather than being concentrated together in a thin layer on the top surface, as was the case for the daguerreotype and the waxed paper process negative. Louis-Désiré Blanquart-Évrard found a solution in 1850 when he showed the first albumen silver prints to the French Academy of Sciences. Rather than soaking the paper in a chloride solution, Blanquart-Évrard introduced the salt into a quantity of diluted egg white, which was then coated onto the paper. Sensitization, printing-out exposure, fixation and washing followed, as with salt prints. The resulting silver image particles were contained in a microns-thick film of protein *on top* of the paper, rather than sinking *into* the paper. This spatial containment of the image particles, as well as the way the surrounding clear protein film saturated the image densities, produced a higher resolution image with a greater dynamic contrast range – darker darks and brighter lights.

Later, it was shown how the colour of the monochrome print image could be manipulated through an extra processing step that "toned" the image to a range of pleasing hues. Gustave Le Gray was again a critical innovator in developing the possibilities of this new printing medium. In the four versions of his treatise on photography that were published between 1850 and 1854, he provided photographers with detailed instructions on how to control the final appearance of their paper prints.

As it happened, the photographic characteristics of albumen paper were perfectly suited to reproducing tonal subtleties of the wet collodion on glass negative; the two materials constituted a well synchronized photographic system that had robust advantages over alternative systems for many years. An infrastructure was created to make albumen paper and enterprises dedicated to printing multiple copies of photographs arose; these became significant economic drivers that employed thousands, and set the stage for later industrial developments. Millions of albumen prints were made during the last half of the nineteenth century.

Two Canadian photographs, one small and one large, are illustrated here. The first (fig. 45a) is a carte-de-visite format portrait of John A. Macdonald, Canada's first prime minister and one of the principle actors in the unification of the British North American colonies into the confederated Dominion of Canada in 1867. Representing an important and well-known public figure of the 1860s, this small portrait print would be produced by the hundreds and sold by photographers and stationers to Canadians who admired this famous and controversial politician. The second (fig. 46b) is a large print (approximately 16½ × 21 inches) made from a huge glass plate negative – probably one of the recently available gelatin dry plates that had made out-of-doors photography a somewhat easier task than in the wet collodion plate era. William McFarlane Notman, son of the founder of the Notman studio, produced a series monumental views of scenery in the Canadian west for the Canadian Pacific Railway; these spectacular scenes were intended to increase traffic on the CPR's newly finished railway line to the west coast. Note that both images, despite their size difference, show similar print resolution since they are both contact prints rather than optical enlargements.

The Canadian Photography Institute holds approximately 11,000 albumen prints in its collections. This reflects the early focus of founding curator James Borcoman in acquiring deep representation of the work of important nineteenth-century French and British photographers, including, Charles Marville, Charles Nègre, Félix Bonfils, Samuel Bourne, Francis Bedford, Francis Frith, and the Skeen studio.

Fig. 45a
George William Ellisson, *Hon. John A. Macdonald (1815–1891)*, 1860?, albumen silver carte-de-visite, image: 9.3 × 5.5 cm;

mount: 10.1 × 6.1 cm
(1:1 reproduction)

Fig. 45b
Photomicrograph detail showing the silver image contained in the clear albumen image carrying layer over the paper fibres of the support.

Fig. 46a
Photomicrograph detail; here the fibres of the paper support are more evident under the albumen image carrying layer.

Fig. 46b
William McFarlane Notman, *Bow Valley, from Upper Hot Springs, Banff*, 1887, albumen silver print, image: 41.9 × 52.6 cm; mount: 50.6 × 60.7 cm

Lantern slide 1850 – c. 1950

The "magic lantern" was an early projector that used an image on glass, a lens and a bright light source to project a luminous and greatly enlarged version of the image on a wall. Drawings and paintings on glass were used as source images from the time of its invention in the late seventeenth century; throughout the eighteenth and early nineteenth centuries the magic lantern show was a popular entertainment as well as being an educational and scientific tool. Photography, when it arrived, was a natural source for the images projected from the magic lantern.

As glass became the standard support for camera materials, starting with the albumen on glass process and followed by the wet collodion negative and, eventually, the gelatin dry plate, it was an easy step to the production of positives on glass that could be projected in the magic lantern. These lantern slides gradually became standardized as a 3½ × 3½-inch sandwich of two sheets of thin glass – one carrying the image and a second cover glass – sealed together with paper tape. The image was typically somewhat smaller than the glass support and might be delimited by a paper aperture mat inserted between the two glass plates. A label with an image description and the name of the publisher would often be adhered to the outside of this package.

When one of these fine-grained, high resolution images was projected on a light-coloured wall in a darkened room through a good quality objective and using a powerful light source, the resulting picture was luminous, detailed and large. If the imagery were suitably exotic, or humorous, or edifying or astonishing, the audience felt satisfied at having had a visual experience that was truly out of the ordinary. In the example shown here by Frederick H. Evans (figs. 47a–b), the tonal modulations and dynamic contrast range of the gelatin silver positive on glass exceeds anything that could be achieved by photographic or lithographic printing at the time.

Monochrome photographs on glass were succeeded by colour transparencies on glass and, eventually, by colour and black-and-white slides on film for projection. The availability, starting in the 1970s, of large-format photographic transparency materials, such as Cibachrome and Duratrans films displayed as backlit images in lightboxes, gave artists a completely new way to achieve the kind of immersive and luminous imagery that had previously only been possible using projectors.

The Canadian Photography Institute holds approximately 100 lantern slides, including a group of 75 F.H. Evans images of the interior of Westminster Abbey. The Gallery holds about a dozen 35 mm colour slide installations and about twenty large-format lightbox works.

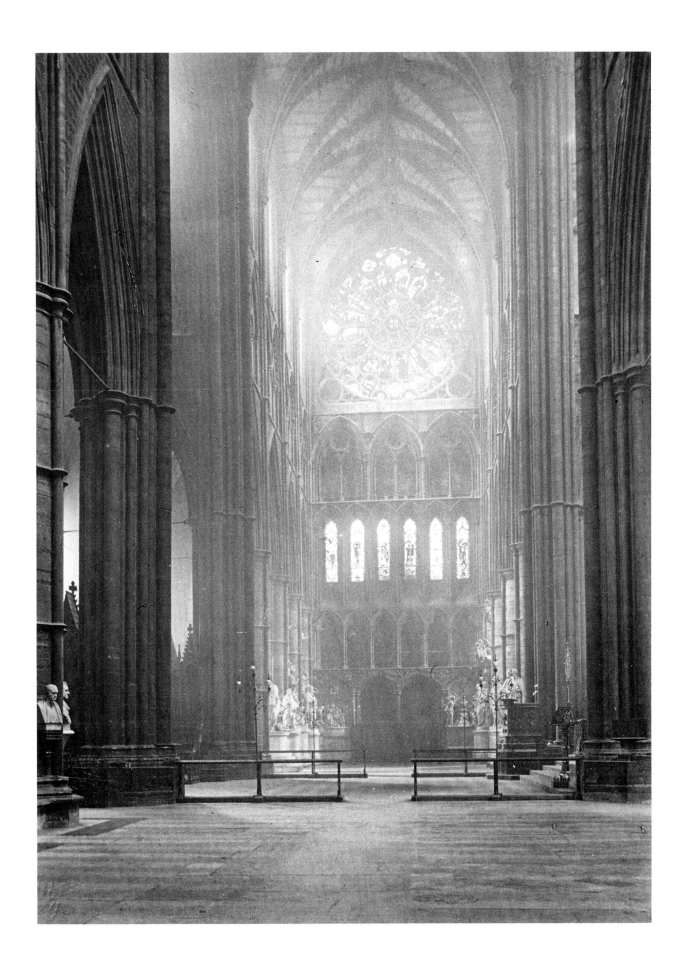

Fig. 47a
Frederick H. Evans, *Westminster Abbey, Across the Transepts, South to North*, before 1902, gelatin silver lantern slide, 8.2 × 8.3 cm

Fig. 47b
Frederick H. Evans, *Westminster Abbey, Across the Transepts, South to North*, before 1902, image from the lantern slide.

Ambrotype and Tintype 1852 – c. 1930

Both the ambrotype and the tintype are based on the wet collodion on glass negative process. To transform the negative collodion image into a positive, the silver image is chemically treated so that it has a creamy off-white colour, rather than soft black or grey as in a normal negative; the low density translucent areas of the image, where there are few or no silver image particles, show a dark-coloured backing placed behind the plate. In this way the tonal relationships of the "negative" are reversed: the areas where image silver occurs appear white, while the areas that received no light exposure – and subsequently have no developed silver particles – appear dark. Both ambrotype and tintype processes produce a unique positive directly from the camera, as with the daguerreotype – no printing step is involved. In both processes, the collodion-silver image layer is protected by a resin varnish coating or an adhesive that seals it to a secondary glass plate.

The first of these collodion variants appeared in the early 1850s in France and Britain. By 1854 the American J. Ambrose Cutting had patented a system for turning a collodion negative on glass into a unique positive and named it after himself – ambrotype. The glass plate with its black backing material is contained in a decorated protective case, similar to the daguerreotype case. The backing may be a layer of black or dark brown paint applied directly to the image plate or may be a dark fabric or paper sheet placed behind the plate. Alternatively, the collodion image could be made on a plate of dark red-coloured glass, called "ruby" glass. Ambrotype plates often copied the fractional plate sizes of the daguerreotype.

A second variant produced a collodion image on a small piece of black-lacquered sheet iron. This was called a tintype or melainotype, although the French term, *ferrotype*, is a more accurate description. They were described in France in 1853 and appeared in the United States three years later. The tintype process proved to be relatively easy and inexpensive – itinerant tintypists proliferated on city streets and even at the edge of American Civil War military encampments, where soldiers who faced imminent battle could have portraits of themselves made to send to their families through the post. They could be mounted in cases, as with ambrotypes, but more often were pasted into small paper mats with decorated apertures (fig. 48a). These hardy little metal plates (fig. 48b) with their varnished collodion images were easy to mail and would usually arrive at their destination undamaged. Tintypes were made in all sizes, from a "full" 8 × 10-inch plate to the tiny "gem" portrait format; the most common size was 2½ × 4 inches, called a "bon-ton." After the collodion era had passed, tintypes made with gelatin silver emulsions continued to be a favoured medium for commercial street photographers who could snap a casual portrait of a passerby and have it processed and finished and in the hands of a purchaser within a short time.

The unusual example illustrated here (figs. 49a–d) combines an ambrotype plate with six tintype vignettes that float above the image of the three women. As with the daguerreotype, tintype and ambrotype images may be heightened with applied pigments applied by hand, as seen here in the rosy cheeks of the women.

The Canadian Photography Institute holds more than 1000 tintypes, 800 of which were added to the collection through the Origins of Photography Collection gift in 2015. The ambrotype collection numbers over 750, of which some 700 came with the Origins of Photography Collection.

Fig. 48a
Unknown photographer, *Portrait of a woman in a flowered bonnet*, c. 1860, tintype, case, open: 7.5 × 12.4 cm (1:1 reproduction)

Fig. 48b
Unknown photographer, *Portrait of a woman in a flowered bonnet*, c. 1860, tintype plate, 2½ × 2 inches (sixteenth plate) (1:1 reproduction)

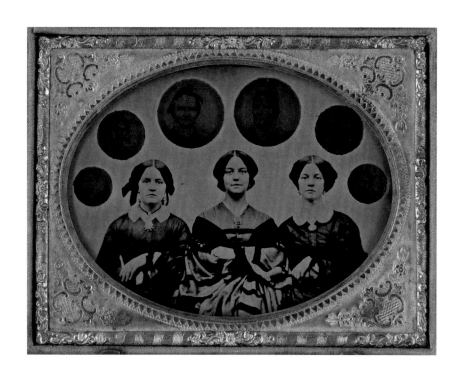

Fig. 49a
Unknown photographer, *Family Portraits*, c. 1857, collage of ambrotypes and tintypes, 8.7 × 11.2 cm (quarter plate) (1:1 reproduction)

Fig 49b
Ambrotype plate, in combined reflected and transmitted light

Fig. 49c
Glass interlayer plate with painted backing for ambrotype and apertures for tintypes, in combined reflected and transmitted light

Fig. 49d
Metal backing plate with adhered gem-format tintypes

Photogravure 1852 – present

Photogravure is not a true photographic process but, rather, falls under the category of photomechanical processes in which photograph images are rendered by printers' ink on paper. Such ink images are binary – the spot of ink is either present (dark) or absent (light) – so they cannot precisely reproduce the continuous tones – light to dark with a continuum of intermediate tones between – of a photographic image. But by breaking the image down into an array of spots of varying sizes and spacings, this approximation of a continuous tone image can convince the eye that all of the intermediate tones are present. When a detail of the image is magnified, the pattern of all-or-nothing spots becomes evident. This strategy results in what are called a "half-tone" images.

Photogravure is especially important in the story of photographic printing for its relation to illustrated book publication. Early on, photographic inventors had been looking for ways to represent photographs in multiple-copy publications – published books and periodicals – that required hundreds (or thousands, or millions) of copies of the same image. It was, in fact, Talbot who established the principles of photogravure with his "photoglyphic engraving" process of the 1850s, in which the light sensitivity of dichromated colloids to are used to create a non-silver photographic printing system. Édouard Baldus produced a huge corpus of photogravures made by his own process starting in 1866. In 1879 the Czech painter Karel Klíč described a practical photogravure process that combined Talbot's system with the carbon tissues that had recently been marketed in England for the carbon printing process (see "Carbon Print and Woodburytype," p. 272, for a short explanation of dichromated colloid systems).

What makes photogravure (fig. 50b) and the other photomechanical processes useful for printing large numbers of copies is that it results in an etched metal printing plate with an intaglio profile which can be inked-up with printers' ink and used to transfer an ink image onto paper; this can be repeated many times over to produce prints in the quantities required for publication. At first, such plates were flat copper plates etched using a procedure similar to aquatints or mezzotint plates. Later versions produced flexible plates that could be mounted in high-speed rotary printing presses. The image "grain," or spot morphology (fig. 50a), of the photogravure is almost identical to that of the aquatint and this can be used to identify this process using a 10× magnifying loupe. Like carbon prints, photogravures are quite stable in most display conditions or in storage, and especially so when the ink and paper constituents are protected from exposure to light and pollutants by being bound inside a book structure.

The Canadian Photography Institute holds more than 1600 photogravures; most of these are components of published books, periodicals, albums or portfolios. They range in their date of creation from the 1850s through the 1990s.

Fig. 50a
Photomicrograph detail showing
the characteristic photogravure
image grain.

Fig. 50b
Alvin Langdon Colburn, *Clarence
H. White (1871–1925)*, 1912, photo-
gravure, image: 20.1 × 15.5 cm;
sheet: 23.4 × 17.4 cm

Carbon Print and Woodburytype 1855 – c. 1950

Early silver prints garnered a reputation – partly deserved – for fading and discolouring soon after their production. Photographers were acutely conscious of the need to find permanent printing media that would remain stable on display or when mounted in a book. There was even a prize competition funded by Honoré d'Albert, duc de Luynes, aimed at finding, on the one hand, a stable photographic printing process and, separately, a way to successfully make photolithographs. In 1862 Alphonse Poitevin was awarded the portion of the prize relating to photographic printing for his 1855 carbon process, named for the carbon-based earth pigments that provide the image colourants.

Both carbon and woodburytype are examples of the pigment processes, so named because they all use finely divided pigment particles – rather than metallic particles or dyes – to provide image density. The light-sensitive component in such processes is a dichromated colloidal substance rather than silver halide. In carbon printing, a sheet of thin paper is coated with a mixture of gelatin, dichromate salt and pigment; this the so-called carbon tissue. When exposed to light through a negative, the gelatin film hardens (that is, it becomes insoluble in water) proportionately to the amount of light exposure it receives. The unexposed portions remain soluble and can be washed away in a subsequent stage of processing leaving a film of pigmented gelatin whose thickness (and resulting visual density) is determined by the negative. Under the transparent parts of the negative where light exposure is greatest, the tinted gelatin remains after washing. One or more transfer steps are usually involved in the process to provide the best image reproduction. Manufactured carbon tissues for making these prints were available in a variety of colours well into the twentieth century.

The woodburytype involves the same principles – using the light sensitivity of dichromated gelatin films and producing a final image layer of pigmented gelatin film of varying thickness adhered to a paper support. But the woodburytype also involves an intermediary mould for forming the image layer and a high-pressure printing press for transferring the image layer onto a final paper support. This makes it a photomechanical process, suitable for the production of large numbers of copies such as would be required for the publication of a photographically illustrated book. The woodburytype was considered the best printing process for published photographs from the time it appeared in 1864 until the end of the nineteenth century. The decline in its use was due to the need for faster and simpler publishing processes, not because of any deficiencies in the quality of the woodburytype image.

The examples illustrated here (figs. 51a–b,52a–b) clearly show two aspects of the carbon/woodburytype image: the prints are in perfect condition, showing no hint of fading or discolouration after 140 years; and, as seen in the photomicrographs, both have a high degree of dynamic contrast between the lightest and the darkest parts of the image.

The Canadian Photography Institute holds approximately 250 carbon prints and 750 woodburytypes. The carbon print group includes Thomas Annan's Scottish portraits, John Burke's images of colonial India, and, in the twentieth century, Josef Sudek's still-lifes and cityscapes of Prague. Important groups of woodburytypes include the portrait collections, *La galerie contemporaine* (c. 1876–84) (from which the Baudelaire portrait is drawn) and Herbert Barraud's *Men and Women of the Day* (1888), as well as John Thomson's early social documentary book, *Street Life in London* (1877).

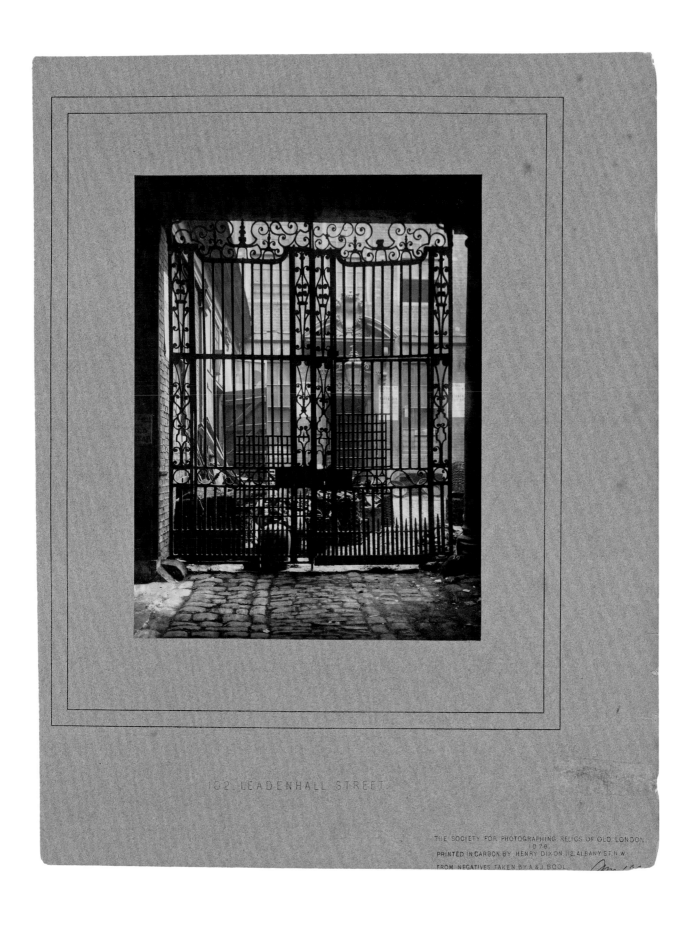

102 LEADENHALL STREET

THE SOCIETY FOR PHOTOGRAPHING RELICS OF OLD LONDON.
1878.
PRINTED IN CARBON BY HENRY DIXON 112 ALBANY ST N W
FROM NEGATIVES TAKEN BY A & J BOOL

Fig. 51a
Photomicrograph detail showing the smooth, somewhat glassy surface of the gelatin image carrying layer over the paper support, with characteristic scattered spots of agglomerated pigment.

Fig. 51b
A. & J. Bool; printed by Henry Dixon and Sons, *102 Leadenhall Street*, 1878, carbon print, image: 22.9 × 17.6 cm; mount: 40.1 × 31.5 cm

1 mm

126, boul. Magenta. - Paris. Phot. Goupil et Cᵉ Cliché CARJAT ET Cᵒ.

CH. BAUDELAIRE

Né à Paris, en 1821, mort en 1867.

Fig. 52a
Photomicrograph detail.

Fig. 52b
Étienne Carjat, *Charles Baudelaire
(1821–1867)*, c. 1863, printed 1878,
woodburytype,
image: 23.1 × 18.2 cm;
mount: 35.3 × 26.6 cm

275

Platinum Print 1870s – present

In the nineteenth century the quest for an image material more permanent than silver led to experiments with a variety of metallic light-sensitive systems. One such pathway led to William Willis' Platinotype process, announced in 1873 and commercialized in 1879. The light-sensitive material used here is an iron compound which, when exposed to light, initiates a series of oxidation-reduction reactions that ultimately lead to the precipitation of fine platinum particles in the top layer fibres of the supporting paper sheet. The Austrians Giuseppe Pizzighelli and Arthur von Hübl published substantial improvements to, and simplification of, this process in 1882 and thereby released its use from Willis' restrictive patent; photographers could now make their own platinum printing paper by following relatively straightforward instructions.

A kind of golden age of platinum printing soon followed, starting with Peter Henry Emerson and Frederick H. Evans in the nineteenth century, then with Edward Steichen, Alvin Langdon Coburn, Edward Weston, Paul Strand and Laura Gilpin in the early twentieth century. The First World War interrupted the supply of platinum for photography, so a chemically similar metal, palladium, was substituted. Commercially manufactured platinum paper went out of production in the 1940s, but platinum/palladium printing has undergone several distinct revivals in the interim. Recently, digital photography has brought enormous help to platinum printers by allowing them to make, from their digital image files, full-size negatives for contact printing that have the right contrast characteristics for platinum paper. These negatives can be produced as inkjet transparencies on a plastic film support.

The platinum image is renowned for its rich blacks and silvery-grey mid-tones; the monochrome image can be chemically toned to produce a range of attractive hues; it is chemically stable and not subject to the chemical deterioration or light-induced fading that can be experienced by other photographic prints (figs. 53a–b, 54a–b).

The Canadian Photography Institute holds more than 750 platinum or palladium prints, including important groups of prints by Frederick H. Evans, Margaret Watkins, Harold Mortimer-Lamb, Stephen Livick and George Steeves. We made an early acquisition of Peter Henry Emerson's *Life and Landscape in the Norfolk Broads* (1886), an important book illustrated with large platinum prints.

Fig. 53a
Photomicrograph detail showing
the platinum image embedded in
the fibres of the support paper.

Fig. 53b
Benjamin Stone, *Man at Entrance
to Houses of Parliament*,
c. 1895–1914, platinum print,
image: 20.6 × 15.5 cm; sheet:
21.4 × 16.3 cm

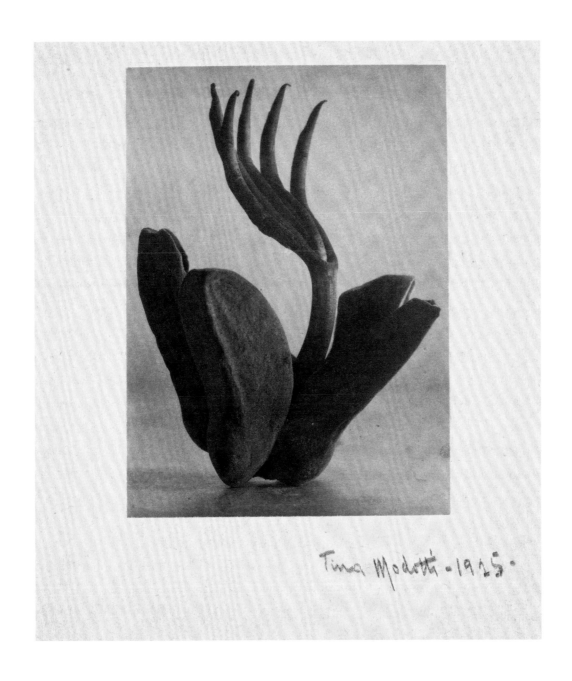

Tina Modotti · 1925 ·

Fig. 54a
Photomicrograph detail showing
the platinum image, chemically
toned to give a different image
colour, embedded in the fibres of
the support paper.

Fig. 54b
Tina Modotti, *"El Manito,"* 1925,
platinum print, 11.9 × 8.9 cm
(1:1 reproduction)

Gelatin Silver Print – Developing-out Paper (DOP)
1880 – present

Photographers had been using various chemical developers to speed up and standardize the production of positive prints since the 1850s. William Henry Fox Talbot had experimented with producing positive prints using his calotype process in 1841. The great French photographic inventor, Louis-Désiré Blanquart-Évrard, had founded his famous Imprimerie photographique in Lille in 1851 based on the – then secret – method of developing positive prints using gallic acid as a reducing agent.

But it was not until the 1880s with the pressures of industrialization and the expansion of the photography market – especially the creation of the amateur photography market – that the familiar practice of printing out positive prints one-by-one in sunlight started to become a serious bottleneck.

Developed out gelatin prints initially came in two varieties. Gelatin *chloride* papers were sufficiently light sensitive to be exposed in a contact printing frame with the artificial light of gas lamps – thus the commercial rubric, "Gaslight Paper." Gelatin *bromide* papers, on the other hand, were even more light-sensitive – to the point that they could be exposed by a projected and enlarged image coming through an optical system. Originally these devices used the light of the sun directed through a series of mirrors; eventually electrical light sources could replace the sun's actinic power. The possibility of producing a print with dimensions larger than the source negative became increasingly important as the size of cameras – and negatives – began to shrink in the early years of the twentieth century.

This new technology required the photographer to acquire an enlarger and a darkroom in which to set it up, since the gelatin bromide papers were too light-sensitive to be handled in even the dimmest room light. However, the advent of gelatin silver printing also brought to printers tremendous variety in the choice of paper textures, colours, and contrasts; the baryta interlayer beneath the image carrying layer could be embossed or tinted; the image carrying layer could be made matte or glossy; the silver halide itself could be manipulated to respond differently to light exposure; and chemical toning could be applied after processing to vary the image colour. Printing papers of the 1920s and 1930s can have very high silver content and can display a tonal richness and subtle contrast distinctions that are remarkable.

Gelatin silver developed-out paper is ubiquitous in photography. Before the advent of digital imaging, most of the photographs made were produced as gelatin silver prints. The libraries and newspaper photo archives of the world are filled with millions of prints made by this method.

Happily, the gelatin print, when properly processed, is among the most stable image-making media ever devised. This is partly due to the relatively low surface-to-volume ratio of the chemically developed silver image particle, much bulkier than the photolytic silver particles produced in the printing-out processes. Even when attacked by a combination of dampness and environmental pollutants, the DOP image particle manages to maintain most of its integrity and morphology, and thus preserves the print's appearance. Leaving aside later developments involving reduced silver content and early experiments with plastic-coated supports, most gelatin silver prints stored in reasonable conditions exhibit remarkable persistence and retention of their original visual qualities.

Generations of photographers have spent their careers gaining an understanding of the qualities of this printing medium, and learning how to control them. Some, as illustrated here (figs. 55a–b, 56a–b) have excelled in doing this.

The Canadian Photography Institute holds an estimated 35,000 gelatin silver developing out prints. The NGC Library and Archives and the other documentary collections in the institution probably contain a similar volume of such photographs.

Fig. 55a
Photomicrograph detail showing
the flat, fibre-less baryta support
for the gelatin image carrying layer.

Fig. 55b
Ansel Adams, *Edward Weston*,
1939, gelatin silver print,
image: 23.4 × 17.8 cm; mount:
45.5 × 35.5 cm

Fig. 56a
This photomicrograph gives some indication of the resolution evident in a print made from a medium format gelatin silver negative – probably 6 × 6 format – that has been moderately enlarged. In this case, the print image dimensions are approximately double those of the negative.

Fig. 56b
Robert Adams, *Longmont, Colorado*, 1979, printed 1985, gelatin silver print, image: 12.7 × 12.7 cm; sheet: 35.4 × 27.6 cm (1:1 reproduction)

POP – Printing-out Paper Prints 1885 – 1940

By 1880 the gelatin bromide dry plate had greatly simplified making a negative in the camera from what it had been when the wet collodion process prevailed. Now the photographic world was ready for a printing process that would match the dry plate in convenience and simplicity. This role was filled by a variety of manufactured printing-out papers (POPs), all of them incorporating a sublayer of gelatin mixed with a white pigment called the baryta layer.

These materials were created with a variety of binders in the photosensitive layer – principally gelatin or collodion, but also casein, starch or albumen. All of them had in common several technically advanced characteristics. First, they were pre-sensitized when purchased and remained sensitive for several weeks, in contrast to albumen paper which typically had to be sensitized by the printer – with a difficult-to-handle silver nitrate solution – just before use. The preformed light-sensitive component was silver chloride, paired with an excess of silver nitrate. This gave the paper the correct sensitivity for printing out by contact using a negative in a printing frame exposed to sunlight – a familiar manipulation for albumen printers and one that could be carried out in a moderately dim room without having to resort to a darkroom and special "safe" lights. Even so, POPs printed faster than albumen. The smooth, reflective baryta interlayer – a barium sulfate-gelatin slurry – produced higher reflectivity, brighter whites and a smoother image surface which had rendered the paper fibres invisible. Also, the baryta could be textured or tinted to produce coloured highlights. Finally, both gelatin-chloride and collodion-chloride prints could be toned after they had been processed, making the possibility of varied image colours possible (for instance, matte collodion papers could be toned to imitate the subtle grey tonalities of a platinum print). Later versions incorporated toning agents into the pre-sensitized manufactured product – the "self-toning" POPs.

As the first example of a photographic printing material that emerged fully formed from the photographic materials industry, these products appeared in quick succession from a number of countries and under various brands. The brand names came to be used generically: in Germany such papers were called *celloidin*; in France they were generally referred to as *aristotypes*; in England and the United States the brand-name POP became the standard generic in English. They may also be called *citrate paper* in English or French, alluding to the citric acid stabilizer that was often incorporated.

George Eastman, more than any other industrialist, synthesized all these technological developments into an integrated package of products and services that made possible the creation of an amateur photography market. The example illustrated here is the final product of a sequence that begins with the consumer purchasing a Kodak No. 2 camera, which came fully loaded with a roll of gelatin bromide nitrate film sufficiently long to make one hundred $3^1/_2$-inch diameter circular images. The camera itself was the model of simplicity – no focusing or exposure adjustments were required, only a pull of a string to reset the shutter – the original "point-and-shoot" camera. When all the exposures had been made, the owner packaged up the entire camera and sent it back to the factory in Rochester, New York where the roll film was developed and contact-printed onto gelatin chloride POP. The prints were mounted in a preformatted album, four to a page (fig. 57). The finished album was sent back to the amateur photographer along with the camera, reloaded with a new roll of unexposed film. This whole system was brilliantly embodied in George Eastman's own slogan: "You Press the Button, We Do the Rest."

In the late nineteenth and early twentieth centuries, POP was the predominant photographic print medium (figs. 58a–b). But as faster, more predictable processing and enlargement from smaller negatives was needed, gelatin papers designed to be developed with reducing agent solutions gradually replaced POP. Even so, contemporary artists will sometimes turn to the use of "obsolete" media to create an appearance that is only achievable with that medium. An example of this is seen in the work of D.R. Cowles who contact prints his large format negatives onto gelatin chloride printing-out paper and then uses gold toning to achieve an inimitable image tone (see pl. 64).

There are an estimated 1500 POP prints, either gelatin or collodion, in the collection of the Canadian Photography Institute.

Subject, *Same.*

Subject, *Same.*
Sounding Steamer Whistle.

Subject, *Same.*

Subject, *Same.*
Playing Cricket.

Fig. 57
Unknown photographer, *Scenes on the Cunard Steamship "Servia,"* 1890, gelatin POPs mounted on an album leaf,

images: 8.9 × 9.2 cm circular, irregular; sheets: 12.3 × 9.9 cm; mount: 30.5 × 27.2 cm.

Fig. 58a
Photomicrograph detail showing
the smooth, fibre-less surface
of the baryta paper beneath the
gelatin image carrying layer.

Fig. 58b
M. Branger Photo-Presse, Paris,
Malécot's aircraft... 1908, gelatin
POP print with black ink crop
marks and inscription,
17.9 × 13.0 cm (1:1 reproduction)

Lippmann Colour Plate 1891 – 1914

The problem of finding a way to record the colours of nature in a photograph had been solved – at least in theory – in 1861 by physicist James Clerk Maxwell who showed that a full-colour image could be constructed from three tinted monochrome images of a coloured object made through three different coloured filters. But this indirect method of colour reproduction, requiring a secondary synthesis step to (re)create the full-colour image, was unsatisfactory in the eyes of physicists and photographers who wanted to see nature's colours reproduced directly. That is, as direct representations of each of the wavelengths of light in the visible spectrum.

In 1891 Gabriel Lippmann, professor of physics at the Sorbonne, announced a solution to the challenge of direct-colour photography with his method of interferential photography. Interference colours – the kind of colours observed on some bird feathers or on a street puddle covered with a skiff of oil – are not dependent on colourants such as dyes or pigments. They are the result of diffraction of reflected light through a thin transparent film in which some wavelengths are amplified (through constructive interference of the incoming and the reflected light) and others are suppressed (through destructive interference between the incoming and reflected beams).

Lippmann photography uses this phenomenon of amplification and suppression of specific wavelengths both in the recording step and the observation mode. In recording blue light, for instance, a particular wavelength – say 470 nano-metres – is transmitted through the photographic emulsion and immediately reflected back when it hits the mirror-like surface of a layer of liquid mercury metal located behind the emulsion. Incoming and reflected blue light waves are amplified and suppressed at regular intervals through the thickness of the emulsion. The intervals are proportional to the 470 nm wavelength of the incoming blue light. This results in a periodic deposition of silver through the emulsion depth – a kind of laminar structure of developed silver alternating with clear emulsion in a regular pattern.

In observation mode, white light is shone onto the finished plate and is reflected back through the emulsion to the viewer's eye. But only the blue wavelength can penetrate and emerge from the laminar structure of the emulsion with its alternating layers of silver particles and transparent gelatin. Other wavelengths are blocked from reflection because they do not "fit" the spacing pattern of the silver layers.

This elegant method simultaneously created a means of making full-colour, stably fixed and direct-colour photographs as well as demonstrating, in a peculiarly material way, an aspect of the wave nature of light. Lippmann received the 1908 Nobel Prize in Physics, "for his method of reproducing colours photographically based on the phenomenon of interference."

But Lippmann's interferential photography was not for the faint of heart, requiring as it did, special camera equipment, fine-grain gelatin silver bromide plates, long exposure times, difficult manipulations involving toxic material, complex viewing arrangements … and there were no paper prints (fig. 59). Not surprisingly, it had no commercial success.

The Canadian Photography Institute has in its long-term care seven Lippmann plates, generously lent from a private collection. The provenance and subject matter of some of these images lead us to attribute these plates to Gabriel Lippmann himself.

Fig. 59
Attributed to Gabriel Lippmann,
Faverol, Normandy, 1914,
Lippmann interferential colour
plate, 12.1 × 9.1 × 2.3 cm

Gum Bichromate Print 1894 – present

Like carbon prints and woodburytypes, gum bichromate prints belong to the pigment processes group, named for their use of pigments instead of silver particles to create image density; these all depend on the light-mediated hardening of dichromated colloids to create a photographic image.

But gum printing uniquely allowed photographers wide leeway in the choice of image colours, textured papers, and in their ability to layer multiple printing steps on top of one another; additionally, the gum bichromate printer exercised control over the appearance of the final image by selectively wielding an actual paintbrush – making it the first photographic process to allow such direct hand manipulation.

Gum printing built on the work of Ponton, Talbot, Poitevin, Pouncy and others who had all pointed to, or perfected, the use of dichromated colloids in photography. But when Albert Rouillé-Ladevèze showed his prints made with dichromated gum arabic at the 1894 exhibition of the Paris Photo Club, photographer-artists were primed to adopt a process that was the antithesis of the hard-edged, high-resolution images that had become possible, even commonplace, with the advent of wet collodion plates and, eventually, dry plate negatives and gelatin prints. Gum prints – with their dissolving, atmospheric images produced by actual hand manipulation – were ideally suited for the tastes and ambitions of Pictorialist photographers in France and their associates in London's Linked Ring and New York's Photo-Secession.

Rouillé-Ladevèze's process involved coating a support paper with a dichromated gum arabic solution that had been tinted with a colourant, often one derived from artist's watercolour cakes or tubes (these included the synthetic pigments and lakes developed in the latter part of the nineteenth century, some of which were considerably more light-fugitive than the brown or black earth pigments typically used for carbon printing). The dried and coated paper was exposed by contact through a negative and then "developed" by treatment with water to remove the unhardened portions of the gum/pigment coating. The water was applied either by immersion in a bath or by a flowing jet of water. During this stage, paintbrushes of varying breadth and stiffness, or other rubbing tools, could be used to selectively remove more or less of the unhardened gum layer. Once completed, the print could be recoated with more gum mixture and the exposure repeated to reinforce the image; or a different colour could be layered on top using a negative with the same image but with altered contrast; or three semi-translucent subtractive colours (cyan, magenta, yellow) could be layered on top of one another, each printed from its corresponding three-colour separation negative, to result in a romantically soft-hued approximation of photography in natural colour.

Gum printing was largely eclipsed after the First World War as the oil processes such as bromoil –processes that use (oily) printers' ink – provided easier avenues to hand-manipulated photographic images. But the wide choice in image colours and textures and the inherent handmade qualities of the gum print attracted a new generation of practitioners starting in the 1960s, when the alternative processes movement began to appear and flourish in art schools and artist studios.

The Canadian Photography Institute holds approximately 100 gum bichromate prints; the process is either used alone or in combination with other processes to create a single print (a "multiple-process print") as in the case of the Coburn illustrated here (figs. 60a–b). Among them are examples from the best known practitioners from the early twentieth century – Gertrude Käsebier, Heinrich Kühn, Edward Steichen, Paul Haviland, Alvin Langdon Coburn; but many are by photographers who were associated with the alternative process revivals that took place in the 1960s, 1970s and 1980s – particularly Betty Hahn (figs. 61a–b) and Stephen Livick.

Fig. 60a
Photomicrograph detail showing the glossy gum layer conforming to the paper fibres of the support; the platinum image is printed first, then overlaid with the reinforcing gum image.

Fig. 60b
Alvin Langdon Coburn, *Two Graves, Edinburgh*, 1904, printed before July 1906, gum bichromate and platinum print, 35.9 × 28.9 cm

1 mm

Fig. 61a
Photomicrograph detail from one
of the negative images in the mon-
tage: two gum applications were
made using different separation
films – one for the brightest parts
of the original scene (black),
another for the mid-tones (yellow).

Fig. 61b
Betty Hahn, *Girl by 4 Roads*, 1968,
gum bichromate print in two
colours, 37.3 × 56 cm

Matte Albumen Silver Print 1895 – 1929

As in other matters of taste, styles of photographic print come in and out of fashion. While matte salted paper was never completely displaced by the glossier albumen papers prevalent through most of the nineteenth century, a kind of salted paper revival began in the 1880s. The aesthetic qualities and the prestige of the platinum print helped to create a desire for print images that were not glossy and which showed the velvety transitions in tonality characteristic of platinum.

In 1895 Arthur von Hübl provided a formula for producing a matte surface print which had the familiarity and advantages of conventional albumen paper. His recipe involved adding a starch – arrowroot was the material of choice – to the albumen-salt coating of the paper. This produced a matte print that could be toned with the various chemical toners – especially platinum toners – that were, by then, a part of the professional and amateur printer's toolkit.

Matte albumen papers were manufactured mainly in Germany and available in Europe but were exported very little to North America, where matte gelatin and matte collodion papers served a similar desire for a less glossy print appearance. The great French photographer Eugène Atget used a variety of traditional albumen, gelatin POP and matte albumen printing papers (figs. 62a–b) throughout his career. Two years following his death in 1927, the last manufacturer of matte albumen paper in Germany ceased production.

The Canadian Photography Institute holds twenty-five matte albumen prints, nearly all of which are by Atget; these were purchased for the collection in the mid 1970s.

Fig. 62a
Photomicrograph detail showing
the silver image contained in
the modified albumen layer over
the paper fibres.

Fig. 62b
Eugène Atget, *Parc de Versailles*,
1901, matte albumen silver print,
17.1 × 21.8 cm

Autochrome 1907 – 1935

The felicitously named Lumière brothers, Auguste and Louis, inherited a photographic materials manufacturing business, based in Lyon, from their father. In the early 1890s they developed a motion picture technology, which proved to be innovative and successful; they made some of the first publicly screened ciné films. During these same years they began work to develop a marketable product for making still colour photographs. They first spent considerable effort and money in trying to commercialize the Lippmann process as well as other technological avenues that eventually proved unsuccessful. But by 1900 they concentrated their efforts on a process based on a monolayer three-colour filter that was used to both analyze a colour scene during exposure and to view the full-colour image by transmitted light. The name they gave their new product, released in 1907, sounded both modern and linguistically neutral: autochrome.

The filter layer consists of a mosaic of orange-, green-, and violet-dyed potato starch granules, packed closely in a single layer on a glass plate. Coated over the filter layer is a panchromatic gelatin bromide emulsion. The camera exposure is made so that the light from the lens passes through the glass plate and the coloured microgranules before it reaches the panchromatic emulsion. Violet light, for instance, is transmitted by the translucent violet filter elements but absorbed by the orange and green elements. So the spot of emulsion underneath the violet element is exposed, whereas spots under the orange and green elements remain unexposed.

The exposed plate is treated with *reversal* processing, so that silver particles are produced in the *unexposed* areas and the emulsion is left clear of silver in the *exposed* areas. When the plate is trans-illuminated, the white light is filtered and transmitted through the violet element, but blocked entirely at the orange and green elements by the silver particles at these locations. Thus, where violet coloured light beams hit the plate in the camera, violet colour is observed on the finished plate. A variable combination of these three additive primary colours (orange, green, violet – today more commonly defined as red, green, blue) can reconstitute any colour of the visible spectrum.

But every colour photographic process possesses its own unique colour rendition character, and that of the autochrome is a particularly gentle, pastel-like colour gamut with a structure reminiscent of pointillism – a result of the tiny spots of pure colour that make up the image and that are almost visible to the naked eye. The autochrome's appearance seems tailor-made for the Pictorialist aesthetic that prevailed in art photography circles in 1907. That the world's first commercially viable colour-photographic process happened to be naturally aligned with the prevalent art movement of the day is one of those brilliant coincidences that occasionally happen.

The Canadian Photography Institute holds three autochrome plates, including one by Heinrich Kühn (pl. 157). The still life illustrated here (figs. 63a–b) was made by the Lumière enterprise as a promotional demonstration of the medium's remarkable colour qualities.

Fig. 63a
Lumière Brothers Studio, *Still-life with Lobster*, c. 1907, autochrome 12.9 × 17.8 cm

Fig. 63b
Photomicrograph detail showing the mosaic of orange-, green-, and violet-dyed potato starch granules with an underlying gelatin silver image layer.

Chromogenic Print 1942 – present

Exotic, complex and costly means of making photographs that reproduced the colours of nature existed prior to chromogenic technology, but they were far too difficult to be commercialized for a mass market. To create a colour process that was as easy to use as black-and-white, a series of problems in chemistry and process engineering needed to be solved. Most of this preliminary work was successfully completed in Germany in the first decades of the twentieth century. But it was two young Americans – the amateur researchers Leopold Mannes and Leopold Godowsky – who in 1935 brought the science and engineering threads together to create a successful product for making colour photographs. By that time the two Leopolds were working at the Kodak Research Laboratory in Rochester; the product they brought to market was a 16mm colour reversal ciné film for the amateur market. It was called Kodachrome.

Colour negative film and colour printing papers using the same technology eventually followed. These all rely on the same strategy. Three gelatin silver halide emulsion layers are stacked on top of one another – the bottom layer is sensitive predominantly to blue light; the middle layer is exclusively sensitive to green light; and the top, only to red light. Organic dyes of the three subtractive primary colours form in the separated layers – yellow, magenta and cyan respectively – in proportion to the amount of silver halide exposed in each location in each of the layers. This is accomplished by dye forming (*chromo genic*) in the chemical reaction of a colourless dye precursor (a "coupler" molecule) and oxidized photographic developer. The more oxidized developer available, the more dye will be formed in that vicinity. When the fully processed photograph is viewed, the stacked monochrome images will be re-assembled by the eye into a full-colour version of the original scene – the principle of trichromy elucidated by Maxwell in 1861 (see Lippmann Colour Plate, p. 288).

During the Second World War colour photography was considered a strategic resource and was reserved for military use. When colour photographic materials for the public re-appeared in the 1950s, they remained considerably more expensive than black-and-white materials. But in the 1970s the cost of colour photography began to decrease and the use of chromogenic film and print materials became ubiquitous. Professional, commercial and artistic photographers switched to colour. Artists who did not define themselves as photographers began to produce "photo-based" art with cameras and colour materials that became as easy to use as a sketch pad. At the end of the 1980s the photographic materials manufacturers introduced a new generation of print materials with hugely improved permanence characteristics – up to that time, colour prints could generally be expected to fade and discolour quickly if they were put on display, and only somewhat more slowly if they were kept in the dark.

Silver halide-based chromogenic printing paper (alternately called "dye coupler" or "C print") still finds application in the age of digital photography: instead of being exposed to an analogue colour negative image through an optical enlarger, a digital image can be printed onto chromogenic paper using a computer-controlled three-colour laser array that passes in a raster pattern over the surface of the paper as it is drawn through the printer. An early printer of this type had the brand-name Lambda, and such prints are sometimes designated by that name. Alternatively, they may be described as LightJet prints, also after an early printer.

The National Gallery of Canada holds approximately 3500 chromogenic prints in its collections. The National Film Board's Stills Division (later the Canadian Museum of Contemporary Photography, now part of the Canadian Photography Institute) began collecting this medium as early as the mid 1960s (figs. 64, 66). By the late 1980s the Gallery – particularly the contemporary art collection – began to make major acquisitions of chromogenic prints (fig. 65). The pace of acquisition of chromogenic prints has slowed in recent years as inkjet has become the principal medium for printing colour photographs.

Fig. 64
Herbert Dassel, *Light Paintings*,
1965, chromogenic print,
27.5 × 36.6 cm

Fig. 65a
Gabor Szilasi, *Bathroom, Lotbinière*, 1976, printed 1979, chromogenic print (Ektacolor), 25.6 × 19.6 cm

Fig. 65b
Photomicrograph detail showing a rough, granular surface, one of several textures available on the resin-coated (RC) paper base that was used as a support for chromogenic prints from the late 1960s.

Fig. 66
Alison Rossiter, *Sponges*, 1983, chromogenic print, 50.7 × 40.6 cm

Dye Imbibition Print (Kodak Dye Transfer)
1946 – 1994

Throughout the twentieth century various products that used dye imbibition technology to produce photographic prints and transparencies in natural colours were available. Technicolor, the famous colour motion-picture film, was an imbibition process. But the most advanced, the longest lived, and the most commonly encountered product of this type is the Kodak Dye Transfer print material, introduced just after the Second World War and marketed for almost half a century.

The imbibition process depends on the capacity of gelatin to absorb dye solutions in an acidic environment and desorb them in an alkaline environment. The Kodak Dye Transfer version of the process involves the production of three black-and-white relief matrices on Kodak Pan Matrix Film from red, green and blue separations derived from an original colour negative (alternately, colour separation negatives could be made from an original positive transparency as a preliminary to producing the matrices). The matrices are processed in a tanning developer that hardens the gelatin in proportion to the amount of developed silver present at each location. The unhardened portions of the gelatin are washed off in a bath of warm water leaving a gelatin relief image, with a thicker film in darker areas of the image and a thinner film in the highlights. Each separation matrix is then immersed in an acidic dye bath of the corresponding subtractive primary colour – cyan, magenta, yellow – where the dye is *imbibed* into the partially hardened gelatin film to an extent proportional to the thickness of the film: the thicker the gelatin, the more dye is absorbed. The coloured matrices are then brought into close contact, one after the other, with a sheet of Kodak Dye Transfer Paper, which is coated with a layer of unhardened alkaline gelatin containing a dye mordant. The dye from the matrix transfers to the receiving layer. Accurate placement of the three matrices on the receiving sheet is accomplished precisely with a pin registration system on a transfer easel.

The complex technical skills and darkroom resources required to carry out dye imbibition printing meant that it was largely performed in professional photographic printing studios specially equipped for this medium. But the unique attractions of the process – broad colour gamut, precise control of colour contrast, stability of the image dyes (at least in dark storage) when other colour materials faded and discoloured quickly – meant that it was preferred for the most demanding and prestigious applications. Kodak Dye Transfer printing became a standard in the post-war print advertising industry just when the pages of magazines became more colourful due to improvements in large-scale lithographic printing presses. Artists used Dye Transfer printing to make portfolios of their colour images.

The Canadian Photography Institute holds approximately 150 dye imbibition process prints – mostly Kodak Dye Transfer prints. Included are important representations of the colour images of Harry Callahan, Harold Edgerton, George Hunter (figs. 67a–b) and John Pfahl.

Fig. 67a
George Hunter, *Wild Horse Race, Calgary Stampede*, 1958, dye imbibition print (Kodak Dye Transfer), image: 38.4 × 48.9 cm; sheet: 50.8 × 61.0 cm

Fig. 67b
Photomicrograph detail showing the three superimposed gelatin image carrying layers on the Dye Transfer Paper.

Silver Dye-bleach Print (Cibachrome, Ilfochrome)
1963 – 2013

Like chromogenic and dye imbibition prints, silver dye-bleach (SDB) prints use three subtractive primary colour dyes (cyan, magenta, yellow) to render natural full-colour images in a print. But the SDB process is, in operation, the opposite of the chromogenic process. In chromogenic processes, dyes are *formed* in situ from colourless coupler molecules. In SDB processes pre-formed dyes are selectively *destroyed* to leave only those dyes, in the proper proportions, that result in the required hue, saturation and intensity of colour at each location. This leads to the alternative name, dye destruction processes.

Many SDB processes were created and marketed throughout the twentieth century, but until the release of Cilchrome in 1963 – later re-christened Cibachrome – none of these products met with significant success in the amateur market or they were available only briefly. But Cibachrome, jointly developed by the Swiss drug company CIBA and the English photo-materials company Ilford, was a significant medium for commercial, amateur and artist-photographers because it was relatively easy to use and produced distinctively sharp, colour-saturated images with a large dynamic range and a hard glossy finish; the azo dyes that constitute the image were significantly more stable and lightfast than the dyes formed in chromogenic prints.

The Cibachrome product, renamed Ilfochrome in 1991 as a result of a corporate realignment, was available variously on pigmented cellulose triacetate, RC paper, or an innovative polyester base containing voided microbubbles that made the plastic support opaque. Transparent and translucent products were made for backlit transparencies. The finished texture was famously glossy, but a "Pearl" finish was also available. From 1974 on, special product kits were specifically designed for the amateur printer to use at home. The speed and ease of use were improved periodically over the half-century that the product remained available.

In the manufactured material, three gelatin silver halide emulsion layers are stacked on top of one another – the bottom layer is sensitive to red light; the middle to green light; and the top, only to blue light. Azo dyes of the three subtractive primary colours are present in the separate layers – cyan, magenta and yellow respectively (An alternative designation for the medium is azo dye print). The print material is exposed in an enlarger to an original positive – slide or transparency. The exposed silver halide is developed in each of the three layers, and then a bleach-catalyst acts – proportionally to the amount of silver present – to destroy pre-formed dye present in that vicinity.

For all of its attractive characteristics, Cibachrome / Ilfochrome never achieved the market penetration that chromogenic materials did. It was more expensive and required longer exposure and processing times. Some photographers disliked its high gloss and high-colour saturation. Its production was halted in 2013.

In Stan Denniston's print (figs. 68a–b), the largely washed-out colours of the urban landscape are interrupted by small areas of brilliant contrast – cyan, pink and turquoise features. The Cibachrome image characteristics are ideal in achieving this effect. Also, this thirty-five-year-old print evidently retains its original appearance.

The National Gallery of Canada holds approximately 1100 SDB process prints in its collections, including many single prints and assemblages acquired by the Canadian Museum of Contemporary Photography, now part of the Canadian Photography Institute.

Fig 68a
Stan Denniston, *U.S.–Mexico
Border, Nogales, Arizona*,
1982–83, silver dye bleach print
(Cibachrome), image: 20 x 29.7 cm;
sheet: 27.7 x 35.3 cm

Fig. 68b
Photomicrograph detail showing
a mixture of cyan, magenta and
yellow spots that are synthesized
by the human eye and brain to

read as a rendition of all colours
and all densities.

Instant Dye Print (Polaroid) 1963 – present

Between 1947 and 2008 the Polaroid Corporation introduced a series of revolutionary products that produced photographic prints directly from the camera (almost) instantly, and without any darkroom work at all. These innovations all depended on carefully controlled diffusion of photographically and optically active molecules through highly engineered transfer layers. Colour versions of instant film – the first was Polacolor, released in 1963 – are called dye diffusion processes. Other companies – Kodak, Fuji, Agfa, and now, The Impossible Project – have all produced dye diffusion materials before or after the 2008 demise of the Polaroid Corporation; but it is Polaroid that has become synonymous with instant photography.

Polaroid introduced a series of materials of ever-increasing fidelity and speed over forty-five years. The most familiar materials are Polacolor and Polacolor 2 (1963–2008) where the negative and positive images had to be physically separated from one another following a development period ("peel-apart" films); and the SX-70 and Spectra products (1972–2006) where all the exposure and processing steps took place within the layers of a single indivisible unit ("integral" films) and which had the delightful characteristic of having the image appear gradually before one's eyes under the full light of day.

The details of how the dye diffusion image comes to be established and visible in the final receiving layer, and the improvements that were brought to the original technology over the years, are necessarily complex and not essential to elucidate here. But all such processes share a similar initial structure, consisting of a multi-layer subtractive colour negative using silver halides as the light-sensitive agent, a receiving layer for the positive image, and a pod containing a viscous fluid reagent mixture that, in the moment following exposure, bursts and is spread evenly between the negative and positive. Most dye diffusion film formats come with their own dedicated camera, designed to handle the complex film and to ensure that the pod bursting and reagent spreading are accomplished reliably. In this completely analogue photographic world that thrived just before digital imaging swept in, the cameras and films used to make instant dye prints are masterpieces of chemical process engineering and icons for the design of complex mechanical/optical devices.

Instant photography brought new ways of photographing. Artists could make life diaries (Andy Warhol), abstract visual notes (Charles Gagnon [see pl. 47]) or transformations of intimate performances (Lucas Samaras, Judith Eglington [fig. 69]). A generation of photographers found that the instant image could be radically altered by all kinds of physical manipulation applied to the print in the moments after it came out of the camera, while it was still developing. Evergon used large-format Polaroid cameras to stage elaborate tableaux, using models adorned with spectacular costumes and decor, creating mythical romances that have the hard-edged verisimilitude achievable only with perfectly controlled mammoth-format photography.

The Canadian Photography Institute holds approximately 125 instant dye prints. These range in size from the standard 7.9 × 7.9 cm image of the SX-70 package, to huge "peel-apart" prints over two metres high.

Fig. 69
Judith Eglington, *Untitled*, 1975,
instant dye print (Polaroid),
image: 7.9 × 7.8 cm; object:
10.8 × 8.8 cm (1:1 reproduction)

Inkjet print 1985 – present

While it is possible to render a digital image onto a conventional chromogenic paper, inkjet* technology is a more direct electronic system that eliminates light-sensitive silver halides and, in fact, does not require a light exposure step. Instead, a print image is constructed by spraying droplets of coloured liquid from a specialized printhead towards a support sheet; the aggregated coloured spots that dry on the support render a monochrome or full-colour image in the viewer's eye, as with other photographic print processes. But in this case the coloured materials are inks made with dyes or pigments, carried in aqueous or solvent-based liquids, and applied from the air; no light-induced oxidation or reduction chemistry is involved.

Much as the creation of a digital image in the camera depends on integrated electronic circuits to capture, process and store the image file, the controlled spray of ink from the printhead of an inkjet printer is mediated by computer algorithms that orchestrate the mechanics of image rendering. Essentially, the computer sends a command to the printhead to expel – or not – a droplet of one of four coloured inks towards each image address. (inkjet printing uses a four-colour subtractive model for image production: cyan, magenta, yellow and black – CMYK.) The resulting mosaic of spots of monochrome ink is made visible by using a magnifying loupe, as shown here in the photomicrograph (fig. 70b).

The basic science behind inkjet technology – observing the way liquid droplets are formed – was described in the nineteenth century by Lord Rayleigh (John Strutt). It was not until the 1970s that inkjet printer technology had developed sufficiently to start rendering colour photographs. In 1985 the Iris printer was introduced and it became the standard for high-quality printing for the art market during the 1990s. Iris prints, though, had poor lightfastness and were easily damaged by exposure to water or even high humidity. Indeed, most early inkjet prints of photographic images were problematic either because of poor stability, poor image resolution, or both. But intense competition among the printer manufacturers to gain advantage in the enormous industrial and home/office printing markets resulted in rapid improvements in inkjet technology, resulting in prints that were more highly resolved, more

reliable, more stable and less expensive. One of the latest versions of inkjet printing, which uses aqueous inks cured by exposure to ultra-violet light immediately after being laid down, currently finds application in commercial printing and advertising; eventually it will be used to make full-colour images for artists and these promise to be vastly more stable and robust than any other colour photographic printing medium to date.

Inks for inkjet printing come in a bewildering array of varieties, mainly distinguished by whether the colourant is a dye or a pigment and whether the vehicle is aqueous or otherwise. Likewise, paper and other types of supports are manufactured with a range of different surface coatings, sizes and engineered image-receiving layers. Ink set and support must be suited to one another to optimize the printing process; mismatches can produce poor initial quality in the printed image or leave the finished print fragile and prone to deterioration. However, the variety of materials available for inkjet printing currently gives the artist-printer enormous latitude in determining the character and appearance of the final print: black-and-white or full colour, wide or restricted colour gamut, matte or gloss, flexible or rigid, supports made of paper fibre/synthetic paper/coated paper/plastic film/metal, dimensions that can reach the size of a billboard. Such a wide choice harks back to the early years of the twentieth century when photographers had a similarly rich variety of print materials to choose from.

Spring Hurlbut chose a combination of ink set and support to make a print with a flat matte surface and a deep neutral black shadow value (fig. 70a); it appears to consist of loose powder on the surface. She uses this visual sleight-of-hand to shock us with the immediacy of her "portrait" of James, represented by his cremated ashes on a black background.

The National Gallery of Canada holds some 800 inkjet prints. The earliest example was made in 1990 and acquired for the collection of the Canadian Museum of Contemporary Photography in 1992.

* A note on terminology: inkjet prints circulating in the art market have been described using a variety of terms: prints from Iris printers were simply called "Iris process"; "giclée print" was popular in the 1990s and noughts; "archival pigment print" is a current – and confusing – formulation.

Fig. 70a
Spring Hurlbut, *James #5* from
the series *Deuil II* [Mourning],
2008, inkjet print, approximately
71 × 81 cm

Fig. 70b
Photomicrograph detail showing a
mixture of cyan, magenta, yellow
and black spots that are synthe-
sized by the human eye and brain
to read as a rendition of all colours
and all densities.

Further reading

Barger, M. Susan. *The Daguerreotype: Nineteenth-Century Technology and Modern Science.* Washington: Smithsonian Institution Press, 1991.

Benson, Richard. *The Printed Picture.* New York: The Museum of Modern Art, 2008.

Davis, Keith F. *The Origins of American Photography, 1839–1885: From Daguerreotype to Dry Plate.* Kansas City: Hall Family Foundation; Nelson-Atkins Museum of Art, 2007.

Eaton, George T. *Photographic Chemistry.* Dobbs Ferry: Morgan & Morgan, 1965. (Republished 1986.)

Eder, Josef Maria. *History of Photography.* Edward Epstean, trans. New York: Columbia University, 1945. Republished, New York: Dover, 1978.

Jürgens, Martin C. *The Digital Print: Identification and Preservation.* Los Angeles: Getty Conservation Institute, 2009.

Lavédrine, Bertrand. *Photographs of the Past: Process and Preservation.* Los Angeles: Getty Conservation Institute, 2009.

Lavédrine, Bertrand. *The Lumière Autochrome: History, Technology, and Preservation.* Los Angeles: Getty Conservation Institute, 2013.

McCabe, Constance, ed. *Platinum and Palladium Photographs: Technical History, Connoisseurship, and Preservation.* Washington: American Institute for Conservation of Historic and Artistic Works, 2017.

Nadeau, Luis. *Encyclopedia of Printing, Photographic, and Photo-mechanical Processes.* 2 vols. Fredericton: Atelier Luis Nadeau, 1990.

Pénichon, Sylvie. *Twentieth-Century Color Photographs: Identification and Care.* Los Angeles: Getty Conservation Institute, 2013.

Reilly, James M. *The Albumen and Salted Paper Book: The History and Practice of Photographic Printing, 1840–1895.* Rochester: Light Impressions, 1980; Second edition, Rochester: RIT Cary Graphic Arts Press, 2012.

Reilly, James M. *Care and Identification of 19th-Century Photographic Prints.* Rochester: Eastman Kodak Co., 1986.

Seiberling, Grace. *Amateurs, Photography, and the Mid-Victorian Imagination.* Chicago: University of Chicago Press, 1986.

Ware, Mike. *Mechanisms of Image Deterioration in Early Photographs.* London: Science Museum, 1994.

Ware, Mike. *Cyanotype: The History, Science and Art of Photographic Printing in Prussian blue.* London: Science Museum, 1999.

Glossary

Additive colour system: a trichromic colour synthesis in which light of the three additive primary colours (red, green, blue) are mixed to render all the possible colours of the spectrum. Colour image recording systems use additive systems to capture three colour images. Autochromes, large back-lit transparencies, 35 mm colour slides, and colour video monitors all use additive colour mixing. Compare with subtractive colour system.

Albumen negative process: an early use of glass as a photographic support; produces a fine-grained, detailed image; introduced by Abel Niépce de Saint-Victor in 1847.

Albumen silver print: see page 260.

Ambrotype: see page 266.

Archival pigment print: a synonym for inkjet print, see page 308. Compare with pigment processes.

Aristotype: the French term for POP, used occasionally in English; see POP – Printing-out Paper Print, page 284.

Autochrome: see page 296.

Azo dye print: a synonym for silver dye-bleach print, see page 304.

Baryta: a mix of finely ground white barium sulphate and gelatin; some types of photographic paper are manufactured with a coating of a baryta slurry, which forms a smooth reflective surface located beneath the light-sensitive emulsion and obscures the paper fibres. Baryta layers can be textured or tinted to provide surface and colour effects.

Blueprint: a synonym for cyanotype, see page 254.

Bromoil print: one of the oil processes, so-called because the final image consists of oil-based printers' ink on paper. Like carbro, this method produced stable ink images without first having to make enlarged negatives. In the final step of the process, ink is hand-brushed on to the processed silver bromide paper, which will accept or reject it to the degree that the gelatin is hardened or swollen with water.

C print: a Kodak colour printing paper of the 1950s; sometimes used as a synonym for chromogenic print, see page 298.

Cabinet card format: a standard mount format for commercial portraits that was common in the late nineteenth and early twentieth centuries; the mount cardboard is approximately 6½ × 4½ inches.

Calotype: Talbot's earliest process for developed-out negatives; see Paper Negative, page 252.

Camera lucida: an optical device used as a drawing aid; a glass prism allows the user to simultaneously see a scene before him/her and a drawing sheet below; the outline of the scene can then be traced onto the sheet.

Camera obscura: an optical device used as a drawing aid. A pinhole aperture pierced in the wall of a darkened room (a) causes a reversed and inverted image of the exterior scene to be projected onto the wall opposite the aperture. A portable version – a wooden box equipped with a lens – was used by amateur and professional draughtsmen to make preparatory drawings of interior and exterior views.

Carbon print: see page 272.

Carbro print: a pigment process variant, closely related to the carbon process; in this case the carbon tissue is "exposed" by contact with a fully developed gelatin silver bromide print; the metallic silver in the bromide print initiates the hardening action in the dichromated gelatin of the pigment tissue. This variant avoided the need for making an enlarged negative for contact printing – the source image could be a small negative enlarged directly onto the bromide print.

Carte-de-visite format: a standard mount format for commercial portraits common in the nineteenth century; the mount cardboard is approximately 4 × 2½ inches.

Cased photograph: a type of housing for daguerreotypes, ambrotypes or tintypes consisting of a slender hinged box; used primarily in Britain and North America. The plates are first sealed into a decorative metal and glass package; the package is then fitted into the tray portion of the case; a hinged lid closes and clasps over the image. Cases are usually composites of wood, leather, paper and velvet; a popular variant is the Union case

(below) made of moulded thermoplastic material. Compare with passe-partout.

Chromogenic print: see page 298.

Cibachrome print: a common brand of silver dye-bleach print, see page 304.

Cliché verre print: a photographic print derived from an image drawn onto a glass plate; the plate is covered with the soot of a candle flame, or otherwise obscured with an opaque covering; the draughtsman uses various tools to remove portions of the covering. The finished plate can be used to produce multiple photographic prints of the drawn image, rendering dark lines on a light background.

Collage/montage: techniques where the final print is an assemblage of print images, cut out and pasted together to form an integral image (collage), or in which the pasted-up assemblage is re-photographed to produce a singular new negative from which multiple prints can be made (montage). Compare with combination printing.

Collodion: a solution of cellulose nitrate dissolved in alcohol and ether; when the solvents evaporate, a smooth transparent film is left. Cellulose nitrate is prepared from the natural polysaccharide, cellulose, derived from plant sources. Collodion is used on glass in the collodion negative and ambrotype processes and on baryta paper for collodion POP prints.

Collodion negative process (also wet plate collodion negative process): a method of making a glass negative on which the silver image particles are confined to a thin, transparent, adhered coating of collodion. The process was most completely formulated by Frederick Scott Archer and published in 1851. Glass plate collodion negatives – and the albumen on glass negative process that preceded it – brought a new level of optical resolution to photographic negatives. The contrast characteristics of a collodion negative were exactly suited to albumen silver printing paper, which became available around the same time.

Collodion positive: a synonym used in Britain for Ambrotype; see page 266.

Collotype: a photomechanical printmaking process that produces an image in printers' ink on paper; used for production of high-quality reproductions in books and other printed matter. A reticulated layer of gelatin on glass establishes the image grain, and provides a unique and characteristic appearance under moderate (10×) magnification. Also referred to as autotype and Albertype.

Contact printing: a mode of photographic printing. The exposure step is carried out with the sensitized paper pressed against the emulsion side of a negative. This sandwich is exposed to light; in the nineteenth century, this meant putting it into full daylight out-of-doors to use sunlight's rich ultraviolet component, to which early photographic materials were primarily sensitive. Most printing-out papers have sensitivity characteristics that make them primarily suitable only for contact printing, not enlargement. Contact printing can be carried out with either POP or papers designed to be developed. Compare with enlargement. Print images made by contact have the same dimensions as the negative image.

Continuous tone image: a description of most photographic processes that produce an image with an infinitely divided range of intermediate densities between the darkest and the lightest areas, at least when observed with the naked eye or moderate magnification. Compare with half-tone images.

Contrast: the ratio between the brightest white density (or the brightest colour) and the darkest black density (or darkest colour) that a photographic system can render. Also called dynamic range. Contrast is a fundamental characteristic of any photographic system and various means are used to quantify and control it.

Combination printing: a technique in which more than one negative is used to make a print image that appears to derive from a single camera exposure. Oscar Rejlander's is an early and famous example in which many negatives were used in the making of a single unified image. Compare with collage/montage.

Cyanotype: see page 254.

Daguerreotype: see page 250.

Density: describes the relative darkness or lightness of image areas in black-and-white or colour photographic materials; it is a defined quantity and is derived from the absorbance of an area on the print as measured by a densitometer.

Developer: a chemical solution that converts light-exposed silver-halide molecules into particles of metallic silver, thereby making visible a previously undetectable latent image. Usually the developer is a chemical reducer, which is itself oxidized during the process of development. Photographic processes that involve printing out do not require a development step.

Dichromated colloid processes: are those which employ a dichromated colloid (such as gelatin or gum arabic) that hardens when exposed to light or when the dichromate interacts with metallic silver. Most of the pigment processes, the oil processes, and the photomechanical processes use dichromate systems. Compare with silver-halide processes.

Digital images: virtual objects in which a two-dimensional image is given a numeric representation, usually binary. They are recorded as data files using standard file formats.

Digital output media: the wide range of print media designed to produce material manifestations of digital images. Often the printers used to make such prints are optical-mechanical devices controlled by computers. The inkjet print is the most common form of digital output media current among photographers.

Digital print: any physical print produced using a digital output medium.

Direct colour reproduction: the rendering of a scene from nature using a one-to-one representation of each of the wavelengths of the visible spectrum and their superpositions, which are present in the original scene. Micro-structural arrangements account for these colours, rather than the presence of a fixed colour substance. These colours exist in nature (certain birds' feathers, flowers, soap bubbles); Lippmann interferential photography (see p. 288) and reflection holograms are the only current examples of this mode of colour reproduction. Compare with trichromy.

Direct positive: a photographic positive produced in the camera without resort to an intermediate negative step. Such objects are unique images; that is, they cannot produce multiple copies. Examples are daguerreotypes, Bayard direct positive process prints, ambrotypes, tintypes, slide film and integral format instant prints.

DOP (developing-out paper): see Gelatin Silver Print – Developing-out Paper (DOP), page 280.

Dry processes: a range of glass plate negative processes developed in the nineteenth century to get around the difficulties of the wet collodion process, in which preparation, exposure and processing of the plate had to occur before the collodion coating dried on the plate. "Dry" collodion processes introduced humectants to maintain the sensitivity of the plate; later, industrially produced gelatin dry plates used the enhanced sensitivity of the gelatin silver halide combination to deliver ready-to-use pre-sensitized and stable plates to photographers. Compare with waxed paper negative process.

Dye: a water-soluble colourant. Many colour photographic processes use synthetic or natural dyes to form images. Usually a mordant is necessary to stabilize the dye in place and make it less soluble; or the dye can be transformed into a non-soluble lake. Compare with pigment, below.

Dye coupler print: a synonym for chromogenic print, see page 298.

Dye destruction process: describes the way silver dye-bleach prints are made, see page 304.

Dye diffusion process: describes the way instant dye prints are made, see page 306.

Dye imbibition print: see page 302.

Dye Transfer (Kodak) print: the brand name for the most common version of dye imbibition print, see page 302.

Enlargement: a mode of photographic printing. Using an optical-mechanical device – an enlarger – small-format negatives can be used to produce larger prints by projecting the image onto a printing paper from a distance. While were available in the albumen print era, enlarging only became widespread with the advent of negatives from small-format cameras, sensitive gelatin silver bromide DOP and powerfully luminous electric light bulbs. Compare with contact printing.

Exposure: the moment when a light-sensitive material is illuminated, either in a camera or through a negative in a printing frame or enlarger. Camera exposure parameters include the inherent brightness of the scene, the lens aperture and the duration of the lens shutter opening. The amount of exposure required is determined by the sensitivity of the particular light-sensitive material. See sensitivity.

Ferro-prussiate process: is sometimes used to describe the way cyanotypes are made, see page 254.

Ferrotype: a synonym for tintype, see page 266.

Fixer: a liquid mixture of compounds designed to dissolve residual undeveloped silver halide after a printing-out exposure or a development step; fixing renders the photograph stable and no longer sensitive to light. The most common fixing agent is sodium thiosulphate – called sodium hyposulphite in the nineteenth century and shortened to "hypo" by many photographers.

Gelatin silver bromide paper: photographic printing paper that uses bromide as the halide source that combines with silver to form a light-sensitive component; bromide paper is sufficiently light-sensitive to be used in enlargement printing. See Gelatin Silver Print, page 280.

Gelatin silver chloride paper: photographic printing paper that used chloride as the halide source that combines with silver to form a light-sensitive component. Chloride paper could be developed out, but it did not have sufficient sensitivity to be used for enlarging – it was strictly used for contact printing. At the time of its introduction in the 1890s it was referred to as "gaslight paper" since it could be exposed indoors using a gas lamp, a common indoor light fixture at the time. See Gelatin Silver Print, page 280.

Gelatin Silver Print – Developing-out Paper: see page 280.

Giclée print: is a synonym for inkjet print, see page 308.

Grain: the image structure of a photograph seen magnified to the point where it becomes detectable. Image grain is characteristic of different printmaking media and can be used to identify processes. The grain of half-tone images – common among photomechanical processes – is usually visible using the magnification obtained with a magnifying loupe (10×). Continuous tone images require higher degrees of magnification to visualize photographic grain. This word can also describe a visual effect seen in a highly enlarged print.

Gum bichromate print: see page 290.

Half-tone image: describes the character of most photomechanical processes, which produce images that consist of tiny spots that are either dark (image) or light (non-image) when viewed under moderate magnification (with a 10× loupe). When viewed from a slight distance without magnification, these on-or-off dots resolve themselves into a readable visual image that appears to have all the intermediate densities. Half-tone grain varies according to dot size, shape, and spacing; the dot network may be a regular screen pattern or may be random. Compare with continuous tone image.

Hand-colouring: used throughout the nineteenth and well into the twentieth centuries to add colour to what were necessarily monochrome photographic images. A range of coloured media and painting techniques were employed over time, but thin washes of watercolour applied over mid-tone areas is the most common, and most convincing, form of hand-colouring.

Ilfochrome print: a common brand of silver dye-bleach print, see page 304.

Image particle: an agglomeration of metallic silver or dye molecules or pigment particles that forms the basic structure of a photographic image. Where image particles are most concentrated, density is high; where they are most thinly distributed, density is at a minimum. In some processes – such as the daguerreotype and ambrotype – this relationship between concentration of image particles and optical density is inverted.

Inkjet print: see page 308.

Instant dye print: see page 306.

313

Instant silver print: is produced by the monochrome (black-and-white) version of the instant dye print process.

Integral film: the instant dye print format in which there is a single sheet delivered from the camera that requires no further manipulation or treatment; after a short time a full-colour image emerges under normal room lighting on the face of the print. An example is the Polaroid SX-70 format. Compare with peel-apart film. See Instant Dye Print, page 306.

Interference (of light waves): a physical phenomenon in which two coincident complex light waves – each incorporating many frequencies of radiation – superimpose themselves on one another, amplifying some frequencies (constructive interference) and nullifying others (destructive interference). Such amplification and suppression can result in the direct rendering of colour in structures such as feathers, soap bubbles and Lippmann photographs. See direct colour reproduction, and also Lippmann Colour Plate, page 288.

Interferential colour photography: see Lippmann Colour Plate, page 288.

Iris: a brand name of an early inkjet print system, see page 304.

Lantern slide: see page 264.

Lens: an optical device common to all modern cameras which allows a focused, reversed and inverted image to form on the surface where image capture takes place, whether that be a sensitized daguerreotype plate or a charge coupled device or CMOS sensor in a digital camera. Lens technology substantially pre-dates photography (in telescopes, microscopes, eyeglasses, cameras obscura), but the arrival of photography occasioned tremendous progress in camera lens design.

Lippmann colour plate: see page 288.

Matte albumen silver print: see page 294.

Mount: the auxiliary support(s), usually paper or cardboard, to which a photographic print is adhered. The purpose of mounting may be decorative or to provide additional support. The large-format prints commonly encountered in current contemporary art practice require mounting to remain undamaged; mounts for such photographs are usually made of metal or plastic resins rather than paper products. This word is used in Britain to denote aperture mats made for display and housing.

Negative: a photograph where the tonal relationships (shadows – intermediate tones – highlights) are reversed relative to the appearance of the original scene. Negatives are usually a first-generation product derived directly from a camera exposure, but not always. Negatives are usually held on a transparent support such as glass or plastic film, but negative prints on paper are known. Negative images are laterally reversed when viewed from the front, so they are flipped over for printing. Some photographs, such as ambrotypes, can be either negative or positive, depending on viewing conditions. The term is largely anachronistic in relation to digital images. Compare with positive.

Offset lithographic processes: a wide range of industrial printing technologies that emerged in the early twentieth century and which, in advanced and highly efficient form, still account for the bulk of commercial printing today. Offset printing may be in black-and-white or colour, for text and images, and is suitable for large press runs. Modern printing presses are largely controlled by computers and fully integrate digital images as source material.

Oil processes: photographic printing techniques that use the light sensitivity of dichromated gelatin systems, resulting in the selective hardening of the gelatin layer. This is similar to the pigment processes, but the oil processes are characterized by a final step in which greasy printers' ink is spread onto the partly wetted, partly dry gelatin: where hardening has taken place, the gelatin remains dry and the ink is accepted; where no light has fallen, the gelatin remains unhardened, swollen with water and unable to retain the oil-based ink. In addition to the standard oil print, the bromoil print and the bromoil transfer print are the only significant variants.

Palladium print: a variant of the platinum print, see page 276.

Paper negative: see page 252.

Passe-partout is a term used in English to describe a type of housing, made primarily from glass and paper, found on daguerreotypes of French

or German origin. The paper aperture mat is often decorated with hand-drawn or printed lines or figures. Compare with cased photograph.

Peel-apart film: the instant dye print format in which a two-component layered package is delivered from the camera. After a specified delay, during which the dye diffusion transfer process occurs, the two layers are separated (peeled) from one another to leave an image receiving layer with the positive image evident and a second layer that contains residual processing chemicals and a negative image. Black-and-white and early colour Polaroid materials were all peel-apart format. Compare with integral film. See Instant Dye Print, page 306.

Photogenic drawing: William Henry Fox Talbot's first successful photographic technique. It is a simple, direct and flexible material that he used for making photograms, camera negatives and positive prints from negatives. See Salted Paper Print, page 246.

Photogram: a photographic image made without using a camera. Translucent or opaque objects are placed directly on sensitized photographic paper and exposed to sufficient light to make a pleasing contrast between the fully exposed paper and the partially exposed profile of the object. William Henry Fox Talbot, Anna Atkins, and Man Ray all made significant use of the photogram technique. Talbot first called such images or shadow images; Man Ray called his "Rayograms."

Photogravure: see page 258.

Photomechanical processes: the set of techniques designed to provide large print runs of photographic positives for use in publications. Most of these processes result in an ink-on-paper image derived from a printing plate used in a (mechanical) press, and which involved no light exposure step to produce the final print image. Most photomechanical processes result in half-tone images. Examples are collotype, offset lithography, photogravure, photolithography, woodburytype.

Photomicrograph: a photograph taken through a microscope.

Photolithograph: a print made by transferring a photographic image to a lithographic stone or plate using a dichromated colloid step. It is a half-tone, photomechanical process print that is materially identical to a conventional lithograph but is derived from a photograph rather than a hand-drawn image.

Pigment: an insoluble colourant. Pigments may be processed from natural materials or may be synthesized. The pigment processes and the oil processes all use pigment particles suspended in some kind of stable, film-forming medium. Pigments have been used increasingly in photographic printing with the advent of ink sets for inkjet printing that contain encapsulated or solvent-borne pigments. Compare with dye.

Pigment processes: the techniques that result in prints with an image-carrying layer made up of pigment particles suspended in a colloidal film of varying thickness, adhered to a paper support; where the film is thicker, the image density is darker; where it is thin, the image is lighter. These processes all depend on the dichromated colloid system (see Dichromated colloid processes) to selectively harden the carrying film. Carbon prints, carbro prints and gum bichromate prints are all pigment processes. Confusingly, inkjet prints are sometimes called "archival pigment prints."

Plain paper print: a synonym for salted paper print, see page 246.

Platinum print: see page 276.

Platinotype: a synonym for platinum print, see page 276.

Print: a photograph – usually a positive, often on a paper support – rendering an image derived from an earlier generation of a photographic object, such as a negative or a digital image. The photographer/printer can substantially modify and interpret the source material during the printing step.

Printing-out processes: print techniques in which the silver-halide is reduced to metallic silver solely by the actinic power of light, usually by the ultraviolet component of daylight; they do not require a separate developer step. Once fully "printed out" (made visible) in daylight under a negative they are toned, fixed and washed. Printing-out papers are almost always used in contact printing mode. Salted paper prints, albumen silver prints and, of course, POP are the most common printing-out processes.

Polaroid: an American company founded in 1937 by Edwin Land; the company designed the diffusion print processes and the customized cameras that were critical in the creation of instant silver prints and instant dye prints. See page 306.

POP – Printing-out paper print: see page 284.

Positive: a photograph where the tonal relationships (shadows – intermediate tones – highlights) are the same as in the original scene. Positives are often a second-generation product derived directly from a negative, although there are a number of direct positive processes (see Direct Positive). Positives are usually held on an opaque support such as paper, although there are many alternative support materials, including opaque and transparent films, glass and even metal panels. Some photographs – such as the daguerreotype or the ambrotype – can be either negative or positive depending on viewing conditions. The term is largely anachronistic in relation to digital images. Compare with negative.

Projection: a mode of viewing in which a photograph on a transparent base is transmitted and enlarged onto a reflective surface through an optical lens system. Digital images can be projected from a digital projector. Film negatives are projected in the course of making an enlarged print. See Lantern Slide (p. 264) for an example of a process designed for projection.

Resolution: measures a photograph's capacity to record distinguishable details of the subject photographed. The composite resolution of an image is determined by the resolving capacity of each component in the imaging chain, including the lens used to make the original image (lens resolution), the resolution of the recording system (film or image sensor resolution) and the display system (print material or digital projector resolution). Human visual acuity may also play a limiting role in overall resolution, which is why we present photomicrographs in the Processes and Formats section.

Reversal processing: a variant technique in film processing that results in a positive image on the camera material, rather than the negative typical of a conventional processing sequence. 35 mm slides, for instance, are reversal processed.

Salted paper print: see page 246.

Salt print: a synonym for Salted Paper Print, see page 246.

Sensitivity: measures a photographic system's capacity to be affected (exposed) by a given quantity of light. Sensitivity determines how long a camera exposure must last to record an image successfully. In the era of silver-halide photography, many numerical systems were developed to describe film sensitivity; the most recent one is the ISO system. The sensitivity of photographic materials remained well below the equivalent of ISO 1 until the mid 1870s when spectral sensitization and gelatin emulsions came into use; by the 1980s film rated at ISO 1000 – that is, more than 1000 times "faster" than those early camera materials – were widely available in the consumer market.

Silver dye-bleach print: see page 304.

Silver-halide processes: use the light sensitivity of the halide salts of silver: silver chloride, silver bromide, silver iodide, and occasionally silver fluoride. These compounds, alone or in combination, were the basis of photography from the time of Talbot and Daguerre until the advent of digital imaging. Exposure to light leads to a photo-chemical reduction of silver-halide atoms to produce metallic silver. The dichromate systems are exceptions in that they do not use silver-halide components. Compare with Dichromated colloid processes.

Stereograph (also stereogram): see page 248.

Stereoscope/stereo viewer: the optical device through which a stereograph is viewed to produce a three-dimensional effect. See Stereograph (also stereogram), page 248.

Subtractive colour system: a trichromic colour synthesis in which materials such as pigments or dyes having the three subtractive primary colours (cyan, magenta, yellow) are mixed to render all the possible colours of the spectrum. Most colour photographic prints designed to be viewed by reflected light use subtractive colour mixing. Modern colour lithographic and inkjet printing systems add a black colour to the three additive primaries to achieve greater colour density – this is the CMYK system. Compare with additive colour system.

Tintype: see page 266.

Toning: a step in the processing of silver-based photographs in which the image tone and contrast can be modified and the stability of the image particles can be enhanced. Gold toning was the most common procedure chosen in the nineteenth century, although platinum, mercury and sulphides were also used. In the gelatin silver print era, toning was used to neutralize the warm tones of POP and to warm the cool tones of developed-out papers. Later, as photographic papers evolved and contained less silver, toning for permanence with metals such as selenium became a standard part of good processing.

Transparency: a photograph designed to be viewed by transmitted rather than reflected light. They are printed on a transparent or translucent support – glass or plastic film, usually. Small transparencies such as lantern slides (see p. 264) and 35 mm slides are designed to be projected. Large-scale film transparencies, increasingly accessible to photographers since the 1970s, are designed for viewing on illuminated panels (lightboxes).

Trichromy: allows the rendering, in natural colours, of a scene from nature using a synthesis of only three primary colours. There are two ways in which this can be done: in the additive colour system three coloured lights (red, green and blue) are combined in proportions that render all of the possible colours; the subtractive colour system mixes three coloured materials (magenta, cyan, yellow) to achieve the same end. Most colour reproduction systems use trichromic mixing, a phenomenon first demonstrated in 1861 by the physicist James Clerk Maxwell and the photographer Thomas Sutton. Compare with direct colour reproduction.

Union case: a type of housing for daguerreotypes, ambrotypes or tintypes common in the United States after 1854. They have the familiar case form – tray and cover hinged together, velvet cushion inside – but the case structural elements are made from an early thermoplastic material formed in a mould process. Elaborate decorative motifs and even genre scenes could be incorporated into the moulded profile on the exterior of the case.

Waxed paper negative process: a variant on the calotype paper negative that was suggested in 1851 by Gustave Le Gray. Here, the paper was treated with molten wax sensitization, rather than the previous practice of applying wax only exposure. This "dry" process – calotype paper was damp while being exposed – allowed negative paper to retain its sensitivity for a longer period, enabled processing to be delayed several days after exposure and provided a more translucent base. However, the dry process was somewhat less sensitive than the calotype. See Paper Negative, page 252.

Woodburytype: see page 272.

Chronology: A Collection in the Making

Compiled by Charlotte Gagnier

From 1923 to the late 1950s the National Gallery of Canada periodically presented exhibitions of photographs organized by a variety external of sources. Some of these highlighted Camera Club photography (*The Canadian International Salon of Photographic Art*, 1934), others presented wartime propaganda (*War for Freedom; Somewhere in France*, 1940; *Twenty-five Years of the Soviet Union*, 1943; and *This is Our Strength* and *The Urals – Arsenal of The Red Army*, both in 1944).

By 1951, the National Gallery Act had expanded its definition of "works of art" to include "pictures, sculpture and other similar property." In the decade to follow, the Gallery presented some of the first monographic exhibitions, including: *Henri Cartier-Bresson: The Decisive Moment: Photographs, 1930–1957*, circulated by the American Federation of Arts, New York and exhibited at the Gallery 11–30 November 1958; *Portraits of Greatness: Photographs by Yousuf Karsh*, 23 September to 23 October 1960; *A Not Always Reverent Journey: Photographs by Donald W. Buchanan*, 16 March to 9 April 1961; and *Robert Capa: War Photographs*, produced by Magnum Photos in co-operation with *LIFE Magazine* and circulated by the Smithsonian Institution, 1–25 March, 1962. This suggested a more serious reception of photography by the Gallery.

Chief Curator R.H. Hubbard noted, in 1962, that national museums do not collect works that record the history of architecture or photography and proposed the Gallery be "given the means and space to undertake these tasks," adding that to prevent the Gallery becoming too involved in matters "apart from its own essential function" these tasks should be at some point transferred to a new museum of applied arts.

In 1964, the Board of Trustees accepted revisions to the National Gallery Act, proposed by members Jean M. Raymond and Donald W. Buchanan, that expanded the term "works of art" to include fine photography as it would be collected at the National Gallery of Canada. The volume of photography exhibitions per year increased noticeably, starting with *The Photographer and the American Landscape* (24 January to 16 February, organized and circulated by Museum of Modern Art, New York), followed by *The World Through One Eye: 28 Photographs by Philip Pocock* and *24 Photographs by Jean Forest*. The latter two circulated in Canada. In 1965 *The Art of Early Photography*, organized by Ralph Greenhill, ran from 7 May to 20 June. In May 1965, Hubbard recommended the Gallery establish a department of Photography, build up a collection and appoint a curator. Six months later, James Borcoman was appointed head of the new Exhibitions and Education branch.

In 1966, as if in anticipation of announcing the decision to start collecting photographs the Gallery organized and hosted three important exhibitions: *Pleasure of Photography: The World of Roloff Beny* shown at the Gallery from 25 March to 17 April and circulated in Canada from May to December; *The Photographs of Jacques Henri Lartigue*, organized by MoMA, was exhibited at the Gallery from 16 September to 12 October concurrently with *Walker Evans: An Exhibition of Photographs from the Collection of the Museum of Modern Art, New York*, both circulating in Canada until December. The Lartigue and Evans exhibitions were billed as the first of a series of shows aimed at stimulating the public's interest in "good photography." In her first report to the Board of Trustees, the newly appointed director, Miss Jean Sutherland Boggs, wrote: "it also seems to me time to begin a collection of photography..." and named James Borcoman as acting Curator of Photography.

What follows is a selected chronology of the collection's evolution and major gifts and acquisitions.

* denotes accompanying publication

1967

31 January: Beaumont Newhall lectures on *Photography in America in 1867*.

17 February: *Photography in the Twentieth Century*, organized by Nathan Lyons, Associate Director, George Eastman House. By popular demand, the show is extended beyond scheduled closing date of 2 April; the exhibition circulates in Canada July to February 1968.

18 February: Nathan Lyons, Associate Director, George Eastman House, moderates a photography symposium for 45 photographers and museum personnel from Montreal, Toronto and Ottawa.

The Gallery purchases three William Henry Fox Talbot calotype prints dating from the 1840s.

In her Report of the Director, Miss Jean Boggs notes the success of *Photography in the Twentieth Century*: "it is a reflection of the National Gallery's increasing recognition of the importance of photography and of the special interest of its Director of Exhibitions and Education, James Borcoman." She adds that Mr. Borcoman's position as Curator of Photography will be made permanent when the Gallery can afford it.

4 April: André Jammes lectures on *La photographie en France en 1867: un second souffle*.

James Borcoman travels internationally, purchasing photographs for the Gallery's collection and researching and studying the history of photography.

With purchases of several hundred prints, many from the collection of André Jammes in Paris, the Gallery now has the basis for a study collection with an emphasis on the development of photography as an art in the nineteenth century.

Early acquisitions include works by Eugène Atget, Felice Béato, Louis-Désiré Blanquart-Evrard, Julia Margaret Cameron, Maxime Du Camp, Frederick Evans, V. Gay, David Octavius Hill and Robert Adamson, Gustave Le Gray, and Charles Nègre.

8 December: James Borcoman reports to the Board of Trustees on the importance of the photography department and how the collection will complement those at the National Film Board of Canada and Public Archives.

1968

1 April: National Gallery is amalgamated under the National Museums of Canada Corporation.

The Gallery establishes a photography acquisition policy: "directed toward photography as an art form and [focusing on] ... earlier and, normally, non-Canadian photography."

18 April to 12 May: *Photographs by Eugène Atget*, organized by the George Eastman House, Rochester, New York.

14 June to 14 July: *Contemporary Photographers: Toward a Social Landscape*, arranged and circulated by George Eastman House, Rochester, New York.

Dorothy Meigs Eidlitz, St. Andrews, New Brunswick (American, 1891–1976) patron and photographer donates 279 works, including works by Eugène Atget, Konrad Cramer, Ansel Adams, Gertrude Käsebier, Lisette Model, Eadweard Muybridge and Nadar. Her donation also includes some of her own photographs.

1969

21 February to 23 March: *Aaron Siskind, Photographer*, organized by George Eastman House; circulated in Canada Sept 1968 to May 1969.

Four Montreal Photographers: Marc-André Gagné, Ronald Labelle, John Max and Michel Saint-Jean, circulated in Canada September to November 1970.

1 September: James Borcoman begins education leave, completing his graduate work at the University of Buffalo and the Visual Studies Workshop in Rochester in June 1971.

1970

James Borcoman is appointed Curator of Photographs. He seeks to fill gaps in the collection, especially work by British photographers, while continuing to add to the strong holdings of French photography.

Dorothy Meigs Eidlitz donates 87 works including stereographs, carte-de-visites, cased photographs and photo albums.

1971

16 April to 30 May: *French Primitive Photography*, organized by the Philadelphia Museum of Art (work from the collection of André Jammes).

* 10 September to 10 November: *The Photograph as Object, 1843–1969: Photographs from the Collection of the NGC*; organized for the Art Gallery of Ontario, Toronto and circulated in Canada.

26 November to 2 January 1972: *Photo Eye of the 20s*, circulated by Museum of Modern Art, New York.

1972

* 1 May to 31 May: *Notations in Passing, 1970: Photographs by Nathan Lyons from the collection of the National Gallery*, curator: James Borcoman. Circulated in Canada from February 1972 to January 1973. Associated publication by Nathan Lyons and James Borcoman.

Photographs by Charles Gagnon, circulated in Canada August to January 1974, organized by the artist.

1 May to 16 March 1973: James Borcoman acts as Head of Publications.

The Gallery publishes "Notes on the Relationship of Photography and Painting in Canada, 1860–1900," by Ann Thomas, in *The National Gallery of Canada Bulletin*.

1973

14 September to 21 October: *Harry Callahan – City*, organized by the George Eastman House of Photography, Rochester.

Acquisition of 84 prints by Auguste Salzmann.

1974

15 March to 21 April: *Diane Arbus*, organized by the Museum of Modern Art, New York.

2 August to 8 September: *Walker Evans*, organized by the Museum of Modern Art, New York.

1975

4 April to 19 May: *Photographs from the Collection*, curator: James Borcoman.

Canadian Architect and Philanthropist Phyllis Lambert donates *Gardner's Photographic Sketch Book of the War* (1866) an album containing 99 albumen silver prints by Alexander Gardner and contemporaries. Acquisition of album by William Henry Fox Talbot containing 48 salted paper prints.

1976

21 May to 20 June: *Charles Nègre*, curator: James Borcoman.

* 10 September to 17 October: *The Camera as Engineer's Witness*, curator: James Borcoman. Circulated in Canada November to May 1977. Associated publication by Ralph Greenhill.

19 November to 2 January 1977: *British Photographers: 1844–1974*, curator: James Borcoman.

1977

Exhibition catalogue *Charles Nègre*, by James Borcoman, receives the Distinguished Achievement Award from the Photographic Historical Society of New York and a bronze medal from the Leipzig International Book Fair.

18 March to 17 April: *Photographs from the Collection*, curator: James Borcoman.

2 September to 9 October: *John Vanderpant: Photographs*, organized by Charles C. Hill; circulated in Canada December 1976 to July 1977.

Harold F. Kells fonds donated to the National Gallery of Canada Library and Archives by Margaret Kells.

1978

Ann Thomas hired as Assistant Curator at the National Gallery of Canada.

6 April to 10 May: *Photographic Crossroads: The Photo League,* organized by the Visual Studies Workshop and by Anne Tucker, Curator of Photography, Houston Museum of Fine Arts.

* 18 July to 4 September: *Process and Transformation: Eleven American Photographers*, organized by James Borcoman in co-operation with the Visual Studies Workshop, Rochester, N.Y.; circulated in Canada November 1977 to June 1978.

1979

27 April to 24 June: *The Painter as Photographer: David Octavius Hill, Charles Nègre and Auguste Salzmann*, Jointly organized by the NGC and the Vancouver Art Gallery, James Borcoman and Peter Malkin.

14 September to 11 November: *Documentary Photography in Canada*, 1850–1920, organized by Ralph Greenhill. Circulated in Canada January to June.

David Heath: A Dialogue with Solitude, curator: James Borcoman. Circulated in Canada 5 October to 20 April 1980.

Phyllis Lambert Photography Fund is established for exceptional purchases.

1980

9 November to 6 January: *Points of View: Photographs of Architecture from the Collection of the National Gallery of Canada*, curator: Ann Thomas. Circulated in Canada January to December 1981.

* 9 May to 21 June: *The Magical Eye: Photographs in the National Gallery,* curator: James Borcoman. Circulated in Canada July to November.

3 October to 1 February: *Gifts to the Photography Collection,* curator: James Borcoman.

1981

16 April to 14 June: *Photography in France 1843–1920*, curator: Ann Thomas. Circulated in Canada April to July 1984.

3 July to 30 August: *Return to Daylight: Photographs of Pompeii by Giorgio Sommer*, presenting a recent gift of photographs from Ottawa collector D.C. Thom; organized by Michael Pantazzi.

13 November to 10 January 1982: *Shanghai 1949: Photographs by Sam Tata,* curator: Ann Thomas.

1982

Gallery receives significant gift of 280 gelatin silver prints by Walker Evans from Phyllis Lambert.

1 May to 27 June: *Photographs by Bill Brandt*, organized by Mark Haworth-Booth, Victoria & Albert Museum, London, coordinated by James Borcoman.

* 23 July to 25 October: *Eugène Atget 1857–1927*, curator: James Borcoman. Circulated in Canada February 1883 to August 1984.

23 September to 7 November: *August Sander: Photographs of an Epoch, 1904–1959*, organized by the Alfred Stieglitz Centre of the Philadelphia Museum of Art.

1983

* 12 February to 17 April: *Eikoh Hosoe: Killed by Roses*, curator: Ann Thomas.

3 November to 2 January: *Sydney Grossman: Photographs 1936–1955,* organized by the Museum of Fine Arts, Houston, Texas.

25 November to 29 January 1984: *Walker Evans: The Phyllis Lambert Gift.*

1984

14 September to 11 November: *Photography and Architecture*, 1839–1939, organized by the Canadian Centre for Architecture, Phyllis Lambert and Richard Pare. In conjunction, Gallery presents symposium "Photography & Architecture: 1839 to the Present Day," 29–30 September.

1985

January: Canadian Museum of Contemporary Photography is founded and affiliated with the Gallery. The CMCP's mandate is to promote contemporary Canadian photography both as a documentary and artistic medium. The collection begins with photographs from the Still Photography Division of the National Film Board of Canada.

* 7 June to 2 September: *Environments Here and Now: Three Contemporary Photographers; Lynne Cohen, Robert del Tredici, Karen Smiley*, curator: Ann Thomas. In conjunction with the exhibition, the Gallery hosts a panel discussion with the three artists.

1988

Phyllis Lambert donates 129 daguerreotypes in celebration of the opening of the new National Gallery of Canada building.

21 May to 19 February: *Intimate Images: 129 Daguerreotypes 1841–1857; the Phyllis Lambert Gift*, curator: James Borcoman.

21 May to 5 September: *Karsh: Portraits of Artists*, curator: James Borcoman.

Lori Pauli is hired as a curatorial assistant for the Lisette Model exhibition.

1989

7 April to 28 May: *Henri Cartier-Bresson: The Early Work 1929–1934*, curator: Peter Galassi, Museum of Modern Art, New York.

29 June to 4 September: *The Cherished Image: Portraits from 150 Years of Photography at the National Gallery of Canada*, curator: James Borcoman.

* 29 June to 4 September: *Karsh: The Art of the Portrait*, curator: James Borcoman. Circulated in Canada June 1990 to November 1992.

15 September to 19 November: *American Prospects: The Photographs of Joel Sternfeld*, curator: Anne W. Tucker, Houston Museum of Fine Arts, Texas.

8 December to 4 February 1990: *Breaking the Mirror: the Art of Robert Bourdeau,* organized and circulated by the Winnipeg Art Gallery, modified by the Gallery for Ottawa showing.

1990

* 5 October to 6 January 1991: *Lisette Model*, curator: Ann Thomas. Circulated internationally February 1991 to December 1992.

The Estate of Lisette Model donates 261 exhibition-quality prints and the Model Archive, as well as a generous endowment to establish The Lisette Model/ Joseph G. Blum Fellowship in the History of Photography. Between 1991 and 2012, twenty-three scholars benefit from the Fellowship.

Lisette Model catalogue receives Wittenborn Award.

1991

1 March to 14 April: *Building the Collections: Recent Acquisitions of Prints, Drawings and Photographs*, photography section curator: James Borcoman.

20 September to 17 November: *Atget, Evans and Friedlander: Correspondences,* curator: James Borcoman.

1992

Lori Pauli becomes Curatorial Assistant for the Photographs Collection.

19 June to 7 September: *All Things that Light Can Be, Photography 1889–1950*, curator: Ann Thomas.

9 October to 10 January 1993: *Women Photographed 1849–1988*, curator: Lori Pauli.

1993

19 February to 9 May: *Observing Traditions: Contemporary Photographs 1975–1993*, curator: Ann Thomas.

* 18 June to 6 September: *Magicians of Light: Photographs from the Collection of the National Gallery of Canada,* curator: James Borcoman. Circulated in Canada June 1995 to April 1996.

1 October to 9 January: *Mortal Yet Divine: Victorian Photography*, curator: Lori Pauli and Ann Thomas.

Photography Collectors' Group is formed to support the Gallery by donating contemporary work to the collection.

1994

4 February to 17 April: *John Coplans: A Self-Portrait*, curator: James Borcoman.

20 May to 5 September: *Sun Illustrations: Photographs of the Near East, 1841–1885*, curator: Ann Thomas.

15–29 September: *Moving Pictures: Films by Photographers*, organized by the American Federation of Arts.

21 October to 8 January 1995: *From Light to Dark: The Look of Photographic Prints*, curator: John McElhone; circulated in Canada June to May 1996.

18 November to 15 January 1995: *Combinations/Dislocations: Collage, Assemblage, and Photomontage from the Collection*, curator: Ann Thomas.

James Borcoman retires.

1995
10 February to 18 June: *Leon Levinstein: The Moment of Exposure*, guest curator: Robert Shamis; circulated internationally July to December.

14 July to 29 October: *Rituals and Transformations: Photographs 1977–1994*, curator: Ann Thomas.

1996
4 April to 9 September: *Vintage Weston*, curator by Lori Pauli; circulated in Canada September 1996 to November 1997.

October to 5 January 1997: *The Male Nude in Photography*.

Celebrating a Vision: Thirty Years of Collecting Photographs at the National Gallery of Canada, October 11 to September 7, curators: Ann Thomas and Lori Pauli. An historical survey of works from the NGC permanent collection homage to James Borcoman, founding curator.

Lori Pauli is promoted to Assistant Curator of Photographs.

1997
14 February to 19 May: *Remembering Ralph Greenhill, 1924–1996*, curator: Ann Thomas.

20 June to 14 September: *Faithful Likeness: Nineteenth-Century Portrait Photography in France*, curator: Ann Thomas.

18 July to 11 January 1998: *Poetic Evidence: Science in Contemporary Photography*, curator: Ann Thomas

* 17 October to 4 January 1998: *Beauty of Another Order: Photography in Science*, curator: Ann Thomas.

Beauty of Another Order: Photography in Science catalogue receives Kraszna Kraus award

24 October to 25 January 1998: *Living Spaces: India through the Photograph and the Miniature Painting*. October 24 to January 25 1998, curator: Ann Thomas, researcher Dipna Horra, Carleton University.

1998
13 February to 24 May: *Yousuf Karsh: Portraits of Artists*, curator: Ann Thomas; circulated internationally December 2000 to May 2001.

15 September to 12 March 2000: *A Passion for Life: Photographs by André Kertész*, curator: Lori Pauli; circulated in Canada.

Lori Pauli is appointed Associate Curator of Photographs.

The Christel Gang fonds, purchased by the Gallery in 1979, is transferred to the National Gallery of Canada Library and Archives.

1999
5 February to 2 May: *A Collective Vision: Gifts to the Photographs Collection*, curator: Ann Thomas.

8 October to 2 January 2000: *Reflections on the Artist: Self-Portraits Portraits of Artists*, co-curators: Richard Hemphill and Lori Pauli.

2000
11 February to 7 May: *Mexico as Muse: Photographs 1923–1986*, curator: Ann Thomas

* 29 September to 7 January: *Fairy Tales for Grown-Ups: The Photographs of Diane Arbus*, curator: Lori Pauli. Circulated in Canada February 2001 to February 2002.

29 September to 2 February: *Natural Magic: William Henry Fox Talbot (1800–1877) and the Invention of Photography*, curator: Ann Thomas. Circulated in Canada February 2003 to November 2003.

6 December to 22 April 2001: *Buenos Aires Biennale – Yousuf Karsh Portraits*, First International Art Biennial of Buenos Aires presented 32 works by Karsh; curator: Ann Thomas.

2001
9 May to 31 December: *With Kind Regards ... Canadian Souvenir View Albums,* May 9 to Dec 31 2001.

Ilse Bing fonds donated to the National Gallery of Canada Library and Archives by the Ilse Bing Estate.

2002
1 February to 12 May: *No Man's Land: The Photographs of Lynne Cohen*, curator: Ann Thomas. Circulated in Canada October 2001 to April 2003.

F. Maxwell Lyte fonds donated to the National Gallery of Canada Library and Archives by M.C. John Lewall, David B. Lewall, and Edward F. Lewall.

Charles F. Gagnon fonds donated to the National Gallery of Canada Library and Archives by the artist.

2003
* 31 January to 4 May: *Manufactured Landscapes: The Photographs of Edward Burtynsky*, curator: Lori Paul. Circulated in Canada May 2003 to January 2006.

Leon Levinstein fonds donated to the National Gallery of Canada Library and Archives by the American Friends of Canada Committee, Inc.

2004
30 January to 2 May: *Faces, Places, Traces: New Acquisitions to the Photographs Collection*, curator: Ann Thomas.

Lynne Cohen fonds donated to the National Gallery of Canada Library and Archives by the artist.

2006
24 February to 25 June: *Portraits from the Photographs Collection*, curator: Ann Thomas

* 16 June to 1 October: *Acting the Part: Photography as Theatre*, curator: Lori Pauli; circulated in Canada February 2007 to May 2007.

10 November to 11 March 2007: *Master of the Instant: Cartier-Bresson Photographs from the National Gallery of Canada*, curator: Ann Thomas.

2007
16 March to 13 August: *A Selection of Works from the Permanent Collection of Photographs – August Sander*, curator: Pauli Lori.

* 4 May to 26 August: *Modernist Photographs from the National Gallery of Canada*, curator: Ann Thomas; circulated in Canada September 2007 to January 2010. The first in a series of exhibitions focusing on selected masterpieces in Photographs collection of the NGC.

17 August to 12 November: *A Selection of Works from the Permanent Collections of Photographs: Platinum and Photogravure*, curator: Ann Thomas.

12 October to 6 January: *Snap Judgments: New Positions in Contemporary African Photography*, organized by the International Centre of Photography, New York.

17 November to 16 March 2008: *On Reading: Photography and Books*, curator: Lori Pauli.

2008
The Photography Collectors Group, Ottawa, donates *Wonder Valley #12* by Mark Ruwedel to the Gallery "in honour of James Borcoman, as an expression of its esteem for his friendship and support" on the occasion of their 15th anniversary.

21 March to 13 July: *"From Today Painting is Dead!": Humour and the Invention of Photography*, curator: Ann Thomas.

* 30 May to 2 October: *Utopia/Dystopia: The Photographs of Geoffrey James*, curator: Lori Pauli. Circulated in Canada October 2009 to January 2011.

23 July to 26 October: *A Passion for Life: Photographs by André Kertész*, curator: Lori Pauli

15 November to 21 June 2009: *Lewis Wickes Hine: Social Photographer*, curator: Ann Thomas.

2009
Canadian Museum of Contemporary Photography and its collection move permanently into the National Gallery of Canada building.

18 April to 20 September: *Yousuf Karsh and Edward Steichen: The Art of the Celebrity Portrait*, curator: Ann Thomas; circulated in Canada May 2010 to September 2011.

4 July to 27 September: *Ball Parks: Jim Dow's Photographs of Baseball Stadiums*, curator: Ann Thomas.

24 October to 10 January 2000: *Recent Acquisitions to the Photographs Collection,* curator: Ann Thomas.

Donald W. Buchanan fonds acquired by the National Gallery of Canada Library and Archives.

Andreas Feininger fonds donated to the National Gallery of Canada Library and Archives by the Estate of Gertrud E. Feininger.

2010

Lori Paul is promoted to Curator of Photographs.

The Gallery receives a gift of more than 3500 works from an anonymous donor, including more than 1700 works by Josef Sudek, 200 by Frederick Evans and circle; images from several news archives and agencies including a significant selection from the Argentinian news agency Editorial Haynes, a portion of the Sydney Morning Herald archive, as well as an archive of more than 1,000 photographs documenting the history of aviation.

* 5 February to 16 May: *19th-Century French Photographs from the National Gallery of Canada*, curator: James Borcoman; circulated in Canada November 2010 to January 2012.

Additional donation to the Charles F. Gagnon fonds to the National Gallery of Canada Library and Archives by Monika Kin Gagnon.

2011

* 4 February to 17 April: *19th-Century British Photographs from the National Gallery of Canada*, curator: Lori Pauli. Circulated in Canada May 2012 to October 2013.

30 April to 21 August: *Andreas Feininger: Nature and the Architect*, curator: Ann Thomas.

13 May to 21 August: *The Study of Hands*, curator: Lori Pauli.

1 June: Following the transfer of the holdings of the Canadian Museum of Contemporary Photography to the Gallery, Andrea Kunard, Associate Curator, and Jonathan Newman, Curatorial Assistant officially join the staff of the Gallery's Photographs Department.

13 June to 5 September: *Fred Herzog: Street Photography*, curator: Andrea Kunard; circulated in Canada from January to April 2013.

14 September to 23 December: *Ulysse Comtois: Photographs*, at National Gallery of Canada Library and Archives.

* 9 December to 1 April: *Made in America 1900–1950: Photographs from the National Gallery of Canada*, curator: Ann Thomas. Circulated in Canada from June to September 2012.

2012

14 January to 6 May: *I Can See it Now! The Instantaneous Photograph*, curator: Jonathan Newman.

11 May to 9 September: *Flora and Fauna: 400 Years of Artists Inspired by Nature*, curators: Ann Thomas and Andrea Kunard, circulated in Canada February 2014 to January 2015.

21 September to 20 May: *Leviathans of the Sky: Photographs of Dirigibles from the National Gallery of Canada*, curator: Jonathan Newman.

* 5 October to 6 January 2013: *Margaret Watkins: Domestic Symphonies*, curator: Lori Pauli. Circulated in Canada from February 2014 to September 2014.

2013

* 1 February 2013 to 14 April 2013: *Don McCullin: A Retrospective*, curator: Ann Thomas; circulated in Canada November 2013 to January 2014.

24 May to 29 September: *Library and Archives Canada – Early Exploration in Canada.*

4 October to 2 March 2014: *Library and Archives Canada - Paul-Émile Miot: Early Photographs of Newfoundland*, curator: Lori Pauli.

2014

James Borcoman is appointed to the Order of Canada for his contributions to the world of photography and his work at the National Gallery.

The Mark McCain and Caro MacDonald Fund supports curatorial research in and acquisitions of contemporary African photography.

14 March to 1 September: *Library and Archives Canada – Arctic Exploration.*

* 27 June to 16 November: *The Great War: The Persuasive Power of Photography*, curators: Ann Thomas and Jonathan Newman.

8 September to 1 March 2015: *Library and Archives Canada – Taking It All In: The Photographic Panorama and Canadian Cities*, curator: Andrea Kunard.

20 December to 3 May 2015: *Clocks for Seeing: Photography, Time and Motion*, curator: Jonathan Newman. Circulated in Canada February to June 2017.

2015

Major donation of Origins of Photographs, a collection comprising more than 12,000 photographs, books and objects from an anonymous donor.

5 March to 30 August: *Library and Archives Canada – For the Record: Early Canadian Travel Photography*, curator: Andrea Kunard.

28 May to 13 September: *Luminous and True: The Photographs of Frederick H. Evans*, curator: Ann Thomas.

25 November: The National Gallery of Canada and the National Gallery of Canada Foundation announce the creation of the Canadian Photography Institute with a generous financial commitment from Scotiabank over ten years and donations of works from a private collector.

Philip Pocock fonds donated to that National Gallery of Canada Library and Archives by the artist.

2016

14 July: The National Gallery of Canada announces the appointment of Luce Lebart as Director of the Canadian Photography Institute; she assumes her role 29 August.

26 October: The Canadian Photography Institute inaugurates its new permanent space in the National Gallery with three exhibitions.

28 October to 12 February 2017: *Cutline: The Photography Archives of The Globe and Mail*, curator: Roger Hargreaves, Archive of Modern Conflict. Exhibited previously at the Scotiabank CONTACT Photography Festival, Toronto, April to June 2016.

28 October to 2 April: *PhotoLab 1: Windows.*

* *The Intimate World of Josef Sudek*, curator: Ann Thomas. Galerie nationale du Jeu de Paume, 6 June to 26 September 2016 and National Gallery of Canada, 28 October to 26 February 2017.

Donation of *The Globe and Mail* archive.

2017

* 7 April to 17 September: *Photography in Canada: 1960–2000*, curator: Andrea Kunard. Exhibition is scheduled to travel in Canada in 2018.

3 November to 16 February: *Between Friends*, curator: Luce Lebart, Director, CPI

3 November to 2 April: *Gold and Silver: Images and Illusions of the Gold Rush* and *Frontera: Views of the U.S.–Mexican Border*, curator: Luce Lebart, Director, CPI

The CPI launches a Research Fellowship Program to "encourage advanced research in the study of the history and criticism of photography."

Plates

** indicates works not shown in the exhibition

"projection" indicates an image of the original photograph was shown in the exhibition.

1
Félix-Jacques-Antoine Moulin
French, 1802–c. 1875
Académie c. 1845
daguerreotype
image: 7.2 × 5.6 cm sight
sheet: 8.2 × 7 cm sixth-plate
Gift of Phyllis Lambert, Montreal,
1988
(no. 30654)

2
Richard Learoyd
British, born 1966
Agnes, July 2013 (4) 2013
gelatin silver print
image: 157.1 × 121.2 cm
Purchased 2014
(no. 46262)

3
Hermann Carl Eduard Biewend
German, 1814–1888
*Myself, with Little Luise on my
Lap, Hamburg* 4 June 1850
albumen silver print
image: 15.7 × 10.3 cm
half-plate: 16.1 × 10.7 cm
Gift of Phyllis Lambert, Montreal
1988
(no. 30585)

4
Joel Sternfeld
American, born 1944
*Canyon Country, California, June
1983* June 1983,
printed August 1987
dye coupler print
image: 34.4 × 43.4 cm
sheet: 40.6 × 50.7 cm
Gift of Irwin Reichstein, Ottawa,
1996
(no. 38348)

5
Robert Frank
American, born Switzerland 1924
*U.S. 90, en route to Del Rio,
Texas* c. 1955–56, printed 1968
gelatin silver print
image: 30.3 × 20.4 cm
sheet: 35.3 × 27.7 cm
Purchased 1969
(no. 21880)

6
Karen Smiley (now Rowantree)
Canadian, born 1947
*David Isakson and Audrey Isakson,
Son and Mother* 1980
azo dye prints (Cibachrome)
image 1: 46.4 × 36.1 cm
image 2: 46.7 × 36 cm
image 3: 46.9 × 36.1 cm
sheet: 50.5 × 40.5 cm each approx.
Purchased 1987
(no. 29778.1-3)

7
August Sander
German, 1876–1964
*Mother and Daughter [Helene
Abelen with Daughter Josepha]*
c. 1926, printed 1928
gelatin silver print

31.3 × 23.9 cm approx.
Purchased 1986
(no. 29328)

8
Anne Fishbein
American, born 1958
Portrait on a Muddy Path 1991,
printed 1993
gelatin silver print
image: 46.2 × 38;
sheet: 50.4 × 40.5
Purchased 1997
(no. 38528)

9
Étienne Léopold Trouvelot
French, 1827–1895
*Direct Photograph of an Electric
Positive Spark (Wimshurst Static
Machine)* c. 1888
albumen silver print
image: 22.2 × 16.1 cm
sheet: 22.2 × 16.1 cm
Purchased 2014
(no. 46249)

10
Hiroshi Sugimoto
Japanese, born 1948
Lightning Fields 138 2009
gelatin silver print
image: 58.7 × 47.1 cm
sheet: 60.3 × 48.9 cm
Purchased 2010
(no. 43204)

11
Jules Janssen
French, 1824–1907
*Studies of the Solar Surface,
1 April 1894* 1 April 1894,
printed 1896
woodburytype
23.1 × 17.1 cm
Purchased 1997
(no. 38533.15)

12
Spring Hurlbut
Canadian, born 1952
James #5 2008
from the series *Deuil II* [Mourning]
inkjet print
71 × 81 cm approx.
Gift of the artist, Toronto, 2012
(no. 45643)

13
Adrien Majewski
French, active Paris 1890s
*Mr. Majewski's Right Hand,
Posed for 20 minutes, Room
Temperature* c. 1895–1900
gelatin silver print
image: 16.8 × 12 cm
sheet: 17.9 × 12.5 cm
Purchased 2014
(no. 46263)

14
Gary Schneider
American, born South Africa 1954
After Naomi 1993, printed 1994
gelatin silver print, toned
image: 90.7 × 72.6 cm

sheet: 92.2 × 74.2 cm
Gift of Zavie and Ida Miller,
Nepean, Ontario, 2000, in honour
of Dr. Brian Druker
(no. 40946)

15
Walker Evans
American, 1903–1975
*Church of the Nazarene,
Tennessee*, 1936, printed later
gelatin silver print
image: 19.1 × 24.2 cm
sheet: 20.2 × 25.2 cm
Gift of Phyllis Lambert, Montreal
1982
(no. 19290)

16
Mark Ruwedel
Canadian, born United States 1954
*Splitting (California Valley #7 and
Salton City #47B)* 2009
gelatin silver print
26.1 × 34.2 cm each
(no. 45553.1-2)

17
Eadweard Muybridge
British, 1830–1904
*"Lizzie M." trotting, harnessed to
sulky* c. June 1884–11 May 1886,
printed November 1887
collotype
image: 19.6 × 36.5 cm
sheet: 48.3 × 61.2 cm
Gift of Dr. Robert W. Crook,
Ottawa, 1981
(no. 31875)

18
Alison Rossiter
American, born 1953
Goya 2009
from the series *Light Horses*
gelatin silver print
50.5 × 60.5 cm
purchased 2009
(no. 42883)

19
Gilles-Louis Chrétien (after Jean
Fouquet)
French, 1754–1811
*Brigadier-General Tadeusz A.B.
Kosciuszko (1746–1817), after a
Portrait by Fouquet* c. 1793
etching on wove paper
plate: 8.1 × 7 cm (circular image)
sheet: 11.6 × 10.7 cm
Purchased 1996
(no. 38256) [projection]

20
Southworth & Hawes
American, active Boston 1843–63
*Portrait of a young girl with hand
on shoulder* c. 1850
daguerreotype with applied colour
21.6 × 16.5 cm whole plate
Gift of an anonymous donor, 2015
(no. LFA21500_211)

21
John Frederick Herschel
British, 1792–1871

*No. 460 Interior View of the Ancient
Theatre, Arles* October 1850
graphite on paper
image: 21.2 × 35.5 cm
sheet: 25 × 38.5 cm
Purchased 2015
(no. 46510) [projection]

22
Charles Nègre
French, 1820–1880
*Self-portrait of the Artist
(standing) with his Family,
Grasse* c. 1852
salted paper print
16 × 21 cm
Purchased 1978
(no. 32355)

23
Camille Corot
French, 1796–1875
Souvenir of the Villa Pamphili 1871
albumen silver print
15.3 × 12.4 cm
Purchased 1967
(no. 21398)

24
Eugène Cuvelier
French, 1837–1900
Forest of Fontainebleau 1863
salted paper print
25.9 × 19.9 cm
Purchased 1998
(no. 39789)

25
William Henry Fox Talbot
British, 1800–1877
The Haystack April 1844
salted paper print
image: 16.4 × 21 cm
sheet: 19 × 22.9 cm
Purchased 1975
(no. 33487.31)

26
Anna Atkins
British, 1799–1871
*Polypodium crenatum,
Norway* 1854
cyanotype
32.9 × 23.6 cm
Purchased 1983
(no. 19712)

27
Amanda Means
American, born 1945
Leaf No. 12 1989
gelatin silver print
image: 120.5 × 95 cm
sheet: 128.5 × 100.9 cm
Purchased 1993
(no. 37047)

28
Unknown artist
French, late 19th century
*The Photographer and his
Model* c. 1875
oil on paper
22.3 × 19.5 cm
Purchased 1976
(no. PSC76:112:20 AJ) [projection]

29
Théodore Maurisset
French, 1803–1860
Daguerreotypemania 1840
lithograph with watercolour on
paper
25.2 × 36.4 cm
Gift of Dorothy Meigs Eidlitz,
St. Andrews, New Brunswick, 1968
(no. 32299) [projection]

30
Honoré Daumier
French, 1808–1879
*A New Process Used to Achieve
Graceful Poses* before 5 June 1856
lithograph on paper
image: 18.5 × 26.5 cm
sheet: 24 × 32.5 cm
Purchased 1976
(no. 21093) [projection]

31
Unknown artist
French, mid 19th century
Masked Balls: Photography
c. 1869
lithograph with watercolour
30.3 × 21.8 cm
Purchased 1976
(no. PSC76:112:22 AJ) [projection]

32
Alfred Grévin
French, 1827–1892
*Pierre Petit, Horoscope after the
Letter* c. 1865
lithograph
33.7 × 25.8 cm
Purchased 1976
(no. PSC76:112:43 AJ) [projection]

33
Attributed to Gabriel Lippmann
French, 1845–1921
Faverol, Normandy 1914
Lippmann interferential colour
plate
12.1 × 9.2 × 2.3 cm
Private collection

34
Antoine François Jean Claudet
British, 1797–1867
Young Boy with Curls after 1851
daguerreotype with applied colour
image: 6.8 × 5.8 cm left sight
sheet: 7.9 × 6.7 cm each
Gift of Phyllis Lambert, Montreal,
1988
(no. 30615)

35
Heinrich Kühn
Austrian, 1866–1944
Hans, Mary Warner and Lotte 1907
autochrome on glass with paper
sealing tape
image: 16.7 × 22.6 cm
sheet: 18 × 24 cm
Purchased 2016
(no. 46976) replica exhibited

36
Harold F. Kells
Canadian, 1904–1986

Hallowe'en Still-life 1933,
probably printed 1935
dye transfer print
24.5 × 30.4 cm
Gift of Margaret E. Kells, 1997
(no. 39806)

37
Fred Herzog
Canadian, born Germany 1930
Jackpot 1961
inkjet print
image: 50.5 × 76.3 cm
sheet: 70.5 × 96.6 cm
Purchased 2007
(no. 2007.39)

38
Robert Walker
Canadian, born 1945
Times Square, New York 2009
chromogenic print
126.6 × 86.2 cm
Purchased 2010
(no. 2010.20)

39
Gustave Le Gray
French, 1820–1884
Great Wave, Sète 1857
albumen silver print
image: 157.1 × 121.2
sheet: 157.1 × 121.2
Purchased 1967
(no. 31460)

40
Edward Steichen
American, 1879–1973
*Nocturne – Orangerie Staircase,
Versailles* 1908
gum bichromate print
29.5 × 38.3 cm
Purchased 1976
(no. 33361)

41
Henry Peach Robinson
British, 1830–1901
Hark! Hark! The Lark! 1882
albumen silver print
26.6 × 37.6 cm
Purchased 1976
(no. 32671) **

42
William Notman
Canadian, 1826–1891
Henry Sandham
Canadian, 1842–1910
*The Terra Nova Snowshoe Club,
Montreal* 1875
collage of albumen silver prints
with graphite, watercolour, and
gouache
image: 37 × 63.9 cm
sheet: 40.4 × 66.1 cm
Purchased 1997
(no. 38435)

43
Georges Hugnet
French, 1906–1976
Untitled 1947
gelatin silver print
16.4 × 12.3 cm

Purchased 1996
(no. 38237) **

44
Raoul Ubac
Belgian, 1910–1985
Reclining Nude 1941
gelatin silver print
25.7 × 39.9 cm
image: 24.3 × 37.4 cm
Purchased 2007
(no. 42070)

45
Alison Rossiter
American, born 1953
*Acme Kruxo, Expiration c. 1940's
(Lament)* 2009
gelatin silver print
12.7 × 17.7 cm
Purchased 2009
(no. 42878)

46
Edgar Lissel
German, born 1965
Bakterium Vanitas-3 c. 2000–01
inkjet print
80.6 × 80.6 cm
Purchased 2010
(no. 42932) **

47
Charles Gagnon
Canadian, 1934–2003
Untitled 1978
9 instant dye prints (Polaroid)
images: 7.9 × 7.8 cm
objects: 10.8 × 8.8 cm
Estate of Charles Gagnon

48
Robin Collyer
Canadian, born Britain 1949
Yonge Street, Willowdale 1994
chromogenic print
image: 48.3 × 58.3 cm
sheet: 50.7 × 60.8 cm
Purchased 1996
(no. EX-96-46)

49
Herwig Kempinger
Austrian, born 1957
181099-271199 1999
dye coupler print, laminated to
acrylic, mounted on aluminium
199.6 × 130 cm
Purchased 2001
(no. 40573)

50
Humphrey Lloyd Hime
Canadian, 1833–1903
*Hon. Hudson's Bay Company
Officers' Quarters: Lower or Stone
Fort* c. September–October 1858,
printed after January 1859
salted paper print
13.7 × 17 cm
Purchased 2012
(no. 45387)

51
Frederick Dally
British, 1838–1914

*Zadoskis' Grave, with Family
Monuments Representing
Deceased Members and
Relatives of the Same – Fraser
River* c. 1867–68
albumen silver print
18.2 × 23.9 cm
Purchased 1972
(no. 21433)

52
Platt D. Babbitt
American, 1822–1879
Niagara Falls from Prospect Point
c. 1855
daguerreotype
image: 13.5 × 18.6 sight
sheet: 16.6 × 21.7 cm whole plate
Gift of Phyllis Lambert, Montreal,
1988
(no. 30584)

53
Francis Frith
British, 1822–1898
*The Great Pyramid and the Great
Sphinx* 1858
albumen silver print
image: 38.1 × 48.4 cm
sheet: 38.1 × 48.4 cm
Purchased 2017
(no. 47534)

54
Maxime Du Camp
French, 1822–1894
*Western Colossus of the Great
Temple, Abu Simbel, Nubia* 1850
salted paper print
22.5 × 16 cm
Purchased 1971
(no. 21569.105)

55
Auguste Salzmann
French, 1824–1872
*Jerusalem. The Holy Sepulchre,
Main Entrance* 1854, printed 1856
salted paper print
15.3 × 21.3 cm
Purchased 1968
(no. 32748.17)

56
Pierre Trémaux
French, 1818–1895
*Turkish Steles, Greek
Ephesus* c. 1862–68
photolithograph on wove paper
image: 26.1 × 20.5 cm
sheet: 54.6 × 36.1 cm
Purchased 1973
(no. 33342.20)

57
Robert C. Tytler
British, 1818–1872
Harriet C. Tytler
British, 1828–1907
*Upper and Lower Sections of Qutb
Minar, Delhi* c. 1857–58, printed
1859
albumen silver prints
95 × 41.1 cm overall
top sheet: 51 × 40.4 cm
bottom sheet: 50.2 × 41.1 cm

Gift of the Vancouver Public
Library, 1997
(38614.1-2)

58
Robert C. Tytler
British, 1818–1872
Harriet C. Tytler
British, 1828–1907
*Upper and Lower Sections of Qutb
Minar, Delhi* c. 1857–58
paper negatives with black ink
additions
top negative: 55 × 41.6 cm
bottom negative: 53 × 41.4 cm
Gift of the Vancouver Public
Library, 1997
(no. 38615.1-2)

59
Jane Dieulafoy
French, 1851–1916
Viçadahyu Portico after 1881,
printed 1889?
photogravure
image: 28.8 × 18.8 cm
plate: 33.8 × 20.9 cm
sheet: 37.1 × 27 cm
Purchased 1973
(no. 21538)

60
Félix Teynard
French, 1817–1892
*Rock-cut Architecture–Tomb of
Amenemhat, Beni Hasan, Egypt*
c. 1851–52, printed 1853
salted paper print
24.7 × 31 cm
Purchased 1992
(no. 36806)

61
Alexander Henderson
Canadian, 1831–1913
*Spring Inundation 1865 – Bank of
St. Lawrence River* 1865
albumen silver print
11.1 × 19 cm
Purchased 1972
(no. 22803.14)

62
Josef Sudek
Czechoslovakian, 1896–1976
Prague at Night 1950
gelatin silver print
image: 22.8 × 29 cm
sheet: 29.8 × 39.8 cm
Purchased 2003
(no. 41283)

63
Paul Strand
American, 1890–1976
Big Leaf, The Garden, Orgeval 1974
gelatin silver print
image: 28.5 × 23.0 cm
sheet: 29.7 × 23.7 cm
Gift of an anonymous donor, 2017
(no. 2017.0487.406)

64
D.R. Cowles
Canadian, born U.S.A. 1950
Ouezzane, Shrine of Amram

*Ben Diwane: Stones Beneath a
Tree* 1995
from the series *Images of Jewish
Morocco: Sixteen Photographs*
gelatin silver print, gold toned
image: 24.7 × 19.9 cm
sheet: 50.6 × 40.6 cm
Purchased 1996
(no. EX-96-119)

65
Thomas Joshua Cooper
American, born 1946
*The Swelling of the Sea, West,
The Atlantic Ocean, Point of
Ardnamurchan, The Furthest
West, Scotland* 1990
gelatin silver print, toned
56.5 × 81.1 cm
Purchased 1995
(no. 37977)

66
Mark Ruwedel
Canadian, born United States 1954
*The Witnesses, Nevada Test Site
(Viewing area for 14 atmospheric
tests at Frenchman Flat,
1951–1962)* 1995
gelatin silver print
image: 37.9 × 47.6 cm
sheet: 61 × 71.3 cm
Purchased 1996
(no. EX-96-68) **

67
Lorraine Gilbert
Canadian, born France 1955
Shaping the New Forest 1990
dye coupler prints
image: 68 × 84.6
sheet: 76 × 101.4 cm each approx.
Purchased 1996
(nos. 38238.1-2) *left panel on
view in exhibition

68
Edward Burtynsky
Canadian, born 1955
*Three Gorges Dam Project, Feng
Jie #3, Yangtze River, China* 2002
dye coupler print
102 × 127.4 cm
Purchased 2004
(no. 41409)

69
Edward Burtynsky
Canadian, born 1955
*Three Gorges Dam Project, Feng
Jie #4, Yangtze River, China* 2002
dye coupler print
102 × 127.3 cm
Purchased 2004
(no. 41410) **

70
Harvey G. Fetter
Active Peru, Indianna 1850s
*Portrait of E.M. Talbot, Robert
Allen and W.A. Wilson* 1853–54
daguerreotype
8.3 × 10.8 cm quarter-plate
Gift of an anonymous donor, 2015
(no. LFA21500_185_39)

71
John Burke
British ?, active India c. 1860–1907
*Temple of Sugandheswara near
Village of Pathan: View of South
Face* 1868, printed 1869
carbon print
20.3 × 26.7 cm
Purchased 1976
(no. 21088.35)

72
Alphonse Bertillon
French, 1853–1914
Measurement of the Foot before
1893
albumen silver print
22.5 × 11.3 cm
Purchased 1980
(no. PSC80:286:17)

73
Spring Hurlbut
Canadian, born 1952
Scarlett #1 2005, printed 2007
inkjet print
image: 32.9 × 86.2 cm
sheet: 57.3 × 109.5 cm approx.
Purchased 2007
(no. 42163)

74
Rosamond W. Purcell
American, born 1942
*Cyclops Skeleton against Uterine
Cyst* 1993, printed 1998
azo dye print (Ilfochrome)
image: 38 × 48.1 cm
sheet: 40.6 × 50.8 cm
Gift of Frederic Borgatta, Ottawa,
2000
(no. 40600)

75
Edward Burtynsky
Canadian, born 1955
*Pivot Irrigation / Suburb South of
Yuma, Arizona, USA* 2011
chromogenic print
121.1 × 162.4 cm
Gift of the artist, Toronto, 2014
(no. 46209)

76
Étienne-Jules Marey
French, 1830–1904
*Study in Motion by
Chronophotography* 1890, printed
before 1967
gelatin silver print
12.8 × 17.8 cm
Purchased 1967
(no. 32402)

77
Eadweard Muybridge
British, 1830–1904
*Jumping, running straight high
jump* c. June 1885–11 May 1886,
printed November 1887
collotype
image: 13.4 × 45.7 cm
sheet: 46.8 × 59.1 cm
Gift of Mrs. Virginia P. Moore,
Ottawa, 1981
(no. 31497)

78
Harold E. Edgerton
American, 1903–1990
*Golf Drive by Densmore
Shute* 1938, printed 1977
gelatin silver print
image: 26 × 26.1 cm
sheet: 35.4 × 27.8 cm
Purchased 1981
(no. 23894.7)

79
Konrad Cramer
German/American, 1888–1963
*Geometric Form Made by
Sympalmograph* 20 October 1949
gelatin silver print
33.9 × 25.9 cm
Gift of Dorothy Meigs Eidlitz,
St. Andrews, New Brunswick, 1968
(no. 21380) **

80
Andreas Feininger
German/American, 1906–1999
Chambered Nautilus Shell 1948
gelatin silver print
image: 19.1 × 24.6 cm
sheet: 20.2 × 25.7 cm
Gift of the Estate of Gertrud E.
Feininger, New York, 2009
(no. 42833)

81
Unidentified photographer
American, mid 19th century
Man with Microscope c. 1850
daguerreotype
14.6 × 19.7 cm whole plate sight
Purchased 1972
(no. 33977) **

82
Arthur Edward Durham
British, c. 1834–1895
J. Hickson
British, active c. 1870
Salicine by Polarized Light c. 1870
albumen silver print
10.4 × 10.4 cm
Purchased 2014
(no. 46213)

83
Wilson A. Bentley
American, 1865–1931
Snow Crystal No. 3070
6 February 1918
gelatin silver print
8.1 cm diameter
Purchased 1996
(no. 38201)

84
Wilson A. Bentley
American, 1865–1931
Snow Crystal No. 3837
17 December 1922
gelatin silver print
8.2 cm diameter
Purchased 1996
(no. 38204)

85
Wilson A. Bentley
American, 1865–1931
Snow Crystal No. 2010
31 March 1911
gelatin silver print
7.4 cm diameter
Purchased 1996
(no. 38203)

86
Wilson A. Bentley
American, 1865–1931
Snow Crystal No. 4271
2 February 1924
gelatin silver print
7.8 cm diameter
Purchased 1996
(no. 38202)

87
John Hall-Edwards
British, 1858–1926
X-ray of a woman's hand with two rings and a bracelet c. 1900
gelatin silver print
image: 22.4 × 20.0 cm
sheet: 29.8 × 21.1 cm
Purchased 2017
(no. 47704) **

88
Josef Maria Eder
Austrian, 1855–1944
Eduard Valenta
Austrian, 1857–1937
Snake 1896
photogravure
image: 27.2 × 21.7 cm
sheet: 30.3 × 24.9
Purchased 2017
(no. 47686.15)

89
Karl Blossfeldt
German, 1865–1932
Valeriana alliariifolia (Valerian)
1915–25
gelatin silver print
29.7 × 11.8 cm
Purchased 1993
(no. 36996) **

90
Dain L. Tasker
American, 1872–1962
Lily – An X-ray 1930
gelatin silver print, toned
29.6 × 24.5 cm
Purchased 1998
(no. 39167)

91
Nicolas Baier
Canadian, born 1967
Neurons 2013
inkjet print
image: 150.4 × 201.7 cm
sheet: 150.4 × 201.7 cm
Gift of the artist, Montreal, 2014
(no. 46300) **

92
Claudia Fährenkemper
German, born 1959
Feet of a Tadpole 25X 2002

gelatin silver print
image: 52 × 41.6 cm
sheet: 57.9 × 46.8 cm
Gift of the artist, Germany, 2006
(no. 42040)

93
Gary Schneider
American, born South Africa 1954
Entomological Specimen No. 8
1992
gelatin silver print, toned
image: 73.3 × 77.9 cm
sheet: 74.4 × 79.1 cm
Gift of Sheila Duke, Kinburn,
Ontario, 2000
(no. 40960)

94
Lewis M. Rutherfurd
American, 1816–1892
Moon 4 March 1865
albumen silver print
57.3 × 44.2 cm
Purchased 1999
(no. 39848)

95
Alison Rossiter
American, born 1953
Principia No. 14 1997
gelatin silver print
26.8 × 34.5 cm
Purchased 1998
(no. 39626)

96
Thomas Ruff
German, born 1958
Constellations 1990, printed 1991
dye coupler print (Fujicolor)
image: 48.1 × 32.1 cm
sheet: 60.9 × 50.8 cm
Gift of Photographers + Friends
United Against AIDS, New York,
1998
(no. 39859.7) **

97
Harold E. Edgerton
American, 1903–1990
Milk Drop Coronet 1957, printed
1984
dye coupler print
image: 49.9 × 39.7 cm
sheet: 50.7 × 40.5 cm
Gift of the Harold and Esther
Edgerton Family Foundation,
Santa Fe, New Mexico, 1997
(no. 38489)

98
Alvin Langdon Coburn
American/British, 1882–1966
Vortograph 1917
gelatin silver print
27.6 × 20.3 cm
Purchased 2005
(no. 41656)

99
Man Ray
American/French, 1890–1976
Rayograph 1922
gelatin silver print
23.9 × 17.8 cm

Purchased 1982
(no. 19202) **

100
László Moholy-Nagy
Hungarian / German, 1895–1946
Photogram c. 1925
gelatin silver print
12.1 × 12.8 cm
Purchased from the Phyllis
Lambert Fund, 1982
(no. 19204) **

101
Franz Roh
German, 1890–1965
Untitled 1922–28
gelatin silver print
18.2 × 24 cm
Purchased 2003
(no. 41135)

102
Gustav Klutsis
Russian, 1895–1938
Dynamic City 1919
gelatin silver print
image: 29.6 × 23.9 cm
sheet: 29.6 × 23.9 cm
Purchased 2014
(no. 46260)

103
John Vanderpant
Canadian, 1884–1939
*Untitled (Wire Fence and
Elevators)* c. 1929–30
gelatin silver print
35.1 × 27.2 cm
Purchased 2013
(no. 45674) **

104
Paul Strand
American, 1890–1976
Barn, Gaspé 1936
platinum print, varnished
11.8 × 15 cm
Purchased 2003 with the support
of the Members and Supporting
Friends of the National Gallery of
Canada and its Foundation
(no. 41146)

105
Frederick H. Evans
British, 1853–1943
Wells Cathedral: A Sea of Steps
1903
platinum print
23.4 × 19.1 cm
Purchased 2009
(no. 42874)

106
Brassaï
Hungarian/French, 1899–1984
Nude c. 1932, printed c. 1950
image: 37.5 × 48.9 cm
sheet: 40.8 × 49.9 cm
Purchased 2005
(no. 41559) **

107
Alexander Gardner
British/American, 1821–1882

*Home of a Rebel Sharpshooter,
Gettysburg* July 1863, printed
1866?
albumen silver print
17.3 × 22.5 cm
Gift of Phyllis Lambert, Montreal,
1975
(no. 20749.41)

108
Felice Beato
Italian, 1832–1909
Interior of the Angle of North Fort
21 August 1860
albumen silver print
24.9 × 29.8 cm
Purchased 1981
(no. 26546.21) **

109
Jules Andrieu
French, 1816–after 1876
*Disasters of the War: City Hall,
Galerie des Fêtes* c. 1870–71
albumen silver print
29.2 × 37.4 cm
Purchased 1975
(no. 20755)

110
Sophie Ristelhueber
French, born 1949
Beirut printed 1984
gelatin silver print
image: 56.1 × 37.3 cm
sheet: 60.8 × 50.5 cm
Purchased 2017
(no. 47705) **

111
Sophie Ristelhueber
French, born 1949
Beirut printed 1984
gelatin silver print
image: 56.2 × 37.3 cm
sheet: 60.8 × 50.5 cm
Purchased 2017
(no. 47708)

112
Lewis W. Hine
American, 1874–1940
*Sanford Cotton Mill. Accident
Case, Carl Thornburg Twelve-
year-old Boy, ... Sanford, North
Carolina* November 1914
gelatin silver print
11.6 × 16.6 cm
Gift of Max Serlin, Winnipeg, 1981
(no. 19570)

113
Gordon Parks
American, 1912–2006
Emerging Man 1952, printed later
gelatin silver print
image: 19.6 × 30.1 cm
sheet: 27.7 × 35.5 cm
Purchased 2012
(no. 45625)

114
John Heartfield
German, 1891–1968
*When the World Is in Flames, Then
We Shall Prove that Moscow Was*

the Arsonist before 28 February
1935, printed before 1942
gelatin silver print
14.7 × 10.3 cm
Purchased 1979
(no. 22865)

115
Gustav Klutsis
Russian, 1895–1938
*Let Us Fulfill the Plan of the Great
Projects* 1930
gelatin silver print with gouache
15.6 × 11.4 cm
Purchased 1993
(no. 36854)

116
Bernard Cole
American, 1911–1982
*Shoemaker's Lunch, Newark,
New Jersey* 1944, printed before
March 1978
gelatin silver print
image: 19.1 × 18.9 cm
sheet: 25.2 × 20.3 cm
Purchased 1979
(no. 21390) **

117
Dorothea Lange
American, 1895–1965
Migrant Mother March 1936,
printed c. 1950–59
gelatin silver print
33.1 × 26 cm
Purchased 1995
(no. 37848)

118
Bill Brandt
British, 1904–1983
*Crowded, Improvised Air-Raid
Shelter in a Liverpool Street
Tube Tunnel* 1940, printed c. 1940
gelatin silver print
image: 23.5 × 19.8 cm
sheet: 25.4 × 20.4 cm
Purchased 2014
(no. 45963) **

119
Margaret Bourke-White
American, 1904–1971
*Boys Studying Talmud, Orthodox
Jewish School, Uzhorod* 1938
gelatin silver print
image: 25.8 × 33.8 cm
sheet: 25.8 × 33.8 cm
Purchased 2006
(no. 41745)

120
Walker Evans
American, 1903–1975
*Parked Car, Small Town, Main
Street* 1932, printed later
gelatin silver print
image: 16.9 × 25.1 cm
sheet: 27.9 × 35.3 cm
Gift of Phyllis Lambert, Montreal,
1982
(no. 19238) **

121
James Van Der Zee
American, 1886–1983
*Couple Wearing Racoon Coats
with a Cadillac, Taken on West
127th Street* 1932, printed c. 1960
gelatin silver print
39.4 × 49.9 cm
Purchased 2012
(no. 45628)

122
Henri Cartier-Bresson
French, 1908–2004
Valencia, Spain 1933, printed
before 1947
gelatin silver print
16.3 × 24.2 cm
Purchased 1984
(no. 28594)

123
Lutz Dille
German/Canadian 1922–2008
New York City 1959, printed 1995
gelatin silver print
image: 22.5 × 19.3 cm
sheet: 23.7 × 30.3 cm
Purchased from the Photography
Collectors Group Fund, 1999
(no. 40190)

124
Shelby Lee Adams
American, born 1950
Brother Shell Firehandling 1987,
printed 1990
gelatin silver print
image: 47.1 × 38.1 cm
sheet: 50.5 × 40.7 cm
Gift of the American Friends
of Canada Committee, Inc.,
2002, through the generosity of
Anne S. Leaf
(no. 41006)

125
O. Winston Link
American, 1914–2001
*Gooseneck Dam and No. 2, Natural
Bridge, Virginia* 1956, printed 1996
gelatin silver print
image: 49.3 × 39.3 cm
sheet: 50.7 × 40.3 cm
Gift of David E. Wright and Mary
Beth Sweet, Ottawa, 2000
(no. 40597) **

126
Dave Heath
Canadian, 1931–2016
Toronto, 26 August 2004
26 August 2004
inkjet print
image: 30.7 × 45.6 cm
sheet: 32.9 × 48.4
Purchased 2006
(no. 2006.18)

127
Robert Capa
German, 1913–1954
Spain 5 September 1936
gelatin silver print
22.6 × 33.5 cm
Purchased 1970
(no. 21305)

128
Louie Palu
Canadian, born 1968
*U.S. Marine Cpl. Philip Pepper,
Age 22, Garmsir, Helmand,
Afghanistan* 2008
inkjet print
image: 50.8 × 33.8 cm
sheet: 61.1 × 50.8 cm
Purchased 2011
(2011.73)

129
Photographic News Agencies Ltd.
British, active London 1940
*Soldiers of the Northern Ireland
Infantry in Training* 4 June 1941
gelatin silver print with applied
media
15.4 × 20.9 cm
Gift of an anonymous donor, 2010
(no. A4568.1.148)

130
Larry Towell
Canadian, born 1953
*Office, Mothers of the
"Disappeared", San Salvador,
El Salvador* 1987
gelatin silver print
image: 19.3 × 28.3 cm
sheet 27.8 × 35.3 cm
Purchased 1989
(no. EX-89-125)

131
Guy Tillim
South African, born 1962
*An Amputee's Grave, Kuito,
Angola* 2000, printed 2005?
inkjet print, monochrome
image: 49 × 73.5 cm
sheet: 61 × 83.5 cm
(no. 41834)

132
Unidentified photographer
Canadian
*Dead Body of William Poole after
he was shot by police while
trying to open safe Toronto Florist
Co-Operative* c. 1948
gelatin silver print with grease
pencil and retouching
18.0 × 22.0 cm
Gift of *The Globe and Mail*
Newspaper to the Canadian
Photography Institute of the
National Gallery of Canada, 2016
(no. NGC00290)

133
Unidentified photographer
active c. 1967
Photographs of Che Guevara
c. 1967 ?
gelatin silver print
17.9 × 24 cm
Gift of an anonymous donor, 2010
(no. A4568.411)

134
Weegee
American, 1899–1968
*Mrs. Patricia Ryan who Shot and

Killed her Husband, a Cop. She
is Shown about to be Brought
into the Magistrate's Court in the
Bronx* c. 1936–38
gelatin silver print
image: 17.2 × 21.6 cm
sheet: 18.2 × 22.9 cm
Purchased from the Phyllis
Lambert Fund, 1981
(no. 26763)

135
Unidentified photographer
El Mundo Fotografia
Crime – Dead Gunman 1961
gelatin silver print
23.8 × 17.9 cm
Gift of anonymous donor, 2010
(no. A3771.7b.5)

136
Unidentified photographer from
Aviation Collection
LZ 127 Graf Zeppelin n.d.
gelatin silver print
12.7 × 17.7 cm
Gift of an anonymous donor, 2010
(no. A3954.24.7)

137
Wide World Photos
*Target for bomb manoeuvres,
California desert* 5 April 1936
gelatin silver print
18.9 × 23.3 cm
Gift of anonymous donor, 2010
(no. A4097.29.77)

138
Hiromi Tsuchida
Japanese, born 1939
Lunch Box c. 1979–82, printed
1994
gelatin silver print
image: 33.9 × 42 cm
sheet: 60.4 × 50.5 cm
Gift of the artist, Tokyo, 1994
(no. 37510)

139
Frauke Eigen
German, born 1969
Shirt (2) 2000, printed 2001
gelatin silver print
49.7 × 49.7 cm
Purchased 2002
(no. 40985.13)

140
Luc Delahaye
French, born 1962
The Milosevic Trial 2002, printed
2003
dye coupler print
image: 110 × 244 cm approx.
integral frame: 115.5 × 249.2 × 5 cm
Purchased 2003
(no. 41267)

141
Margaret Watkins
Canadian, 1884–1969
Domestic Symphony 1919
palladium print
21.2 × 16.4 cm

Purchased 1984 with the
assistance of a grant from the
Government of Canada under
the terms of the Cultural Property
Export and Import Act
(no. 20627)

142
André Kertész
Hungarian/American, 1894–1985
Fork, Paris 1928
gelatin silver print
image: 7.5 × 9.2 cm
sheet: 8.5 × 10.6 cm
Purchased 1978
(no. 31336)

143
Horst P. Horst
German/American, 1906–1999
Untitled c. 1935
gelatin silver print
image: 22.7 × 16.8 cm
sheet: 23.5 × 17.2 cm
Gift of Rodney and Cozette de
Charmoy Grey, Geneva, 1979
(no. 22851)

144
Horst P. Horst
German/American, 1906–1999
Mainbocher Corset, Paris 1939,
printed later
gelatin silver print
image: 24.3 × 19.2 cm
sheet: 35.3 × 27.7 cm
Purchased 2005
(no. 41644)

145
Horst P. Horst
German/American, 1906–1999
Untitled c. 1931–35
gelatin silver print
21.5 × 16.7 cm
Gift of Rodney and Cozette de
Charmoy Grey, Geneva, 1979
(no. 22862)

146
Edward Burtynsky
Canadian, born 1955
Breezewood, Pennsylvania 2008,
printed 2010
chromogenic print
119.4 × 152.3 cm
Purchased 2012
(no. 45399)

147
Robert Walker
Canadian, born 1945
Times Square, New York 2002
chromogenic print
119.1 × 79.8 cm
Purchased 2010
(no. 2010.22)

148
Robin Collyer
Canadian, born Britain 1949
Yonge Street, Willowdale 1995
chromogenic print
image: 48.7 × 58.9 cm
sheet: 50.7 × 60.8 cm
Purchased 1996
(no. EX-96-47)

149
Albert Gallatin Hoit
American, 1809–1856
*Portrait of Nancy Southworth
Hawes* c. 1836
oil on canvas
97.8 × 85.1 × 9.5 cm
Gift of an anonymous donor, 2015
(no. LFA21500_316_2) **

150
Southworth & Hawes
American, active Boston 1943–63
*Portrait of Nancy Southworth with
Painted Portrait* c. 1842–43
daguerreotype
8.3 × 7 cm sixth-plate
Gift of an anonymous donor, 2015
(no. LFA21500_316_1)

151
John Benjamin Dancer
British, 1812–1887
*Self-portrait with Scientific
Apparatus?* c. 1853
daguerreotype
left plate: 7.6 × 6.7 cm
right plate: 7.7 × 6.8 cm
image: 6.9 × 5.9 cm each
Gift of Phyllis Lambert, Montreal,
1988
(no. 30627)

152
Bertha Wehnert
German, 1815–1901
*Uncle (Sali) Salomon Hirzel,
Bookseller in Leipzig* after 1847
daguerreotype
image: 6.2 × 5 cm sight
sheet: 8.3 × 6.6 cm
Gift of Phyllis Lambert, Montreal,
1988
(no. 30606)

153
Unidentified photographer
American
Portrait of an Unidentified Woman
c. 1850
daguerreotype with applied colour
8.3 × 7 cm sixth-plate
Gift of an anonymous donor, 2015
(no. LFA21500_185_76)

154
Julia Margaret Cameron
British, 1815–1879
Alethia (Alice Liddell) October 1872
albumen silver print
32.4 × 23.7 cm oval
Purchased 1975
(no. 21285)

155
Louis-Rémy Robert
French, 1819 or 1811–1882
*Henriette Caroline Robert
(1834–1933)* c. 1851
paper negative, waxed process
image: 22.3 × 17.3 cm
sheet: 23.2 × 18.5 cm
Purchased 1996
(no. 38208)

156
Louis-Rémy Robert
French, 1819 or 1811–1882
*Henriette Caroline Robert
(1834–1933)* c. 1851
albumen silver print
image: 22.5 × 16.7 cm
sheet: 23.7 × 17.9 cm
Purchased 1996
(no. 38207)

157
Heinrich Kühn
Austrian, 1866–1944
Study of a Youth (Walter Kuhn ?)
c. 1908
gum bichromate and platinum print
47.7 × 36.5 cm
Purchased from the Phyllis
Lambert Fund, 1979
(no. 31343) **

158
John Vanderpant
Canadian, 1884–1939
The Ebony Mask 1936
gelatin silver print
image: 35.4 × 27.5 cm
sheet 35.4 × 27.5 cm
Purchased 2013
(no. 45723)

159
Walker Evans
American, 1903–1975
*Family Snap Shots in Frank
Tengle's Home, Hale County,
Alabama* July–August 1936,
printed April 1969
gelatin silver print
image: 19.1 × 24.1 cm
sheet: 20.2 × 25.2 cm
Purchased 1969
(no. 21720)

160
Walker Evans
American, 1903–1975
*Penny picture Display,
Savannah* March 1936 ?, printed
April 1969
gelatin silver print
image: 24.1 × 19.1 cm
sheet: 25.2 × 20.2 cm
Purchased 1969
(no. 21737)

161
Walker Evans
American, 1903–1975
Photographer's Display c. 1936
gelatin silver print
image: 24.1 × 19.3 cm
sheet: 25.2 × 20.3 cm
Gift of Phyllis Lambert, Montreal,
1982
(no. 19264)

162
John Max
Canadian, 1936–2011
Untitled March 1963, printed
before July 1968
gelatin silver print
image: 50.2 × 34.9 cm
sheet: 50.7 × 40.9 cm

Purchased 1968
(no. 32276)

163
Lucia Moholy
Czechoslovakian, 1899–1989
Franz Roh (1890–1965) 1926,
printed later
gelatin silver print
39.3 × 30.1 cm
Purchased 1985
(no. 29152) **

164
Edward Steichen
American, 1879–1973
Sunburn, New York 1925
gelatin silver print, toned
image: 24 × 19.4 cm
sheet: 25 × 20 cm
Purchased 1999
(no. 40068)

165
Lisette Model
Austrian/American, 1901–1983
Woman with Veil, San Francisco
1949
gelatin silver print
49.2 × 40.1 cm
Gift of Dorothy Meigs Eidlitz,
St. Andrews, New Brunswick, 1968
(no. 20488)

166
Unidentified photographer
*Unidentified Portrait of Three
Women Dressed as Men* c. 1845
daguerreotype
10.8 × 8.3 cm quarter-plate
Gift of an anonymous donor, 2015
(no. LFA21500_234)

167
Yasumasa Morimura
Japanese, born 1951
*To My Little Sister: For Cindy
Sherman* 1998
azo dye print
image: 66.7 × 119.9 cm
sheet: 88.6 × 142.5 cm
Purchased 2004
(no. 41421)

168
Zanele Muholi
South African, born 1972
ZaVa, Amsterdam 2014
from the series *Somnyama
Ngonyama* [Hail the Dark Lioness]
gelatin silver print
image: 38.1 × 48.6 cm
sheet: 50.4 × 64.1 cm
Purchased 2017 with the generous
support of the Mark McCain and
Caro MacDonald Photography Fund
(no. 47082)

169
Jean-Gabriel Eynard
French, 1775–1863
*Self-portrait (Fourth from Left)
with Friends* 1841 ?
daguerreotype
image: 11.2 × 15.3 cm sight
sheet: 12.2 × 16.3 cm

Gift of Phyllis Lambert, Montreal, 1988
(no. 30636)

170
August Sander
German, 1876–1964
Farmer's Family, Westerwald
c. 1910–20
gelatin silver print
15.7 × 20.9 cm
Purchased 1979
(no. 32882)

171
John Benson
American, born 1927
Untitled 1969
gelatin silver print
image: 25.4 × 30.7 cm
sheet: 27.7 × 35.3 cm
Purchased 1970
(no. 20847)

172
Diane Arbus
American, 1923–1971
Retired man and his wife at home in a nudist camp one morning, N.J., 1963 1963, printed 1973
gelatin silver print
image: 36.5 × 36.5 cm
sheet: 50.6 × 41.0 cm
Purchased 1977
(no. 20676)

173
John Coplans
American, born Britain 1920
Self-portrait 1985
gelatin silver print
image: 47 × 45.8 cm
sheet: 50.7 × 60.7 cm
Gift of the artist, New York, 1989
(no. 30215)

174
Gary Schneider
American, born South Africa 1954
John in Sixteen Parts, V 1996, printed 1997
gelatin silver print, toned
image: 91.6 × 73.7 cm
sheet: 92.9 × 75 cm
Gift of Kathryn Finter and Jim des Rivières, Ottawa, 2000
(no. 40945)

175
Lee Friedlander
American, born 1934
Finland 1995, printed 2001
gelatin silver print
image: 37.7 × 37.4 cm
sheet: 50.3 × 40.7 cm
Purchased 2001
(no. 40776)

176
Robert Mapplethorpe
American, 1946–1989
Donald Sutherland 1983
gelatin silver print
image: 48.7 × 38.8 cm
sheet: 50.5 × 40.2 cm
Purchased 2009
(no. 42484)

177
Pascal Grandmaison
Canadian, born 1975
Glass 6 2004–05
digital chromogenic print on Plexiglas
180.3 × 180.3 × 7.5 cm
Purchased 2008
(no. 2008.5)

178
Arnaud Maggs
Canadian, 1926–2012
Self-portrait 1983
12 gelatin silver prints
image: 37.5 × 37.5 cm each approx.
sheet: 40.4 × 40.4 cm each approx.
Purchased 2009
(no. 42556.1-12)

179
Spring Hurlbut
Canadian, born 1952
A Fine Line: Arnaud #4 2016
inkjet print
63.3 × 63.1 cm
Purchased 2016
(no. 47709)

180
David Wojnarowicz
American, 1954–1992
Silence through Economics
c. 1980–88, printed 1988–89
gelatin silver prints
image 1: 22.7 × 30.3 cm sight
images 2–3: 15.1 × 17.7 cm each sight; image 5: 22.7 × 30.3 cm sight
82.4 × 79.8 cm overall
Purchased 1991
(no. 35906.1-5)

181
Lynne Cohen
Canadian, 1944–2014
Untitled (easel) 2007
chromogenic print 2007
78.7 × 100.3 cm
Purchased 2008
(no. 42407)

182
Angela Grauerholz
Canadian, born Germany 1952
Viewing Room 2016
inkjet print
image: 101.5 × 134.5 cm
sheet: 112 × 146 cm
Purchased 2017
(no. 47530)

183
Andrew Moore
American, born 1957
Restoration Studio 2002
chromogenic print
image: 159 × 202.2 cm
sheet: 159 × 202.2 cm
Purchased 2014
(no. 46250)

184
Sammy Baloji
Congolese, born 1978
Essay on Urban Planning from 1910 to the Present Day City of

Lubumbashi 2013
12 inkjet prints mounted on aluminum, 1 wall component consisting of a gelatin silver print mounted between glass in a recto-verso, wall-mounted frame
79.7 × 119.8 cm each
Purchased 2017 with the generous support of the Mark McCain and Caro MacDonald Photography Fund
(47089.1-13)

185
Leonce Raphael Agbodjélou
Beninese, born 1965
Untitled 2012
chromogenic prints
image: 150 × 100 cm each
sheet: 159.9 × 110 cm each
Purchased 2017
(no. 47535.1-3) **

186
Isabelle Hayeur
Canadian, born 1969
Mississippi 2 2013
inkjet print, mounted on aluminum
image: 158.1 × 121 cm
sheet: 158.1 × 121 cm
Purchased 2014
(no. 46228)

187
Mark Ruwedel
Canadian, born United States 1954
Wonder Valley Survey 2013–14
15 gelatin silver prints
18.9 × 24.2 cm each
Purchased 2017
(no. 47691.1-15)

188
Kay Hassan
South African, born 1956
Untitled 2008
dye coupler print, laminated to acrylic
image: 123 × 186.5 cm
sheet: 150 × 212 cm
Purchased 2009
(no. 42483)

189
Zhang Huan
Chinese, born 1965
To Raise the Water Level in a Fish Pond (Close Up) 1997
dye coupler print
image: 69 × 103 cm
sheet: 83 × 117 cm approx.
Purchased 2011
(no. 43322)

190
Benoit Aquin
Canadian, born 1963
The Motorcycle, Inner Mongolia, China 2006
inkjet print
image: 81.4 × 122.2 cm
sheet: 102.2 × 145 cm
Purchased 2010
(no. 2011.3)

191
Michel Campeau
Canadian, born 1948
Untitled 6778 (Niamey, Niger)
2005–10
inkjet print
image: 91.7 × 68.7 cm
sheet: 111.7 × 89.4 cm
Purchased 2010
(no. 2010.35)

192
Jakub Dolejs
Canadian, born 1975
Escape to West Germany, 1972
2002
chromogenic print
198.4 × 121.7 cm
Purchased 2007
(no. 2007.69) **

193
Robert Burley
Canadian, born 1957
Implosions of Buildings 65 and 69, Kodak Park, Rochester, New York
6 October 2007, printed 2013
inkjet print
28.8 × 35.4 cm
Purchased 2014
(no. 46235.5) **

Figures

Fig. 1
James Borcoman examining the
collection, September 1973
Photo: Duncan Cameron, Capital
Press
National Gallery of Canada Library
and Archives
(no. 074573)

Fig. 2
August Sander
German, 1876–1964
The Cycling Club c. 1927, printed
c. 1955
gelatin silver print with black ink
border
20.9 × 26.6 cm
Purchased 1987
(no. 29732)

Fig. 3
Karl Spiess
German, 1891–1945
Woman with Bicycle c. 1930–35
from a glass negative, 18 × 13 cm
Courtesy Estate of Karl Spiess

Fig. 4
Cover of *The Photograph as
Object: Photographs from the
National Gallery of Canada*
(Ottawa: National Gallery of
Canada, 1969). Cover image:
Edward Steichen, *Portrait, Lake
George* (colorized, detail), 1903,
printed April 1906

Fig. 5
James Borcoman, Phyllis Lambert
and Jean Boggs at the opening
of the exhibition *Charles Nègre*,
20 May 1976
National Gallery of Canada Library
and Archives
(no. B200576-2 #21)

Fig. 6
Eugène Atget
French, 1857–1927
*Café, Boulevard Montparnasse,
6th and 14th Arrondissement*
June 1925
gelatin silver print
17.2 × 22.1 cm
Purchased 1970
(no. 21123)

Fig. 7
Geoffrey James
Canadian, born Britain 1942
Boulevard St. Martin, Paris 2000
gelatin silver print
image: 35.1 × 45.2 cm
sheet: 63.5 × 71.2 cm
Purchased 2003
(no. 2003.16)

Fig. 8
Edward Weston
American, 1886–1958
Charis, Santa Monica 1936,
printed before July 1969
gelatin silver print
24.1 × 19.2 cm
Purchased 1969
(no. 33663)

Fig. 9
Chuck Samuels
Canadian, born 1956
After Weston 1991
gelatin silver print
23.2 × 18.6 cm
Purchased 1995
(no. EX-95-21)

Fig. 10
Illustration of a camera obscura
from Althanasius Kircher, *Ars
Magna Lucis et Umbrae* (1646)
book in ivory leather, containing
copper engravings and text,
folio 31 × 24.5 cm, p. 806.
(no. PSC77:353)

Fig. 11
John Moffat
Scottish, 1819–1894
*William Henry Fox Talbot, English
Pioneer of Photography* c. 1864
carte-de-visite
National Museum of Science &
Media, Bradford, UK
(no. 10325478)

Fig. 12
William Henry Fox Talbot
British, 1800–1877
Shadow of a Flower 1839?
salted paper print
11.1 × 7 cm
Purchased 1973
(no. 33538)

Fig. 13
Gertrude Käsebier
American, 1852–1934
Thanksgiving, Oceanside
c. 1905–09
platinum print, heightened with
watercolour
11.2 × 21.4 cm
Purchased 1986
(no. 28987)

Fig. 14
Stan Douglas
Canadian, born 1960
Abbott & Cordova 7 August, 1971
2008
digital C-print mounted on
aluminum
Courtesy the artist, David Zwirner,
New York/London/Hong Kong,
and Victoria Miro, London/Venice

Fig. 15
Rodney Graham
Canadian, born 1949
*The Gifted Amateur, Nov. 10th,
1962* 2007
dye coupler transparency in
fluorescent lightbox
286.1 × 556 × 17.8 cm installed
Purchased 2008
(no. 42347.1-3)

Fig. 16
Jeff Wall
Canadian, born 1946
The Vampires' Picnic 1991
Cibachrome transparency in
fluorescent lightbox

image: 229 × 335.2 cm
lightbox: 248.4 × 353.8 × 20.2 cm
Purchased 1992
(no. 36801)

Fig. 17
Eric Renner
American, born 1941
*Self-portrait Diffraction Through
the Pinhole* 7 June 1977
gelatin silver print
40.4 × 50.4 cm
Purchased 1978
(no. 32691)

Fig. 18
Frédéric Salathé
(after H.L. Pattinson)
Swiss, 1793–1860
Niagara. Horseshoe Falls 1840?,
printed 1841
aquatint on paper, mounted on
wove paper
image: 14.5 × 20.2 cm
sheet: 21.7 × 25.4 cm
Purchased 1976
(no. 21505)

Fig. 19
Timothy H. O'Sullivan
American, 1840–1882
*Historic Spanish Record of the
Conquest, South Side of Inscription
Rock, New Mexico, No. 3*
c. May–October 1873,
printed c. October 1873–75
albumen silver print
20.3 × 27.6 cm
Purchased 1986
(no. 29537.40)

Fig. 20
Carl Strüwe
German 1898–1988
*Prototype of Individuality
(Single Cells of Diatoms)*
1933, printed c. 1956–88
gelatin silver print
image: 23.2 × 17.5 cm
sheet: 23.9 × 18.1 cm
Purchased 2007
(no. 42153)

Figs. 21a–b
Louis-Jacques Mandé Daguerre
Boulevard du Temple, Paris 1838
daguerreotype
Bayerisches Nationalmuseum,
Munich
(no. R6312)

Fig. 22
Lisette Model
Austrian/American, 1901–1983
New York c 1939–45
gelatin silver print
34.5 × 26.6 cm
Gift of the Estate of Lisette Model,
1990, by direction of Joseph G.
Blum, New York, through the
American Friends of Canada
(no. 35180)

Fig. 23
Bill Brandt
British, 1904–1983
A Lyons Nippy (Miss Hibbott) 1939
gelatin silver print
24.9 × 19.9 cm
Purchased 2009
(no. 42555)

Fig. 24
John Thomson
British, 1837–1921
The Crawlers before 1877
woodburytype
11.6 × 8.8 cm
Purchased 1985
(no. PSC85:224:30)

Fig. 25
Paul Outerbridge, Jr.
American, 1896–1958
Knife and Cheese 1922, printed
later
platinum print
image: 12.2 × 9.6 cm
sheet: 12.7 × 10.2 cm
Purchased 1991
(no. 35924)

Fig. 26
Ken Lum
Canadian, born 1956
Amrita and Mrs. Sondhi 1986
dye coupler print and acrylic paint
on opaque Plexiglas
102.0 × 225.9 × 6.3 cm irregular
Gift of Ydessa Hendeles, Toronto,
1993
(no. 37583)

Fig. 27
Unidentified photographer
American, late 19th century
Street Scene Paris and *Scene[s]
on Cunard Liner "Umbria" from
Liverpool to New York* 1890
from the album *Kodak Photographs*
gelatin POPs mounted on an
album leaf
image: 8.9 × 9.2 cm circular
irregular each; sheet: 30.5 × 27.2 cm
Purchased 1976
(nos. 34295.24a-d)

Fig. 28
Lucia Moholy
Czechoslovakian, 1899–1989
Lily Fischel c. 1928–32
gelatin silver print
image: 37.5 × 27.6 cm
sheet: 39 × 29.4 cm
Purchased 1990
(no. 30733)

Fig. 29
Gary Schneider
American, born South Africa 1954
John in Sixteen Parts (installation
view), 1996, printed 1997
16 gelatin silver prints
image: 91.5 × 73.5 each approx.
sheet: 92.7 × 74.7 each approx.
Courtesy the artist

Fig. 30
Lee Friedlander
American, born 1934
New York City 1966, printed 1973
gelatin silver print
16 × 24 cm
Purchased 1974
(no. 21898.7)

Fig. 31
Jeff Wall
Canadian, born 1946
Stereo 1980
Cibachrome transparency,
serigraph on plexiglas, two
fluorescent lightboxes
image: 220.7 × 220.9 cm each
lightbox: 245.7 × 245.6 × 27.2 cm
each
Purchased 1982
(no. 28013.1-2)

Fig. 32
Cindy Sherman
American, born 1954
Untitled #411 2003
dye coupler print
111.8 × 76.1 cm
Purchased 2004
(no.41431)

Fig. 33
George Steeves
Canadian, born 1943
George David Steeves
3 July 1992, printed 27 June 1996
gelatin silver print
image: 45.5 × 30.4 cm
sheet: 50.6 × 40.5 cm
Purchased 1997
(no. EX-97-246)

Fig. 34
Rafael Goldchain
Canadian, born Chile, 1953
*Self-portrait as Reizl Goldszajn
(Poland 1905-Buenos Aires,
Argentina, 1975)* 1999–2001
chromogenic print
99 × 79.5 cm
Purchased 2007
(no. 2007.10)

Fig. 35
Jeff Wall
Canadian, born 1946
The Destroyed Room 1978,
printed 1987
Cibachrome transparency in
fluorescent lightbox
image: 158.8 × 229 cm
lightbox: 179 × 249 × 20.6 cm
Purchased 1988
(no. 29997)

Figs. 36a–b
Steven Shearer
Canadian, born 1968
Sleep II 2015
inkjet print on canvas
288.3 × 694.1 cm
Gift of the artist, Vancouver, 2016
(no. 47159.1-3)

Figs. 37a–b
Geoffrey Farmer
Canadian, born 1967
Leaves of Grass 2012
cut-out images from *LIFE* maga-
zines, archival glue, miscanthus
grass, floral foam and wooden table
installation dimensions variable
Purchased 2012 with the generous
support of the Audain Endowment
for Contemporary Canadian Art
of the National Gallery of Canada
Foundation
(no. 45632)

Figs. 38a–b
Robert Adamson and David
Octavius Hill
Elizabeth Rigby (Lady Eastlake)
1849
salted paper print
19.5 × 14.0 cm
Purchased 1977
(no. 31246)

Figs. 39a–b
C.R. Chisholm & Bros.
Falls of Montmorency, Quebec
c. 1865–70
stereograph card with two
albumen silver prints
8.6 × 17.6 cm
Purchased 1974
(no. 21332)

Figs. 40a–b
Jeremiah Gurney
Fireman, New York City c. 1853
daguerreotype with applied colour
10.2 × 8.0 cm (quarter plate)
Gift of an anonymous donor, 2015
(no. LFA21500_104)

Fig. 41a
Édouard Baldus
French, 1813–1889
Interior of the Louvre 1852
waxed paper negative
26.2 × 19.7 cm
Purchased 1967
(no. 20868)

Fig. 41b
Édouard Baldus
French, 1813–1889
Interior of the Louvre 1852
salted paper print from a waxed
paper negative
25.6 × 19.0 cm
Purchased 1967
(no. 20867)

Fig. 42
Stephen Livick
Untitled 1974
cyanotype with applied colour
image: 41.7 × 34.2 cm
sheet: 60.7 × 50.5 cm
Purchased 1974 (no. 31414)

Figs. 43a–b
Edward S. Curtis
Piegan c. 1900–13
cyanotype
20.1 × 15.4 cm

Gift of Benjamin Greenberg,
Ottawa, 1982
(no. 19061)

Fig. 44
Various photographers
*The Photographic Album for the
Year 1855* (1856)
album, in green half-leather
binding, leather corners and
brown cloth, with gold-embossed
title, containing 40 photographs
and letterpress
45.1 × 32.3 × 4.0 cm
Purchased 1973
(no. 20515.1-40)

Figs. 45a–b
George William Ellisson
*Hon. John A. Macdonald
(1815–1891)* 1860?
albumen silver carte-de-visite
image: 9.3 × 5.5 cm
sheet: 10.1 × 6.1 cm
Purchased 1972
(no. 21646)

Figs. 46a–b
William McFarlane Notman
*Bow Valley, from Upper Hot
Springs, Banff* 1887
albumen silver print
image: 41.9 × 52.6 cm
sheet: 50.6 × 60.7 cm
Purchased 1972
(no. 20501)

Figs. 47a–b
Frederick H. Evans
British, 1853–1943
*Westminster Abbey, Across
the Transepts, South to North*
before 1902
gelatin silver lantern slide
8.2 × 8.3 cm
Gift of an anonymous donor, 2010
(no. 45311)

Figs. 48a–b
Unidentified photographer
*Portrait of a woman in a flowered
bonnet* c. 1860
tintype, case open: 7.5 × 12.4 cm
plate: 6.4 × 5.1 cm (sixteenth plate)
Gift of an anonymous donor, 2015
(no. LFA21500_185_72)

Figs. 49a–d
Unidentified photographer
Family Portraits c. 1857
collage of ambrotypes and
tintypes
8.7 × 11.2 cm (quarter plate)
Gift of an anonymous donor, 2015
(no. LFA21500_230)

Figs. 50a–b
Alvin Langdon Colburn
British, 1882–1966
Clarence H. White (1871–1925)
1912
Photogravure
image: 20.1 × 15.5 cm
sheet: 23.4 × 17.4 cm
Purchased 1971
(no. 21482)

Figs. 51a–b
A. & J. Bool
British, active London 1870–78
printed by Henry Dixon and Sons
102 Leadenhall Street 1878
carbon print
image: 22.9 × 17.6 cm
mount: 40.1 × 31.5 cm
Gift of Donald C. Thom, Ottawa,
1983
(no. 19820)

Figs. 52a–b
Étienne Carjat
French, 1828–1906
Charles Baudelaire (1821–1867)
c. 1863, printed 1878
woodburytype
image: 23.1 × 18.2 cm
mount: 35.3 × 26.6 cm
Purchased 1973
(no. 32781.143)

Figs. 53a–b
Benjamin Stone
British, 1838–1914
*Man at Entrance to Houses of
Parliament* c. 1895–1914 platinum
print
image: 20.6 × 15.5 cm
mount: 21.4 × 16.3 cm
Purchased 1981
(no. 19763)

Figs. 54a–b
Tina Modotti
Italian/American, 1896–1942
"El Manito" 1925
platinum print
image: 11.9 × 8.9 cm
mount: 23.7 × 18.9 cm
Purchased from the Phyllis Lambert
Fund, 1979
(no. 32195)

Figs. 55a–b
Ansel Adams
American, 1902–1984
Edward Weston 1939
gelatin silver print
image: 23.4 × 17.8 cm
sheet: 45.5 × 35.5 cm
Gift of Dorothy Meigs Eidlitz,
St. Andrews, New Brunswick, 1968
(no. 20520)

Figs. 56a–b
Robert Adams
American, born 1937
Longmont, Colorado 1979, printed
1985
gelatin silver print
image: 12.7 × 12.7 cm
sheet: 35.4 × 27.6 cm
Gift of Avi Lior, Nepean, Ontario,
1998
(no. 39963)

Fig. 57
Unidentified photographer
American, late 19th century
*Scenes on the Cunard Steamship
"Servia"* 1890
from the album *Kodak
Photographs*

gelatin POPs mounted on
an album leaf
image: 8.9 × 9.2 cm circular,
irregular each; sheet: 30.5 × 27.2 cm
Purchased 1976
(nos. 34295.2a-d)

Figs. 58a–b
M. Branger Photo-Presse, Paris
*Malécot's aircraft, piloted by
MM. E. Carboy and Yvon, being
tested before the military approval
committee* 1908
gelatin POP print with black ink
crop marks and inscription
17.9 × 13.0 cm
Gift of an anonymous donor, 2010
(no. A4110.42.23)

Fig. 59
Attributed to Gabriel Lippmann
Faverol, Normandy 1914
Lippmann interferential colour plate
12.1 × 9.1 × 2.3 cm
Private collection

Figs. 60a–b
Alvin Langdon Coburn
British, 1882–1966
Two Graves, Edinburgh 1904,
printed before July 1906
gum bichromate and platinum print
35.9 × 28.9 cm
Purchased 1975
(no. 21499)

Figs. 61a–b
Betty Hahn
American, born 1940
Girl by 4 Roads 1968
gum bichromate print in two colours
37.3 × 56 cm
Purchased 1969
(no. 22915)

Figs. 62a–b
Eugène Atget
French, 1857–1927
Parc de Versailles 1901
matte albumen silver print
17.1 × 21.8 cm
Purchased 1974
(no. 21181)

Figs. 63a–b
Lumière Brothers Studio
France, studio active from the
1890s –early 20th century
Still-life with Lobster c. 1907
autochrome
12.9 × 17.8 cm
Purchased 2016
(no. 46975)

Fig. 64
Herbert Dassel
Canadian, born Russia, 1903–2001
Light Paintings 1965
chromogenic print
image: 27.5 × 36.6 cm
mount: 50.8 × 40.6 cm
Purchased 1966
(no. EX-66-313)

Figs. 65a–b
Gabor Szilasi
Canadian, born Hungary 1928
Bathroom, Lotbinière 1976,
printed 1979
chromogenic print (Ektacolor)
image: 25.6 × 19.6 cm
mount: 35.5 × 27.9 cm
Gift of Evelyn Coutellier, Brussels,
1988
(no. 36096.18)

Fig. 66
Alison Rossiter
American, born 1953
Sponges 1983
chromogenic print
50.7 × 40.6 cm
Purchased 1984
(no. EX-84-101)

Figs. 67a–b
George Hunter
Canadian, 1921–2013
*Wild Horse Race, Calgary
Stampede* 1958
dye imbibition print (Kodak Dye
Transfer)
image: 38.4 × 48.9 cm
sheet: 50.8 × 61.0 cm
Purchased 1966
(no. EX-66-287)

Figs. 68a–b
Stan Denniston
Canadian, 1953
*U.S.–Mexico Border, Nogales,
Arizona* 1982–83
silver dye bleach print
(Cibachrome)
image: 20 × 29.7 cm
sheet: 27.7 × 35.3 cm
Purchased 1984
(no. EX-84-389.1)

Fig. 69
Judith Eglington
Canadian, born 1945
Untitled 1975
instant dye print (Polaroid)
image: 7.9 × 7.8 cm
object: 10.8 × 8.8 cm
Purchased 1975
(no. 75-X-1064)

Figs. 70a–b
Spring Hurlbut
Canadian, born 1952
James #5 from the series *Deuil II*
[Mourning] 2008,
inkjet print
71 × 81 cm approx.
Gift of the artist, Toronto, 2012
(no. 45643)

Donors

We gratefully acknowledge the support of the following individuals:

The American Friends of Canada Committee, Inc.
The of American Federation of Arts
Paul R. Baay
Nancy Baele
W. Bruce C. Bailey
William Baker
Murray F. Ball
Bernstein Development Fund
Bernstein Prospero Fund/ Courtesy Jane and Raphael Bernstein
The Estate of Ilse Bing Wolff
Peter Boneham
Dr. and Mrs. M.J. Boote
James Borcoman
F. Maud Brown
Laing and Kathleen Brown
Valerie Burton
Claude Cadieux
Vivian and David Campbell
Canadian Centre for Architecture
Gary Carroll
Robert-Jean Chénier
Stephen Chetner
Helen Chisholm
Ian Christie Clark
Van Deren Coke
The Council for Canadian American Relations
Evelyn Coutellier
Dr. Robert W. Crook
DTT Works Art Ltd.
The Harold and Esther Edgerton Family Foundation
Peter and Pat Edwards
Terry Edwards Frampton
Dorothy Meigs Eidlitz
Anstace and Larry Esmonde-White
The Gertrud E. Feininger Estate
Tomas Feininger
Leonard J. Fowler
Donald Fraser
Monica Fraser
The Estate of Winnifred Frost
Karen Gabbett-Mulhallen
Michiko Gagnon
The Estate of Charles Gagnon
Benjamin Greenberg
Ralph Greenhill
Miriam Grossman Cohen
John Gutmann Bequest
The Estate of Robert Handforth
Reverend Joseph L. Hennessey
Victoria Henry
Herzig Somerville Ltd.
William Hingston
Robert H. Hubbard
Andrew Hubbertz
Eleanor Joy Hurlbut Fitzpatrick
Charles Isaacs and Carol Nigro
Catherine G. Johnston
Estrellita Karsh
Judith Kassman Wexler
Margaret E. Kells
Dr. Albert Kerenyi

Ketchum Mary and Clarke Ketchum
Michael and Sonja Koerner
Paul La Barge
Phyllis Lambert
Anne S. Leaf
Mr and Mrs Noel Levine
Anne Levitt
David Lewall and Edward and John Lewall
The Estate of Herbert List
C. Ainslie Loomis
Andrew M. Lugg
The Estate of Frank C.C. Lynch
Robert de Maisonneuve Rowan
Marnie Marriott
Glenn McInnes and Barbara McInnes
Mr. and Mrs. Andrew Mellon
William John Melson, Barbara Elizabeth Melson Estes and families
Aaron Milrad
G.H.S. Mills
David Milman
The Estate of Lisette Model
Mrs. Virginia P. Moore
Geoffrey Morrow and Margaret Spence
Vera Mortimer-Lamb
National Gallery of Canada Foundation with the support of The Members and Supporting Friends
National Gallery of Canada Foundation CMCP Endowment Fund
Diana Nemiroff
The New Orleans Museum of Art
The Ottawa Camera Club
Marguerite Parenteau
Photographers + Friends United Against AIDS
Ward C. Pitfield
Charles Polowin
The Provincial Archives of Alberta
The Rennie Foundation
George R. Rinhart
Varvara Rodchenko and Aleksandr Lavrentiev
Guy Rodrigue
Paul Sabourin
Thomas Sabourin
Michael S. Sachs
Larry J. Schaaf
Joseph E. Seagram & Sons, Inc.
Max Serlin
Albert A. Shipton
Sandra L. Simpson
Graham L. Smith
Joel Solomon
Rosemary Speirs
Charles Taylor
Irving Taylor
Teleglobe Employees' Art Committee Fund
Elian Terner
Pierre Théberge
Donald C. Thom
Ann W. Thomas
Jacques Toupin
Rosemarie Tovell
J. Van Rooy

The Vancouver Public Library
Visual Studies Workshop
The Andy Warhol Foundation for The Visual Arts
Mrs. Wilder
Major R.F. Wodehouse
The Zabriskie Gallery
Peter Zegers
and the members of the Photography Collectors Group: Lewis Auerbach; Barbara Gage Bolton; Frederic Borgatta; George R.Carmody; Jim des Rivières and Kathryn Finter; Sheila Duke; Anna Ekstrandh and Anders Nordstrom; Brian Finch; Jocelyn Gordon; Tom Gray; Adrienne B. Herron; Richard B. Herron; Anna J. Kirkbride; John Kirkbride; Kent Laver; Barbara Legowski; Avi Lior; Brian and Linda MacIsaac; Robert Milin; Zavie and Ida Miller; John Przybytek; Irwin Reichstein; Victor Rygiel; Jane F. Scott; Mira Svoboda; Lyndon Swab; M.E. Welsh; Amalia and Stanley Winer; David E Wright and Mary Beth Sweet

Artists
Vikki Alexander
Nicolas Baier
Robert Bourdeau
Jim Breukelman
Ed Burtynsky
Lynne Cohen
Sorel Cohen
John Coplans
David Cowles
Bruce Cratsley
Jennifer Dickson
Chris Dikeakos
Stan Douglas
Alan Dunning
Claudia Fährenkemper
Audrey and Robert E. Flack
Robert Fones
Etta Gerdes
Pam Hall
Thaddeus Holownia
George Hunter
Spring Hurlbut
Arnaud Maggs
Geoffrey James
Louis Joncas
Elaine Ling
John Massey
David McMillan
David Miller
Gubash Milutin
John Pfahl
Herb Quick
Sylvie Readman
Sophie Ristelhueber
Judith Joy Ross and the James Danziger Gallery
Alison Rossiter
Mark Ruwedel
Gary Schneider and John Erdmann
Ursula Schulz-Dornburg
Rosalind Solomon
Hiromi Tsuchida
Bill Vazan
Ian Wallace

Copyright &
Photo Credits

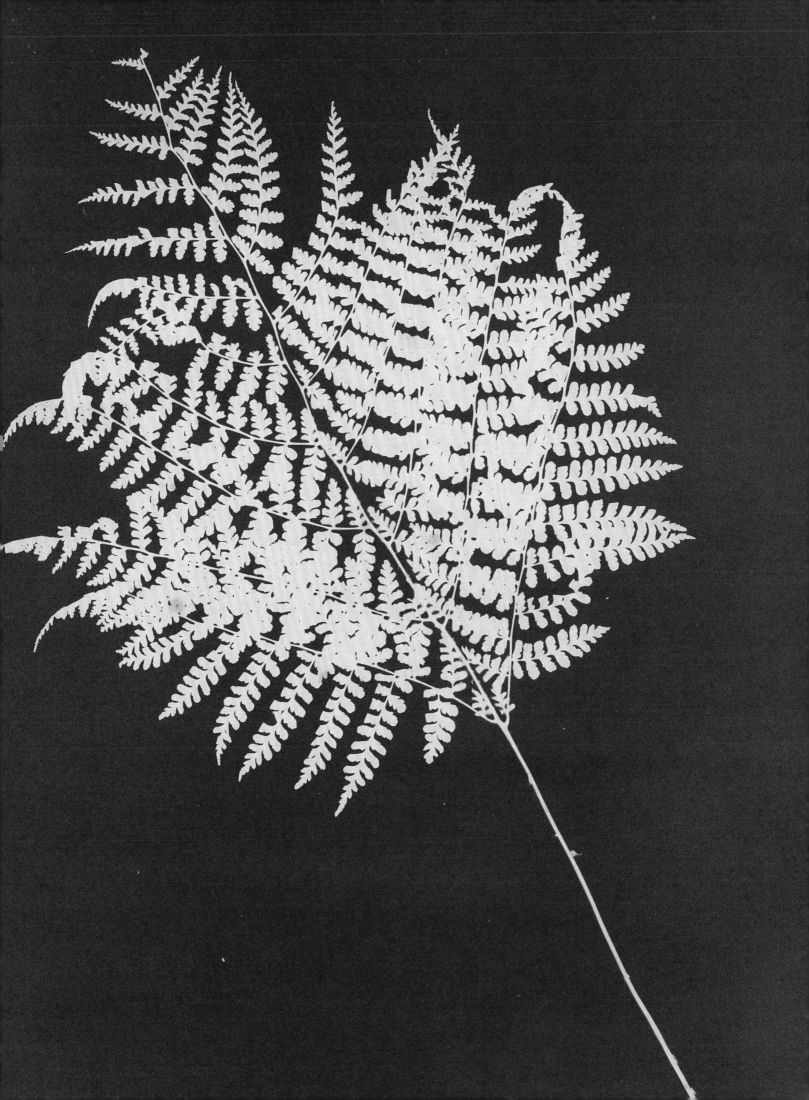

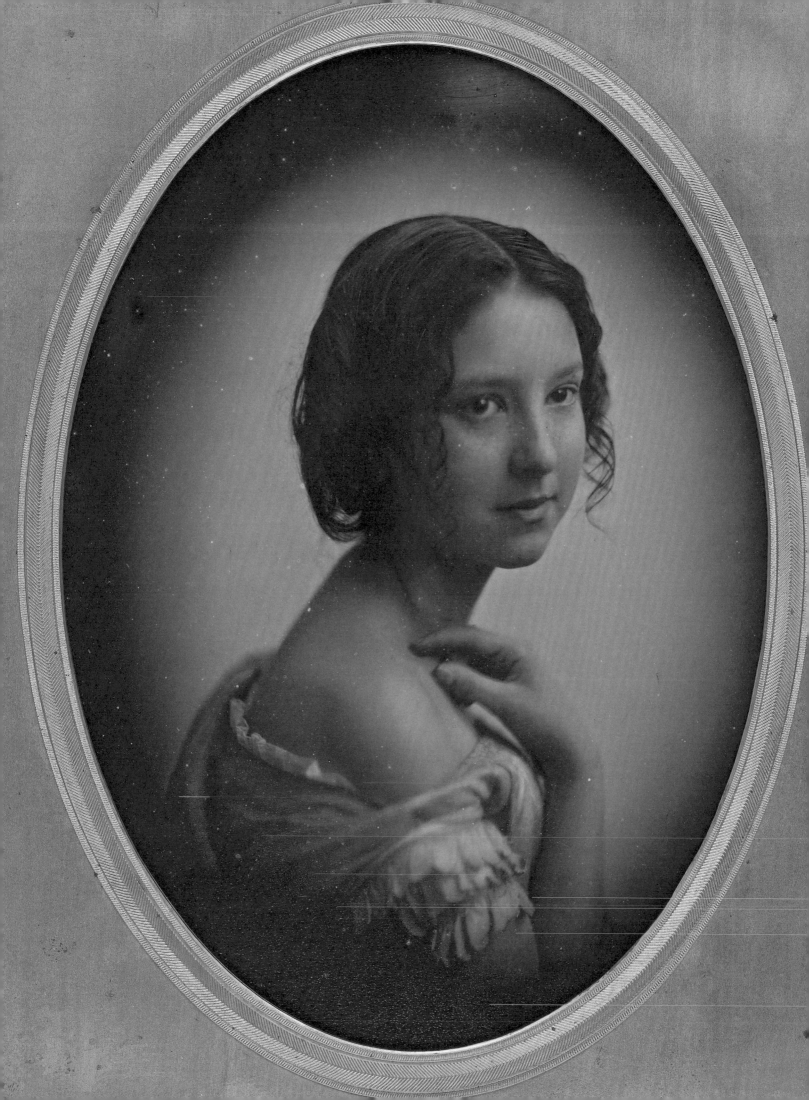